BRITISH ARTISTS AT WORK

AMANDA ELIASCH

GEMMA DE CRUZ

ASSOULINE

12925

OS 709.41 ELI

YORK ST. JOHN
COLLEGE LIBRARY

12925

OS 709.41 ELI

BRITISH
ARTISTS
AT WORK

Photographs Amanda Eliasch

**Texts Gemma de Cruz
with additional material by
Kay Hartenstein-Saatchi
and Martin Maloney**

**Original concept by
Franca Sozzani**

ASSOULINE

Tis not an art book but much more simply a guide to contemporary British artists at work. The project arises from an editorial idea for Italian Vogue responding to a keen curiosity about the major players on the London art scene—recognized as some of the most important in the world—what they are like, where they work. On my part it represents an effort to capture my great enthusiasm and deep passion for a realm that is extremely stimulating and, for me, a continual source of inspiration. I believe in the utility of this guide, underlining the value of its journalistic slant while shunning any inclination towards art criticism. My sincere thanks go to all the artists who participated in the realization of this publication.

Franca Sozzani, Milan, December, 2002

BRITISH ARTISTS AT WORK

NICHOLAS BARKER	JIM LAMBIE
SIR PETER BLAKE	PETER LIVERSIDGE
PATRICK CAULFIELD	MARTIN MALONEY
MAT COLLISHAW	MARTIN MCGINN
MICHAEL CRAIG-MARTIN	LISA MILROY
DEXTER DALWOOD	SARAH MORRIS
IAN DAVENPORT	TIM NOBLE & SUE WEBSTER
PETER DAVIES	JULIAN OPIE
TRACEY EMIN	RICHARD PATTERSON
TIERNEY GEARON	DAN PERFECT
GILBERT & GEORGE	GRAYSON PERRY
KIRSTEN GLASS	MARC QUINN
STEVEN GONTARSKI	FIONA RAE
ANTONY GORMLEY	MICHAEL RAEDECKER
JUN HASEGAWA	NEIL RUMMING
SOPHIE VON HELLERMANN	JENNY SAVILLE
HOWARD HODGKIN	D. J. SIMPSON
RACHEL HOWARD	SAM TAYLOR-WOOD
GARY HUME	GAVIN TURK
RUNA ISLAM	REBECCA WARREN
CHANTAL JOFFE	GILLIAN WEARING
SARAH JONES	RACHEL WHITEREAD
ANISH KAPOOR	

FOREWORD BY AMANDA ELIASCH

I know nothing about the art world but I have been involved in making a book for Italian *Vogue* for Franca Sozzani, the editor. I suppose I became interested in art about ten years ago when I met Charles Saatchi at the Amanpuri Hotel in Thailand. I was sitting by the swimming pool and he was sitting with the film director David Puttnam. He asked me where I lived and I told him in Chester Square. "Well, introduce me to your husband because we need clever young people like him." So we became friends, but not within the art world. Johan was his "cleaner," as he called him, he'd clean up his mess and he cleaned up the Saatchi deal between the old and new companies. I really appreciated Charles's help recently as he assisted me with my photographic shows of nudes. The last one he came to he said, "Oh, definitely, definitely commercial, stick to 1930s Paris." I had been working with Martin Maloney and doing some colour photographs, and Martin said, "Keep on with them." Charles said, "If you keep on with them you'd better go into magazines." So I went to New York and took my book round and I got a call back from *Visionaire.* I then telephoned Katy Barker who was the only photographic agent I knew and asked her advice. She told me that I couldn't show nudes and that I should do some fashion photographs. So I was introduced to a girl named Rushka Bergman who helped me take the correct photographs for my book. I showed them to the photographer Michel Comte, who took me to Italian *Vogue.* I then did one or two jobs for Franca, including the *Kartell Catalogue*, which many photographers did. It showed artists in their chairs. She liked the pictures and suggested I do a book on artists in their studios. I asked for a writer, and Martin suggested Gemma de Cruz, and we drew up a list together. The list in the book is quite varied: It is Young British Artists and a few of the Establishment who actually made the young artists or helped to make them. I liked the older guys because I think as a culture we seem to have lost respect for anybody over the age of forty-five, which is a pity as you can learn so much from people of all ages and backgrounds. The artists represented in this book were in London when I was shooting the book—there were others we would have liked to include who were not working in London at the time.

DAMIEN HIRST
While visiting White Cube, I was shown Damien Hirst's satellite dish that was going up to Mars to do a colour analysis of its surface. Of course I wanted to be on that dish. Damien Hirst is a genius, and I've seen him be very kind to Kay. He would have preferred not to appear in this book, but has to. He has produced his own books, which are widely available. A.E.

Damien Hirst and I «grew up» together in the London art world, in a historical sense. I had just moved to London from New York to set up an avant-garde contemporary art gallery, and he was a student at Goldsmiths College. When he curated his now famous *Freeze* exhibition in 1988, which launched the careers of many of his fellow artists and his own, he called me to insure that my new beau Charles Saatchi and I wouldn't forget to come. Forget? We were desperate to see this show.

Damien had organized the exhibition in a dreary warehouse in the Docklands, and we arrived on a cold but sunny day. There was a problem finding the keys but eventually we entered. It was like a breath of fresh air seeing this art and witnessing really new ideas. One must remember that shows like this weren't happening in London at that time, and young emerging artists didn't have the opportunity to show their work in such a professional way.

The next time I saw Damien's work was in an exhibition space in Woodstock Street. The show, *In and Out of Love,* featured a magical installation of live tropical butterflies emerging from their cocoons and flying around the room. Hung on the walls were confectionary-coloured canvases with butterflies glistening on them. It really knocked my socks off. I can even remember the way it smelled. It was just so beautiful and romantic and exhilarating. Damien was firmly on the map.

I adored Damien from the first moment I met him, and we became fast friends. He's an original, and his enthusiasm is infectious. I kind of get heart palpitations when I'm with him and his surfing-mad partner, Maia Norman. And he is truly generous; he'd give you the shirt off his back. Damien was notorious for remarking loudly and often, «I want to be famous»; he is such a creative volcano, it was inevitable. His ambition was felt throughout the art world and spilled over into the tabloid press. Hirst became a household name, but it didn't stop him from making serious art.

Damien teamed up with Jay Jopling at White Cube, who understood and respected his dreams, no matter how fantastical they were. Then Damien made the Shark, *The Physical Impossibility of Death in the Mind of Someone Living* (1991), and the world went berserk. My then-husband and I bought it, and the Shark became the centerpiece of the *Sensation* exhibitions in London, Berlin, and New York.

A night out with Damien is a sure cancel the whole next day event. He's a world-class party animal once he gets going. One evening recently at Les Trois Garcons in London he caught my handbag on fire and then, when I was leaving to go home, he rushed up to me and stuffed into my pocket a little glass insect I had been coveting earlier at the bar. I don't really consider this theft, it's just a Damien moment.

He's got this desire to live forever, and I hope he does. If he doesn't, although I think he might, maybe he should make a glass box for himself, fill it with formaldehyde, and have Maia and his sons, Connor and Cassius, haul him in. That way we'll all have him, One to One, Always, Forever, Now.

Kay Hartenstein-Saatchi

NICHOLAS BARKER

I had seen Nicholas Barker about town long before I met him sunning himself like a lazy lizard poolside at the Cipriani Hotel in Venice. One can't help but fall for his old-fashioned charm and demeanour. He's the type of guy who opens doors for ladies and compliments them on their clothes. And he always looks the part of English dandy in his slightly wrinkled seersucker suit and straw hat. He and his wife, Liza Bruce, the swimwear designer, seemed to live the life of the privileged classes as they were always about to go or had come back from some rich folk's villa or yacht. He is a great gossip and has been an agony aunt to many of his friends. He's been the listening ear and the tear-stained shoulder for at least half a dozen of divorces I know of. It was much later when Nicholas told me he was a painter and asked me round to the Kensington studio he shares with Liza that I realised he was a struggling painter trying to find his voice after having studied at St. Martin's School of Art a decade ago. Because of my perception of Nicholas I expected his studio to be furnished with old leather chairs and dark velvet curtains, so I was really surprised when I walked in to find fluffy white carpets, pink satin upholstered chairs and his paintings hanging just so on the colourful walls. This studio is what I would call Mae West boudoir chic. The paintings he was doing at the time had provocative words on candy-colored canvases. They were like sexy Ed Ruscha paintings. Playful and kitsch.

Later, when Nicholas met the painter Martin Maloney, they immediately struck up a fast friendship and he asked Martin's advice on his work. When I next saw Nicholas's work in a group show curated by Martin at Anthony d'Offay's new space at Haunch of Venison Yard, it had changed drastically. He had taken Old Master images and on top of these recognizable paintings he collaged images of sexy women from soft-porn magazines. Lots of airbrushed bosoms in lacy bras and glossy red parted lips. Pin-up girls in classical landscapes and velvet drapery. They ooze a fluffy and coy sexuality. The new work was large and painted in the bold, broad strokes of a billboard painter and up close the detail becomes obscured and crudely painted. Like Old Master paintings I thought his idea was to hang them high on the damask walls of a stately home, but not many aristo-wives would want these cheesecake lingerie-clad gals on their walls.

As I stared at his paintings I began to imagine Nicholas not so much as the Court Jester Gent I had come to know, but maybe a sexually repressed teenager with a well-fingered copy of *Playboy* tucked under his mattress! I remember his walking up to me at the show and asking me how I liked his new work. I actually blushed and told him they were terrific. And they are if you like that kind of thing. And I was reassured when he jumped in his elegant old Rover in his pin-stripe suit and well polished shoes and drove into the night. K.H.S.

APRIL 10TH, 10.00, NICHOLAS BARKER
I suppose I had a completely different view of the artists involved than Gemma. I saw them with fresh eyes in their own surroundings with their own distinct characteristics. Gemma obviously had a more intellectual idea about them and was influenced by their work, which for the most part I didn't know. When I entered Nicholas Barker's studio it reminded me of the 1970s. Pink fluffy carpets, a pink chair, a huge Barbie, plastic sculptures, antlers, and leopard skin rugs. Everything was quite messy and there were a number of sex magazines lying around. There were huge paintings that were completely different from the ones that he was currently painting, and plastic sculptures with sayings on the front of them. I once did a shoot with him with a nude, and he was fun, bringing out circus costumes for the model. Although there is a 1970s feel about his studio, it also has a feeling of antiquity about it, with beautiful light. He lives with his wife, who makes stunning swimsuits that make even the fat look good. Nicholas leads an interesting life between London and India. A.E.

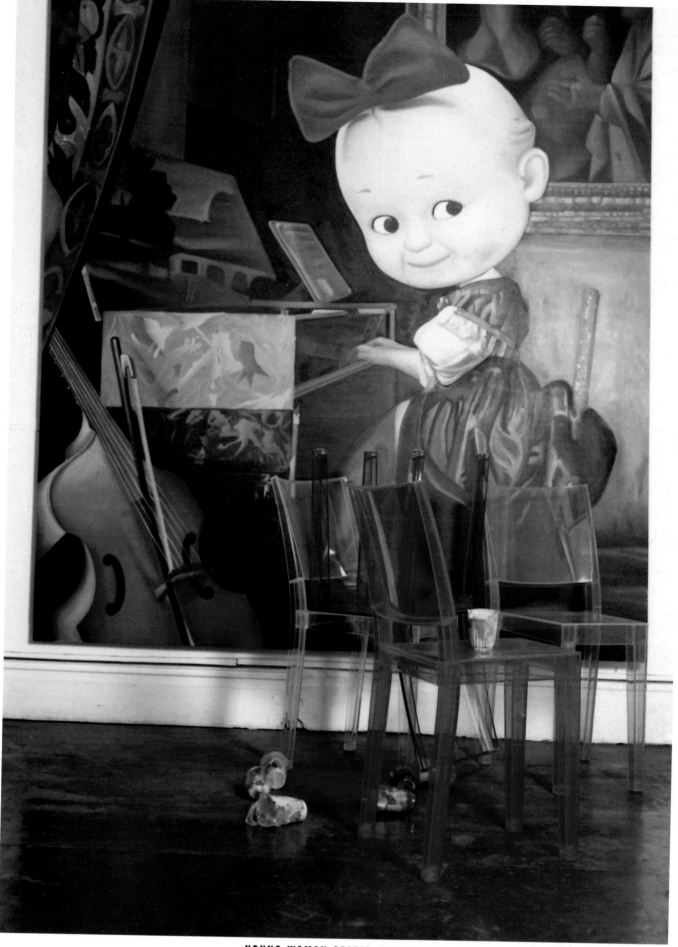

YOUNG WOMAN SEATED AT VIRGINAL, 2002. OIL ON CANVAS, 213 X 167 CM.

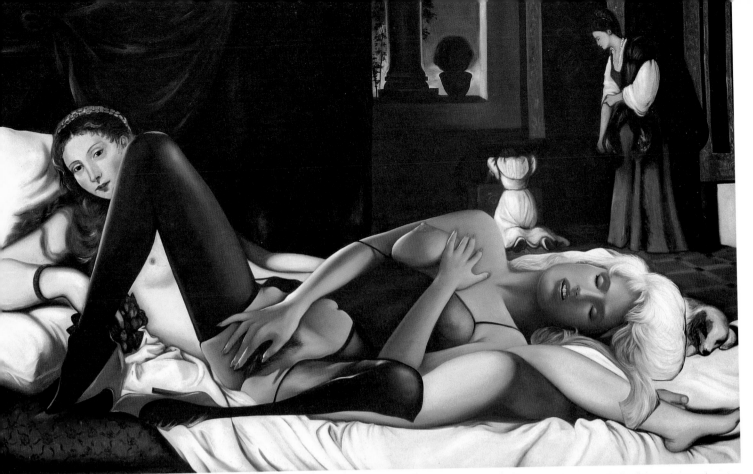

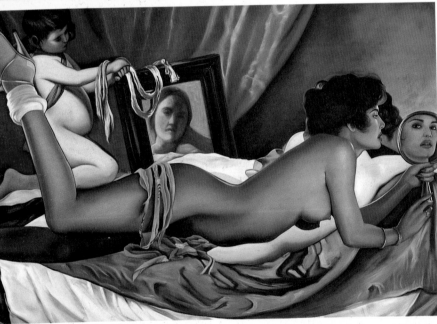

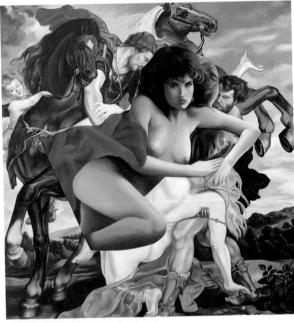

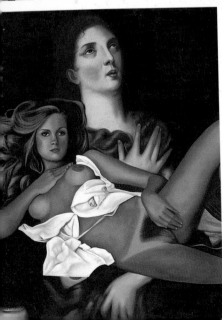

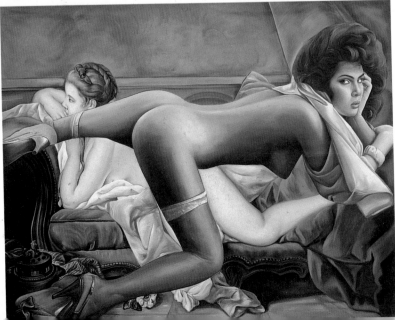

ABOVE: PORTRAIT OF MADDALENA, 2002. OIL ON CANVAS, 170,6 X 121,9 CM.
LEFT (FROM THE TOP CLOCKWISE): THE VENUSES OF URBINO (BOTH OF THEM), 2000-2001, 193 X 312 CM;
THE RAPE OF THE THREE DAUGHTERS OF LEUCIPPUS (KING OF ARGOS), 2000, 254 X 235 CM; LES MADEMOISELLES
MURPHY (OH LA LA), 2000, 189 X 243 CM; SAINT MARY MAGDALENS IN PENITENCE, 2001, 252,7 X 196,8 CM;
THE ROQUEBY VENUSES (LOOKING GOOD!), 2000-2001, 243,8 X 289,5 CM. ALL: OIL ON CANVAS.

SIR PETER BLAKE

Peter Blake began his career as a rebel but is now seen as British art's eccentric father. As a student at the Royal College in the late 1950s, he was influenced by American artists Robert Rauschenberg and Jasper Johns's use of Pop imagery, and he made his own British version that was illustrative and autobiographical. He cut his subjects out of popular culture and collaged them into his paintings. He painted boys and girls, and most famously himself, holding comics and wearing badges (*Children Reading Comics*, 1954, and *Self-Portrait with Badges*, 1961) as a way to put pop imagery into his work. He went on to use pop icons such as Marilyn Monroe and Elvis Presley, making paintings that epitomise the outlook of a young man in swinging, 1960s London.

His most-referenced work is the cover design for The Beatles' album *Sgt. Pepper's Lonely Hearts Club Band,* which connected him to the biggest band in pop music and turned his art into a mass-produced item, an unlimited edition that anyone could own. It put him, the artist, back into the pop world he was describing.

In 1969, Blake moved to the West Country of England and became a founding member of the Brotherhood of Ruralists. His paintings at that time explored fantasy and childhood, using literary subjects such as *Alice in Wonderland* and Shakespeare's Titania. He returned to popular culture at the beginning of the 1980s with various projects, the most memorable being his 1985 poster design for Live Aid. Blake's painting style changed considerably when he was made associate artist at the National Gallery in 1994: his tight illustrative and realist manner loosened and became more painterly. He worked in a studio within the National Gallery for two years, combining elements from paintings in the collection with his own compositions. In *The Venuses, Outing to Weymouth* Blake incorporated the Madonnas of Velázquez, Titian, and other Old Masters into one painting. They kept their original poses but re-emerged as women sunbathing in a landscape reminiscent of John Constable. Even the title of the show, *Now We're 64,* was a collage of meaning, referencing The Beatles, A. A. Milne, his decision to retire, and his shared birth year with the cheetah from Tarzan, who is featured in his painting *Tarzan Family in the Roxy Cinema in NY.* The painting, which was started in 1964, was reworked during Blake's two years at the National Gallery. It turns the characters from the television series *Tarzan* into famous subjects from art history, such as Leonardo's *Mona Lisa* and Michelangelo's *David.*

In 2001 Blake was appointed senior hanger of the Royal Academy's Summer Exhibition, where some of the academicians marked him a troublemaker for daring to include photographers in his choice of invited artists. Blake's curated room showed mutual respect between himself and contemporary artists such as Damien Hirst and Tracey Emin, whom he included in the exhibition.

JULY 9TH, 2.00, SIR PETER BLAKE
Blake's studio is like a curiosity shop, he has just been in the *Harry Potter* film and, complete with long white beard, he is perfect for it. He is a collector; there are shelves and shelves of pop memorabilia and paintings in very rich colours against dark green and red walls. It reminds me of the back of antique shops which are full of goodies you want to explore. He was happy to explain the art world to my son who was with me that day. Sadly, I had to leave within an hour as that was all the time we were allowed. A.E.

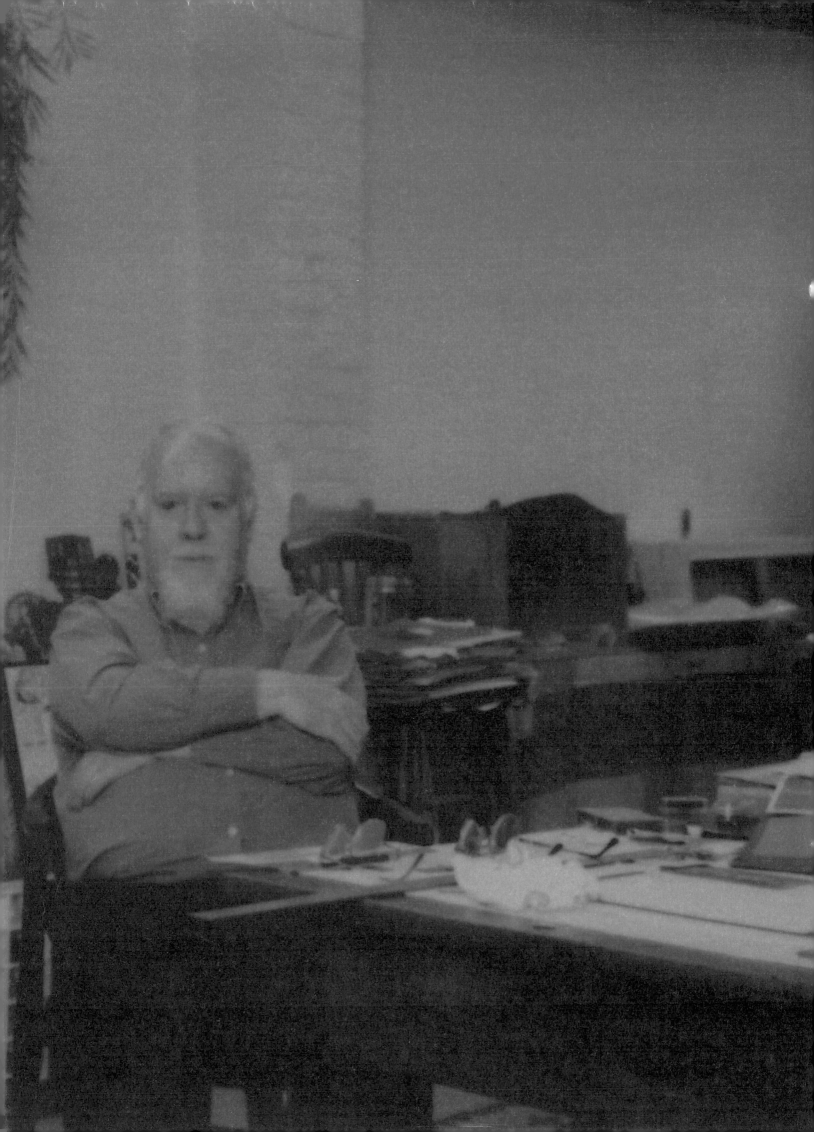

AMERICAN TRILOGY, TRILOGY, TRILOGY, 1998. OIL, PHOTOGRAPHS
AND ASSEMBLAGE ON BOARD, 3 S/S PANELS, 123,8 X 234,8 CM OVERALL.

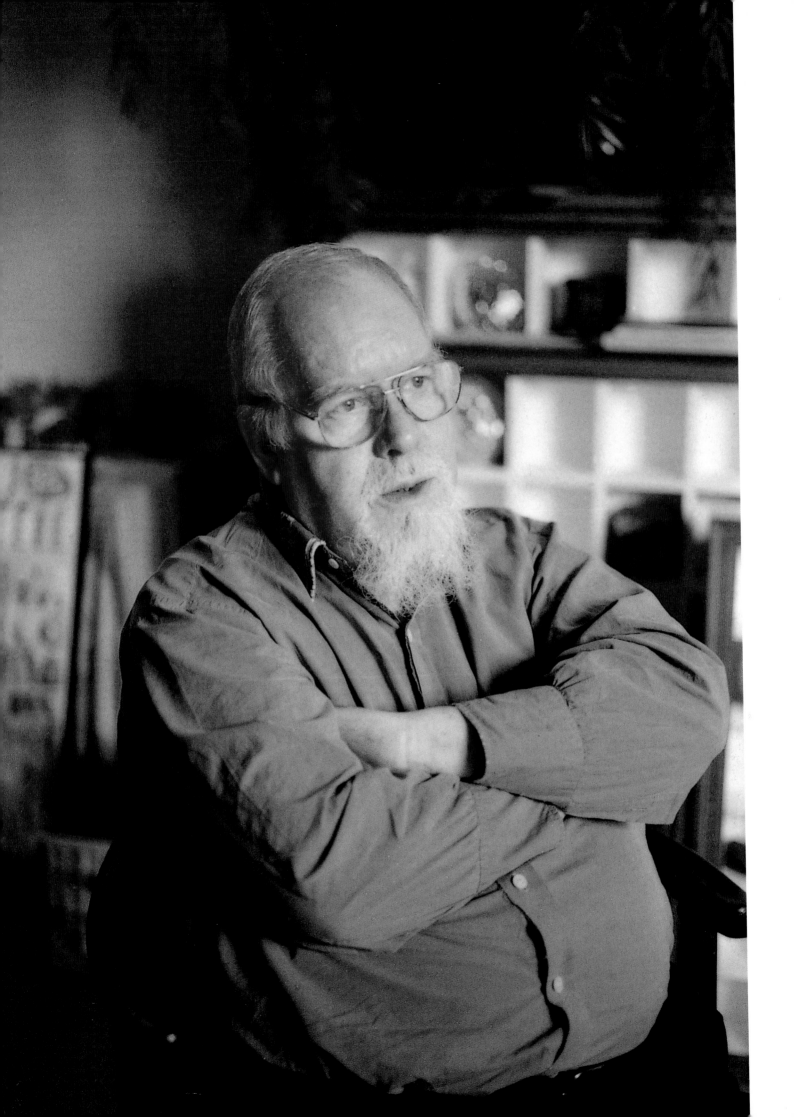

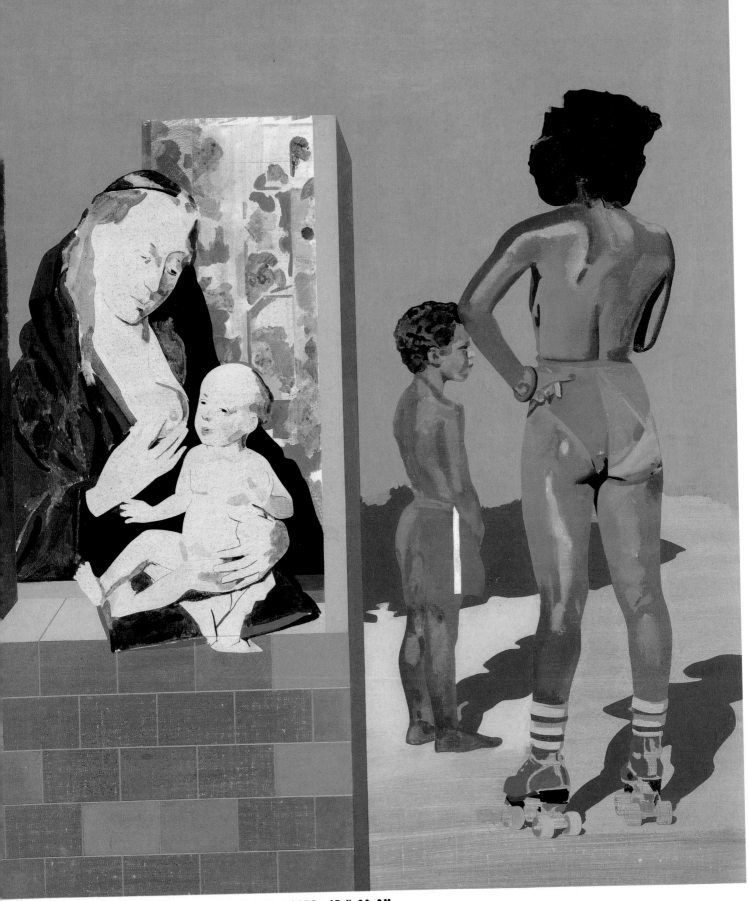

MADONNA OF VENICE BEACH, 1995. OIL ON BOARD, 47 X 39 CM.

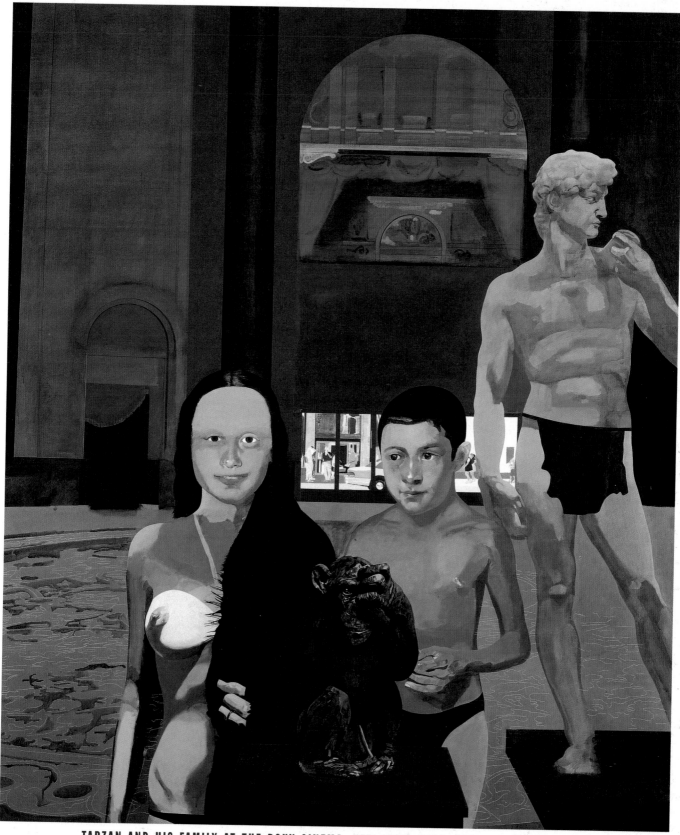

TARZAN AND HIS FAMILY AT THE ROXY CINEMA, NEW YORK, 2002. CRYLA ON CANVAS, 182,9 X 152,4 CM.

PATRICK CAULFIELD

In 1956 Patrick Caulfield studied graphic design for one term at Chelsea School of Art before switching to the painting department. He went on to the Royal College of Art from 1960 to 1963, after which he was included in the high-profile group exhibition *The New Generation 1964* at the Whitechapel Gallery. He had his first solo show at the Robert Fraser Gallery in 1965 and then in 1968 at Waddingtons, with whom he still shows today.

Early in his career, Caulfield rejected the politeness of English figurative painting in favour of loud colours and flat shapes. His greatest influences came from his Royal College tutor Jack Smith and the American artist Philip Guston. While Caulfield didn't find his voice in Abstract painting, the influence of Guston did affect the way he simplified his compositions. He avoided gestural mark-making and used household paint to achieve a consistent flat surface.

During the late 1960s, Caulfield began a series of large-scale interiors which placed detailed black line drawings on top of monochromes. These paintings described a lot of detail in a simple way. Caulfield often adapted his paintings from images found in interior design books. *Inside a Weekend Cabin* (1969) and *Dining Recess* (1972) are composed of drab colors but have one item, such as a tablecloth or lampshade, painted white. These objects are like holes in the composition, but they create the focal point in the painting. Likewise, in *Paradise Bar* (1974) and *After Lunch* (1975) Caulfield painted other styles into the composition by including them as pictures on the wall of his interiors. In *After Lunch* he pitted his simplified approach to painting against the conventional verity of a photorealist landscape. The conversation between the two styles is mutually supportive, as they bring out the best in each other—both are convincing two-dimensional images but are simultaneously at odds. Such areas of realism appear regularly in Caulfield's work—a real bunch of flowers in a cartoon vase, real food on a flat coloured shape which becomes a plate.

Throughout the 1990s Caulfield had eliminated the use of black lines but continued to make work based on eating and drinking. He turns ordinary interiors into decorative paintings and arranges disparate still lifes separated by painting languages rather than subjects. Without including figures, his paintings record how people live. His subjects are tables and chairs, bars and restaurants, food and objects from everyday life, turning them into both elegant shapes and observed details.

JUNE 26TH, 11.00, PATRICK CAULFIELD
As I entered at 10 a.m. he asked if I wanted a whiskey. I told him I didn't drink but if he had any slimming pills that would be great! I was dying to look at his paintings but didn't see any on obvious display, although I caught a glimpse of strong colours downstairs. There was a very pretty garden, which his studio overlooked. I had been told that he taught some of the artists, but he said he hadn't taught anyone anything. He also asked if I had found the art world bitchy, but I hadn't. A.E.

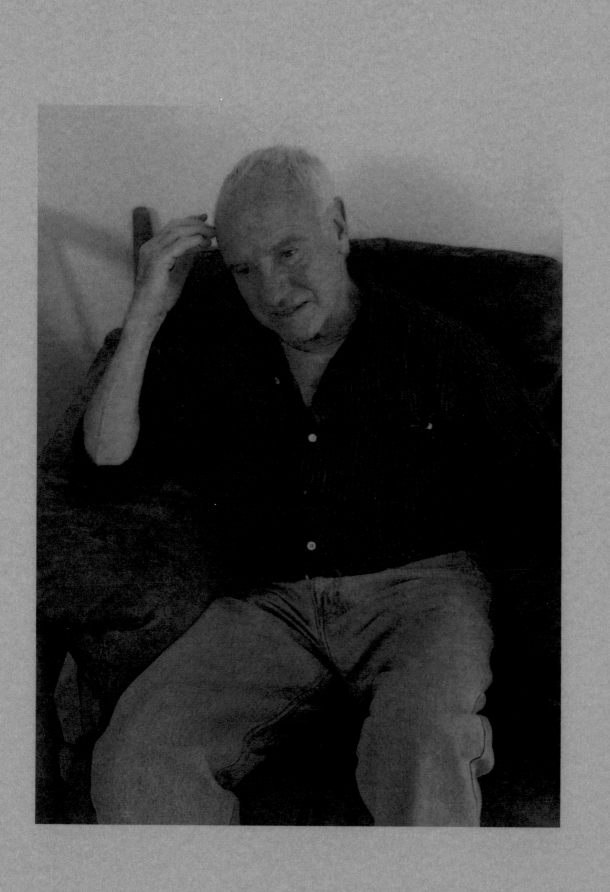

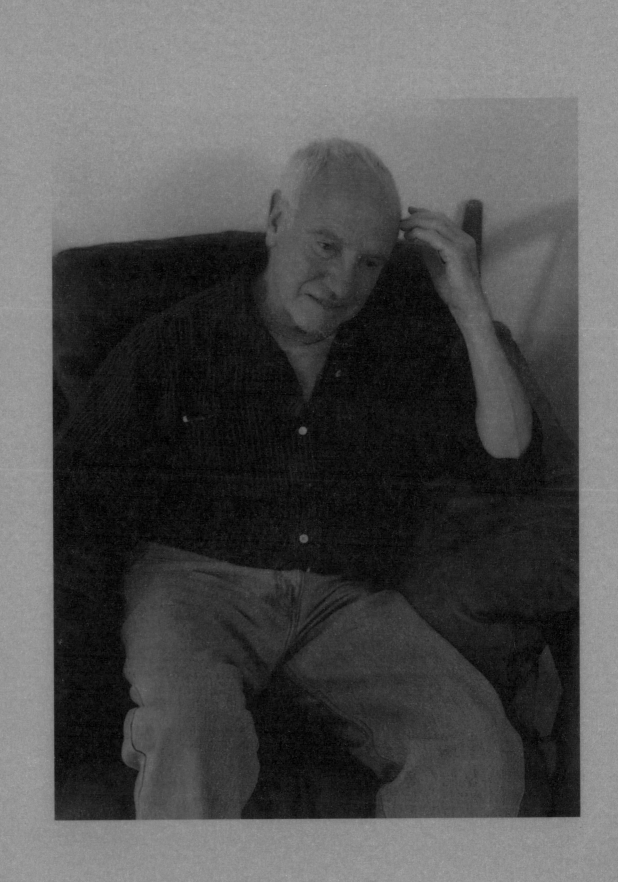

PATRICK CAULFIELD

SOUVENIR, 1999. ACRYLIC ON CANVAS, 76,8 X 61,6 CM.

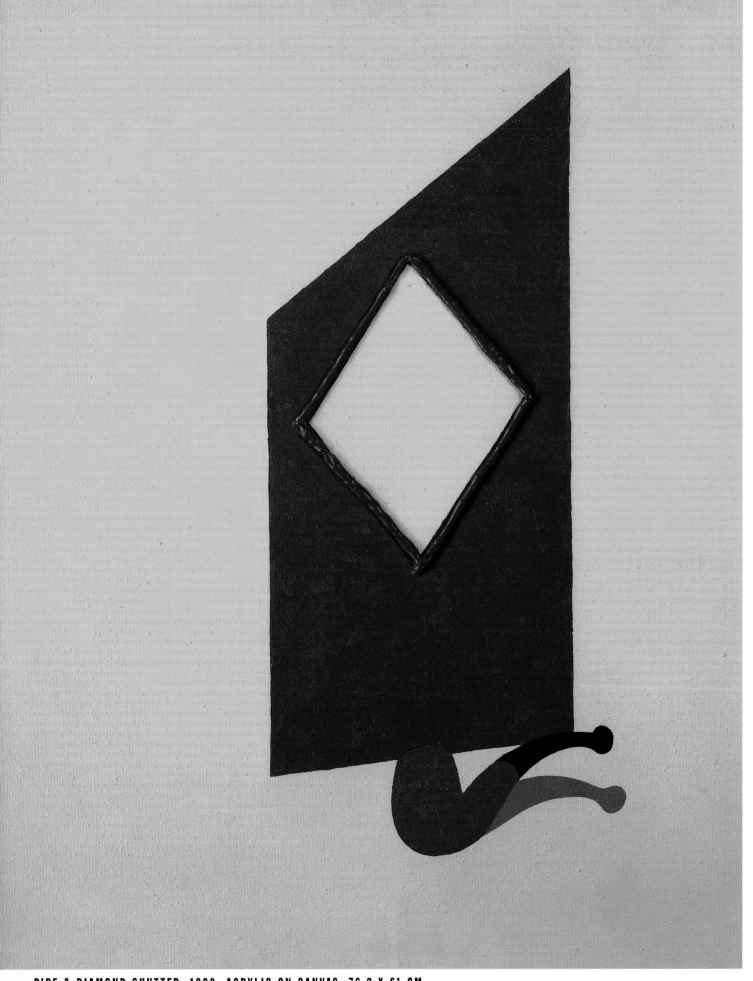

PIPE & DIAMOND SHUTTER, 1990. ACRYLIC ON CANVAS, 76,2 X 61 CM.

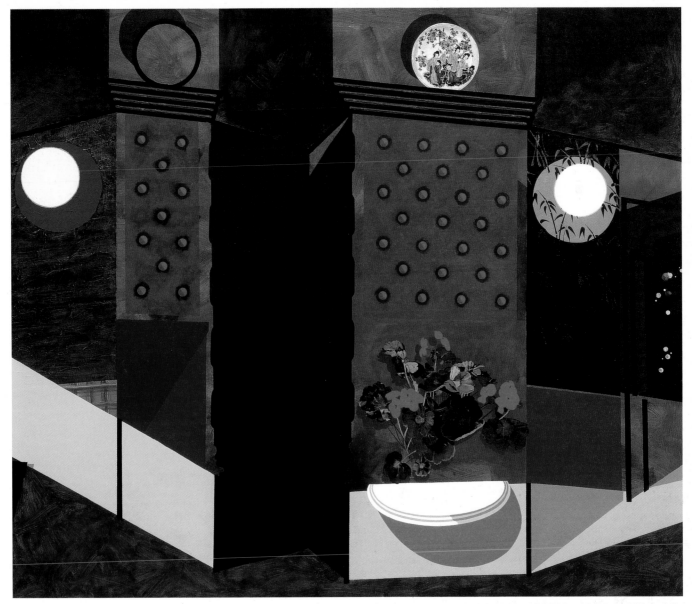

LUNCH-TIME, 1985. ACRYLIC ON CANVAS, 205,7 X 243,8 CM.

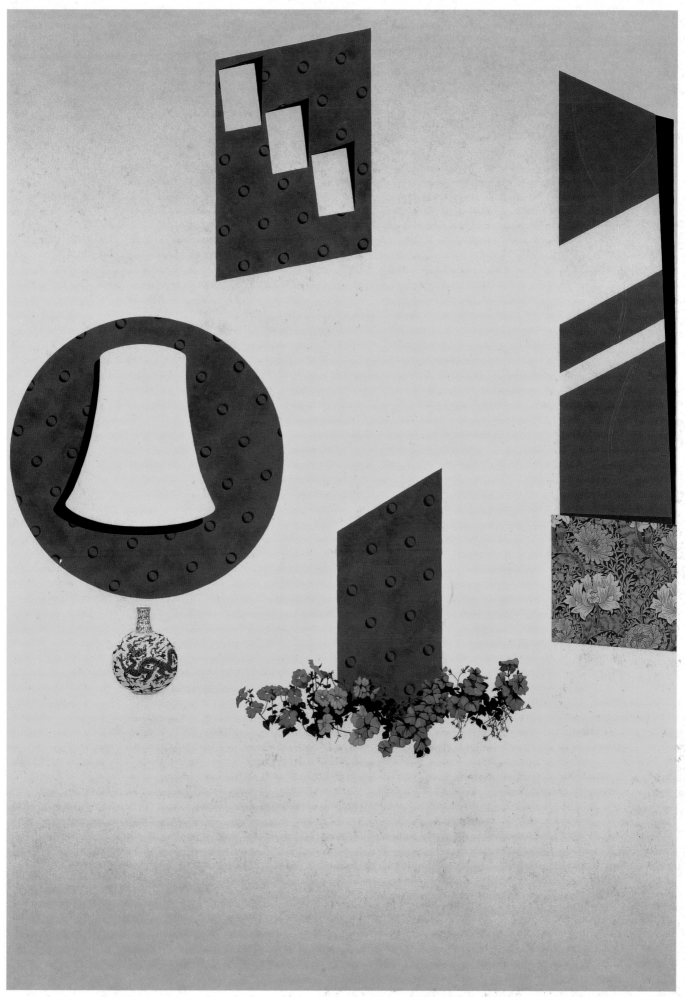

ABOVE: LOUNGE, 1989. ACRYLIC ON CANVAS, 289,5 X 205,7 CM.
LEFT: 2A, 2002. ACRYLIC ON BOARD, 77,5 X 52,1 CM.

MAT COLLISHAW

Mat Collishaw works mostly in film and photography, subverting images of beauty or horror. He often combines video and sculpture, installing new technology inside old objects to project moving images inside items of furniture or ornaments. Sometimes he re-visits an old technique, such as with *In the Old-Fashioned Way* (1992), in which a nineteenth-century pumphouse cog drives a life-size reproduction of an old black-and-white pornographic image of a zebra having sex with a naked girl.

Collishaw's work asks us how it feels to be confronted by images that are emotionally provocative. He investigates how reproduced images such as photographs, film, and TV have weakened our instinctive reaction to be repelled by disturbing scenes. He knows the dislocating effects on our sense of reality of watching five minutes of war footage on the news followed by an hour of a TV hospital drama with fake blood. He delves into topics usually handled by documentaries but without their false concern, replacing social commentary with an element of fantasy and decoration. For example, in *Snowstorm* (1994) he projected an image of a homeless person sleeping inside an oversized souvenir snowstorm. In *Bullet Hole* (1988) he enlarged a scientific photograph of a bullet wound to the head and presented it on a grid of lightboxes so it resembled an ambiguous sexualized image.

In his 2002 exhibition at Cosmic Galerie in Paris he showed *Stoned Immaculate* (2002), in which a tramp who has been unknowingly filmed is seen sniffing glue and rolling about on the pavement, then he suddenly and uncontrollably vomits, covering most of the screen. There is an accompanying tinny sound playing out Procol Harum's *Whiter Shade of Pale,* and just after the lyric "I was feeling kinda seasick," the tramp vomits. If you watched this incident take place in real life it would be repulsive, but within the gallery, it appears as a carefully composed image with a "meaningful" sound track. By framing the event, Collishaw glorifies it, isolating it as a performance that has been secretly filmed from a distance. Transformed into art, its hard-hitting nature has been removed, and this film generates a gamut of emotional responses from sad to funny, ordinary to poetic.

There is a ruthless directness to Collishaw's work. He invites his viewers to stare at and indulge in images they would normally avoid. In *Kristallnacht* (2002) he shows a wall of black-and-white photographs beneath glass that has been deliberately cracked. Here, Collishaw has reproduced images from the aftermath of the Night of Broken Glass on November 9, 1938, when Nazis ran riot in the German-Jewish community. The gallery lights are dimmed and a spinning mechanism of polarized paper with a light shining underneath creates a disjointed effect similar to watching a jumpy, vintage film. The result is magical until you realize the subject. As with much of his work, Collishaw seduces us with his visual effects, then slaps us hard with his images. He asks us to look at the unacceptable, playing with romantic idealization and real-life imagery in the process.

JUNE 12TH, 1.00, MAT COLLISHAW
Mat Collishaw is completely different. As part of the young, cool brigade he is very sexy with an air about him that is calm and quiet. He didn't speak a lot, but he has a clear sense of humour with twinkling eyes. His studio is very neat and in the corner is a potted plant of red geraniums. On his desk were many different black, white, and grey mosaic tiles for his next show. It's cold in a spartan way, very much the studio of a bachelor. A.E.

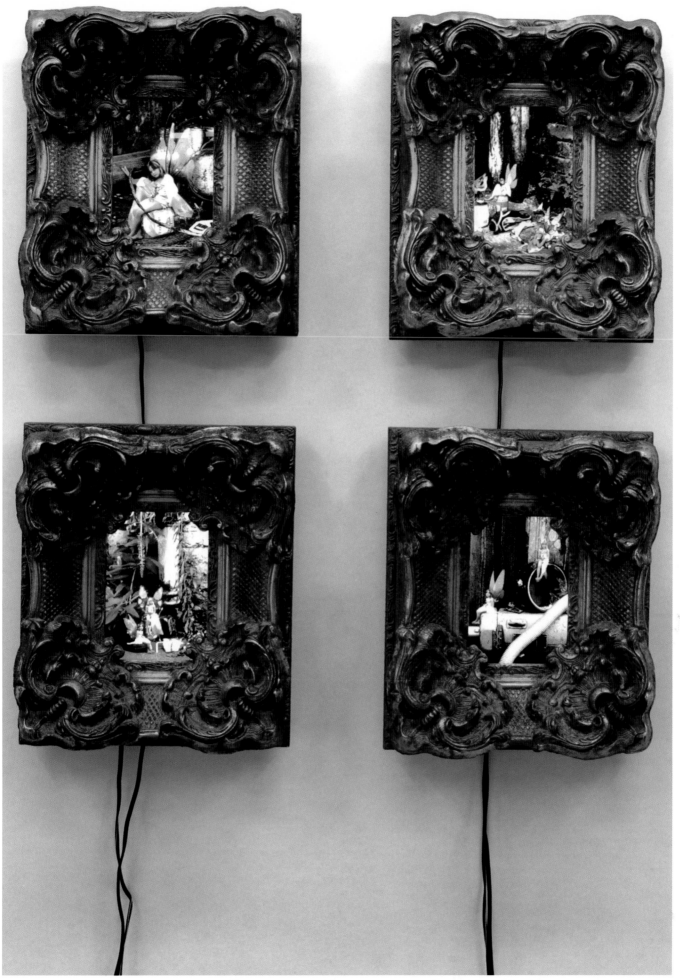

SUGAR AND SPICE, ALL THINGS NICE. THIS IS WHAT LITTLE GIRLS ARE MADE OF, 2000.
GILT FRAME, GLASS, PAPER, ACETATE, INK, WOOD, LIGHT PANEL, 35,5 X 31 X 10 CM.

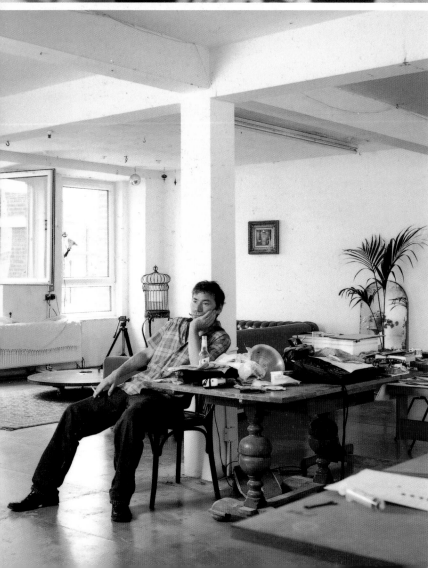

SHAKIN' JESUS, 2002. 3 EDITIONS, DVD 4 MINS, DIMENSIONS VARIABLE.

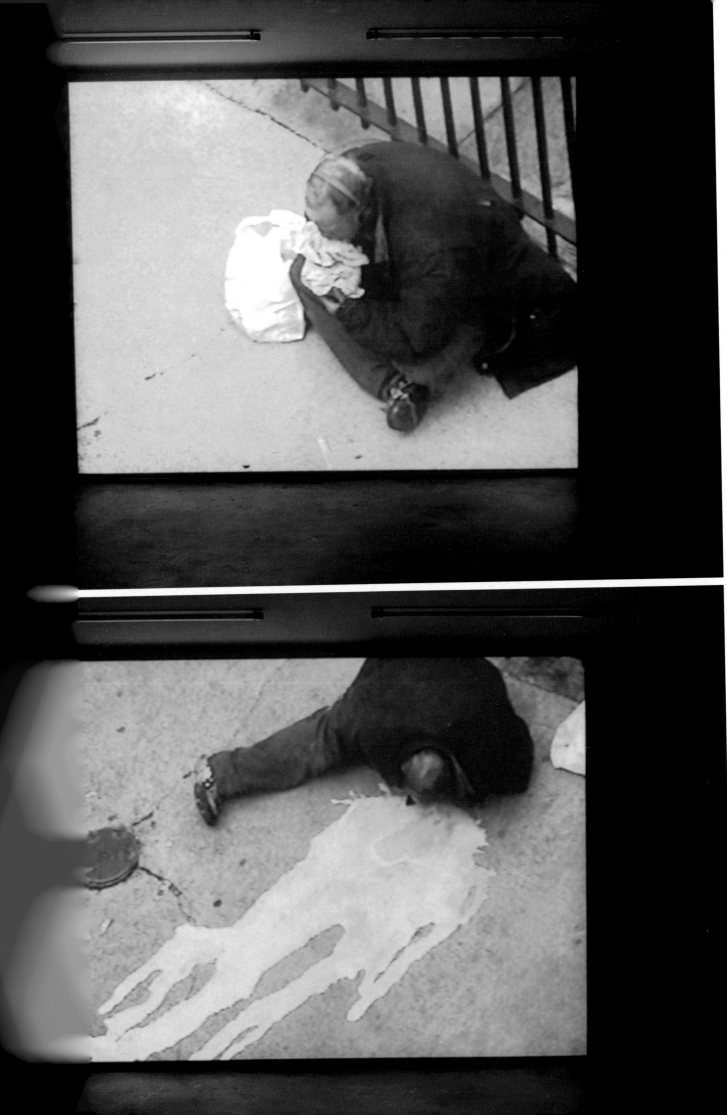

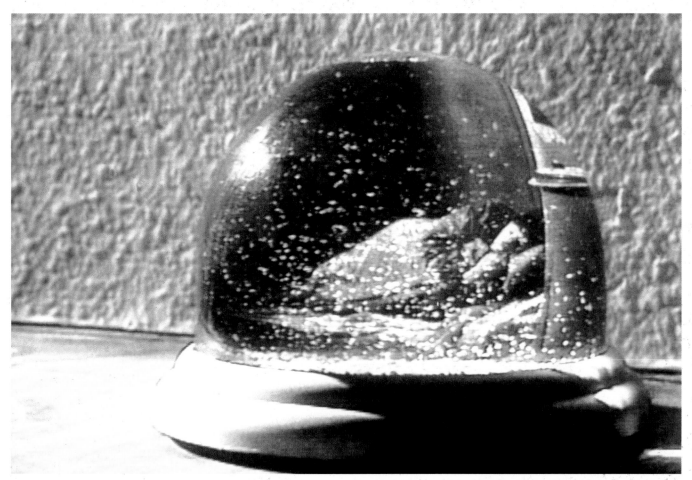

ABOVE: SNOWSTORM, 1994. FROSTED GLASS, VIDEO PROJECTION, DIMENSIONS VARIABLE.
LEFT: STONED IMMACULATE, 2002. LOOP VIDEO PROJECTION FROM DVD.

MICHAEL CRAIG-MARTIN

Michael Craig-Martin is as well known for teaching art as he is for being an artist. Born in Dublin in 1941 Craig-Martin moved to Washington, DC with his family in 1946. He studied painting at Yale University from 1961 to 1966, after which he moved to England to take up a teaching position at Bath Academy of Art. His work at this time was made from plywood, household paint and Formica. These sculptures resembled functional objects made to a domestic scale and questioned the idea of artistic form. He went on to use manufactured objects, such as bottles, buckets, tables and electric fans, as material for his sculpture. In 1973 Craig-Martin made *An Oak Tree,* which was presented as the single work in his exhibition at the Rowan Gallery in London. *An Oak Tree* comprised an ordinary glass tumbler filled with water placed on a glass shelf with an accompanying text, a mock interview in which Craig-Martin discusses how, or if, he has "transformed" the glass of water into an oak tree. This work combined a cool minimal aesthetic, a conceptual idea and the use of prefabricated materials. *An Oak Tree* is a key work in the history of contemporary British art and in many ways remains an unsolved question.

Craig-Martin taught at Goldsmiths College from 1974 to 1988, during which time he channeled the ambition of his students, guiding them to make work of a professional standard, thus giving them the possibility to become successful artists straight from college. The most famous group of former students are the now established, YBA's. Craig-Martin returned to Goldsmiths in 1994 when he was appointed Millard Professor. In recent years Craig-Martin has made large scale paintings, on canvas or directly onto the gallery walls. He paints from a personal catalogue of everyday objects in flat areas of bright colour with black outlines. These pared-down descriptions of objects, which include items such as ladders, televisions, fire extinguishers, torches, filing cabinets, and desk lamps, are instantly recognisable but play with the viewer's perception both in terms of the colours used to describe them and their wildly distorted scale.

The objects have been taken out of context and used as ready-made images. They are described in a clear, uniform way, they are emotionally blank with no gestural mark-making, logos, or personal detail. Yet the distorted scale, colour clashes and compositional arrangement gives them a pop edge. His selection of recurring objects relates to his own choice of objects as well as those borrowed from particular points in art history. For example in the *Intelligence* exhibition at Tate Britain, 2000, he included Man Ray's Surrealist spiked iron, Duchamp's wine rack, a Magritte wine glass and a Jasper Johns's can of paintbrushes.

JUNE 27TH, 12.00, MICHAEL CRAIG-MARTIN
Michael Craig-Martin has an air of a king. His studio is brand new, everything is chic, sleek, and it lies just behind the Victoria Miro Gallery in the East End. Very New York. I had to make two appointments with him to photograph it. His work surfaces are all in stainless steel and on the wall hang huge paintings. He was very calm in black Prada, also very interesting, there were heaps of books on everything to do with art. I felt I was in the presence of God, in fact I have never seen so many good-looking, godlike men in my life. He had an office where everything looked efficient; in fact, he looks as if he would return your emails immediately. A.E.

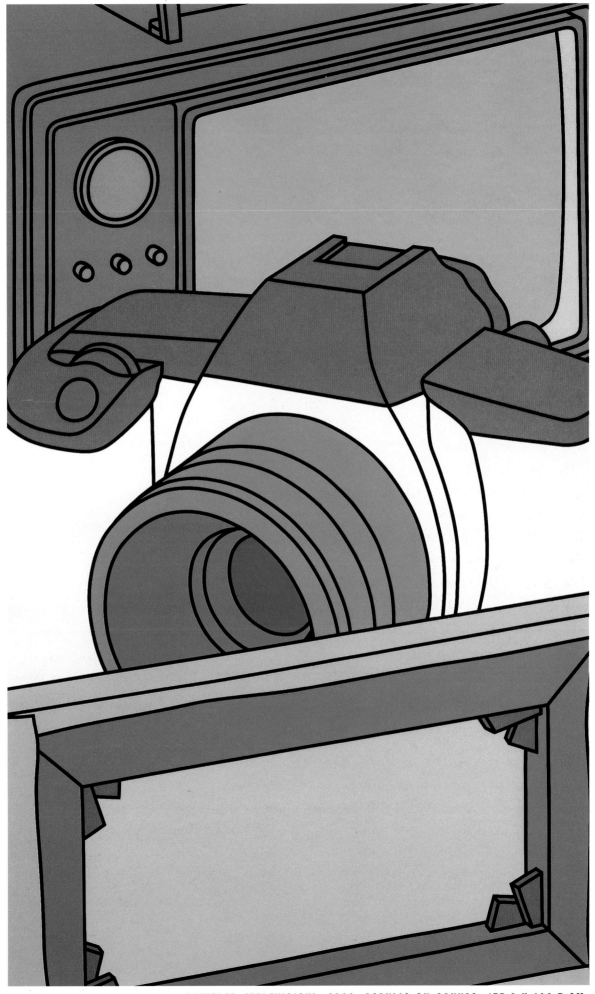

MICHAEL CRAIG-MARTIN

UNTITLED (TELEVISION), 2002. ACRYLIC ON CANVAS, 175,3 X 106,7 CM.

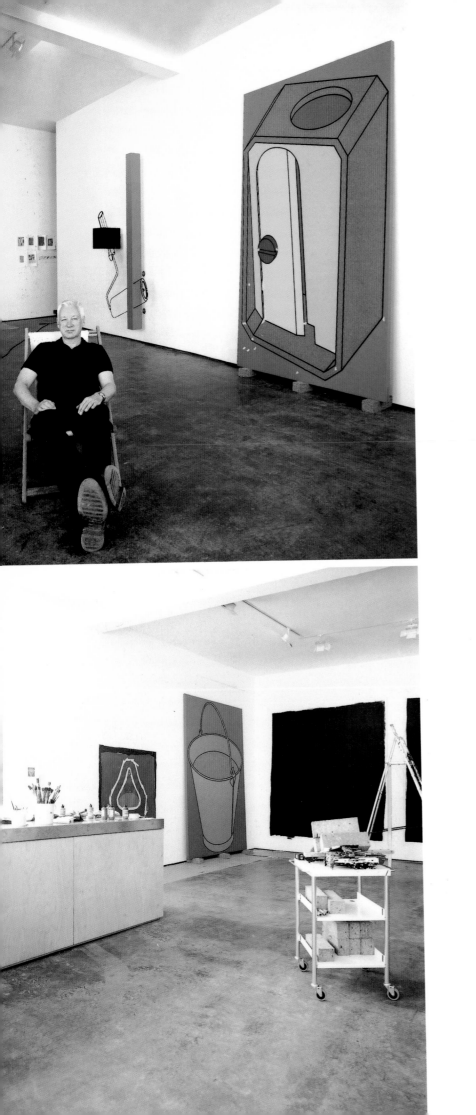

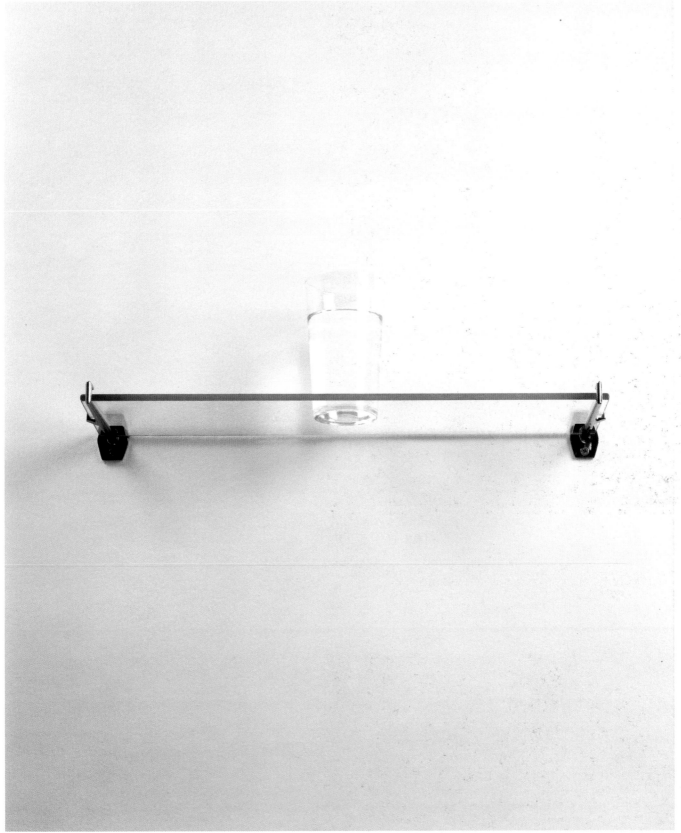

MICHAEL CRAIG-MARTIN

OAK TREE, 1973. OBJECTS, WATER AND PRINTED TEXT, 13 CM HIGH.

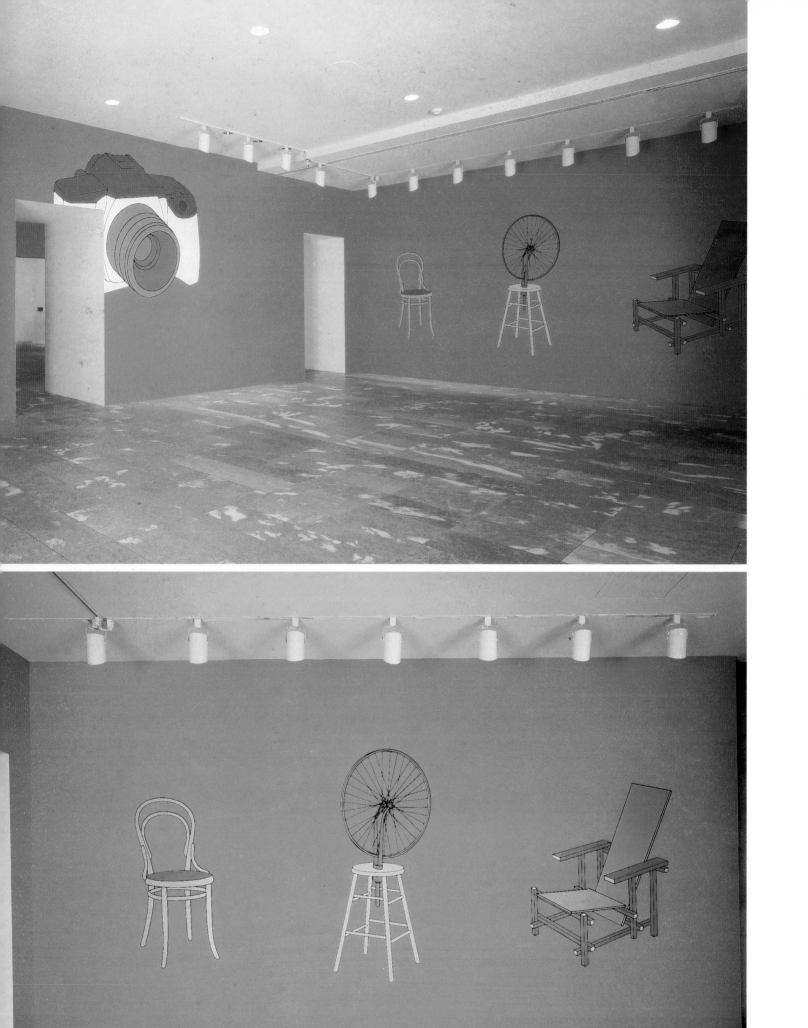

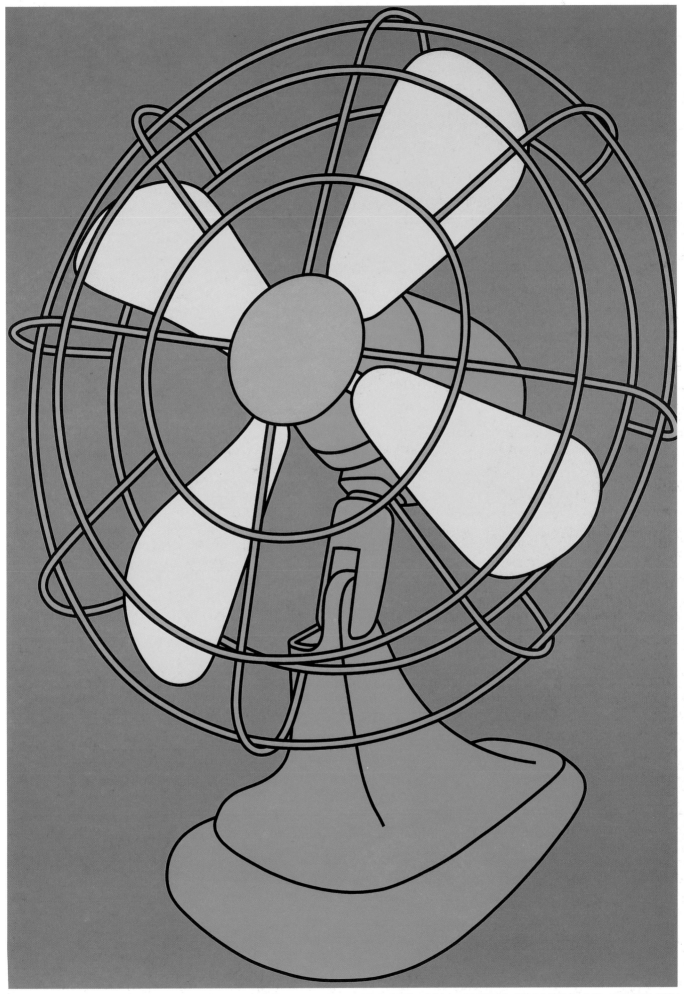

MICHAEL CRAIG-MARTIN

ABOVE: UNTITLED (ELECTRIC FAN), 2002. ACRYLIC ON CANVAS, 210,8 X 287 CM.
LEFT: INSTALLATION AT MOMA, NEW YORK, 2000.

DEXTER DALWOOD

Dalwood paints glamour and fiction into his personal relationship with art history. He takes the ready-made atmosphere attached to controversial news events from the recent past and combines these with his knowledge of painting to update traditional landscape and interior genres. Instead of painting contemporary life with an outdated style he looks back in both subject and representation, rendering true-life stories from the past with chronologically staggered styles of painting, from Frank Stella to Gerhard Richter. His paintings are worked up from small collages made from cut-out images in home interior magazines to construct an imagined visual description of a place or scene. Like his collages, the paintings also exist as component parts but are made up of theoretical elements rather than physical ones. When he transforms the collage into a painting he keeps the rough edges, awkward scale, and crooked perspective, wanting the viewer to see that this is an idea of a place rather than a picture-perfect rendition. In paintings such as *Room 100, The Chelsea Hotel* (1999), and *Ian Curtis 18.5.80* (2001), he builds the mood in the paintings around the myth of two different pop heroes. *The Chelsea Hotel* describes the imagined aftermath of Sid Vicious stabbing Nancy Spungen in 1978. He pays attention to low light and a dull colour scheme using sharp edges and angles to imply violence, whereas *Ian Curtis* sets the scene for where the troubled genius committed suicide. The focal point of *Ian Curtis* is a noose-shaped bare light bulb, taken directly from a Phillip Guston painting. Dalwood uses the layout of the room to suggest a state of mind; it is overly tidy and unemotional. The window, filled with L.S. Lowry's smoky Salford rooftops offers the only glimpse of the outside world, one that now, by association with Lowry, is popular and romanticized. Dalwood's use of painting styles is often aligned to fit the time of the subject of the painting; sometimes this dominates the image as in *Brian Jones Swimming Pool*, where the canvas is virtually filled by a Clyfford Still-style painting. The painting uses the controversial death of the 27-year-old Rolling Stone as a metaphor for the way sublime abstract painting ideals were fading at that time. Putting the spotlight onto the subject allows him to paint in a style that he admires without making a painting that looks outdated.

APRIL 4TH, 11.00, DEXTER DALWOOD
Dexter Dalwood's studio was full at the time I did the Kartell catalogue for Franca Sozzani, but when I went round again it was completely empty and white. He had sold everything in L.A., can you believe his luck? He has the look of Frankenstein about him, he is very critical and notices everything. You have to be accurate. He wants to participate, and I love his pictures. I own one of them, *Stalin's War Room*. They fascinate me because I have that sort of instinct to look into people's drawers and read their diaries. I know it's bad but I like it. I wonder what Prince Charles's bedroom is like and what Andy Warhol's bathroom was like, so his pictures hold a fascination for me. A.E.

STALIN'S WAR ROOM, 2000. OIL ON CANVAS, 180 X 240 CM.

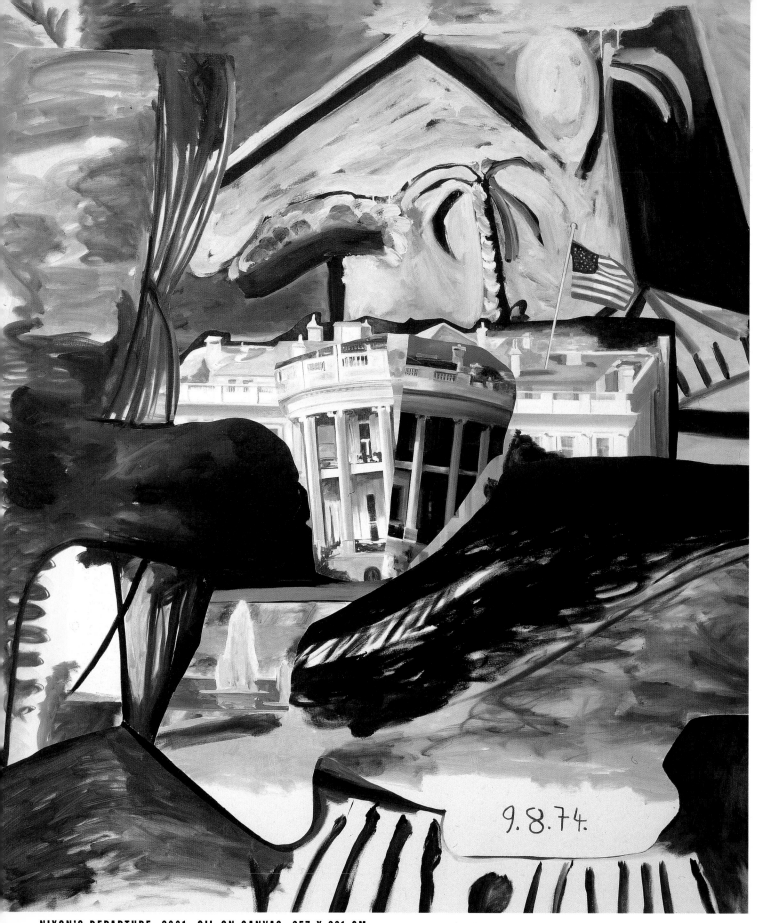

9.8.74.

NIXON'S DEPARTURE, 2001. OIL ON CANVAS, 257 X 231 CM.

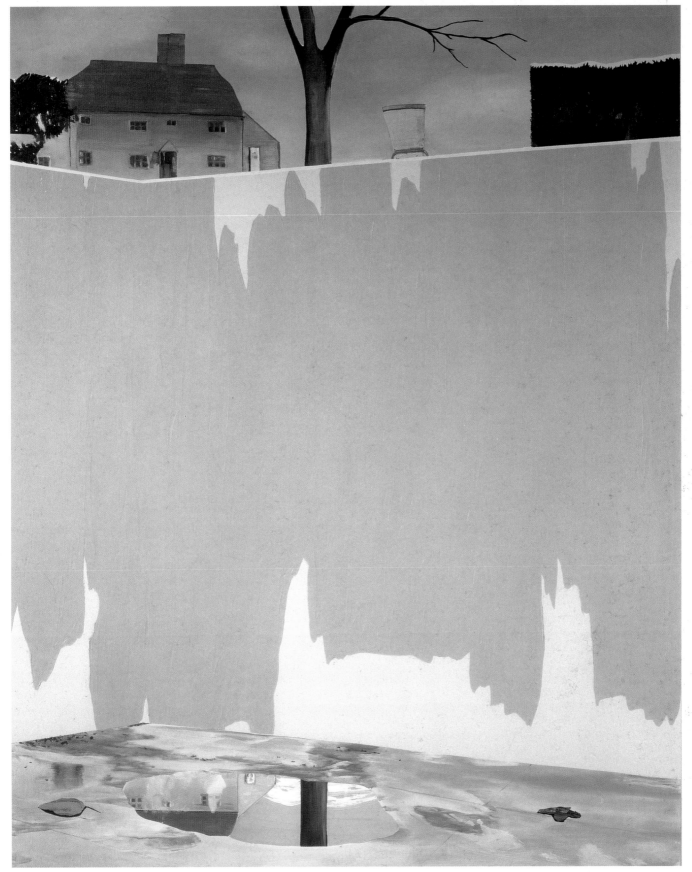

BRIAN JONES' SWIMMING POOL, 2000. OIL ON CANVAS, 275 X 219 CM.

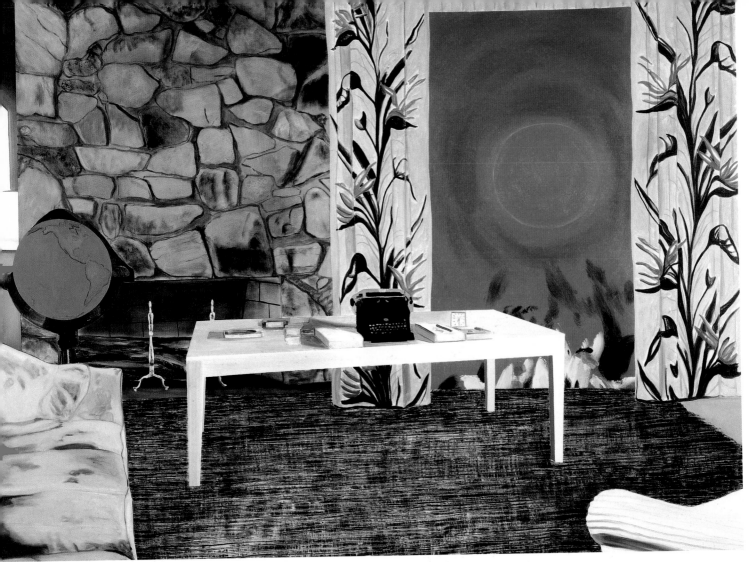

McCARTHY'S LIST, 2002. OIL ON CANVAS, 204 X 279 CM.

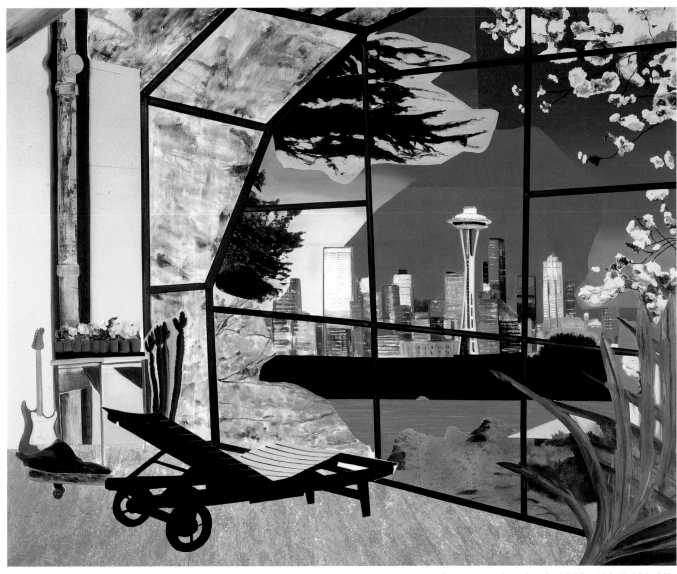

KURT COBAIN'S GREENHOUSE, 2000. OIL ON CANVAS, 214 X 258 CM.

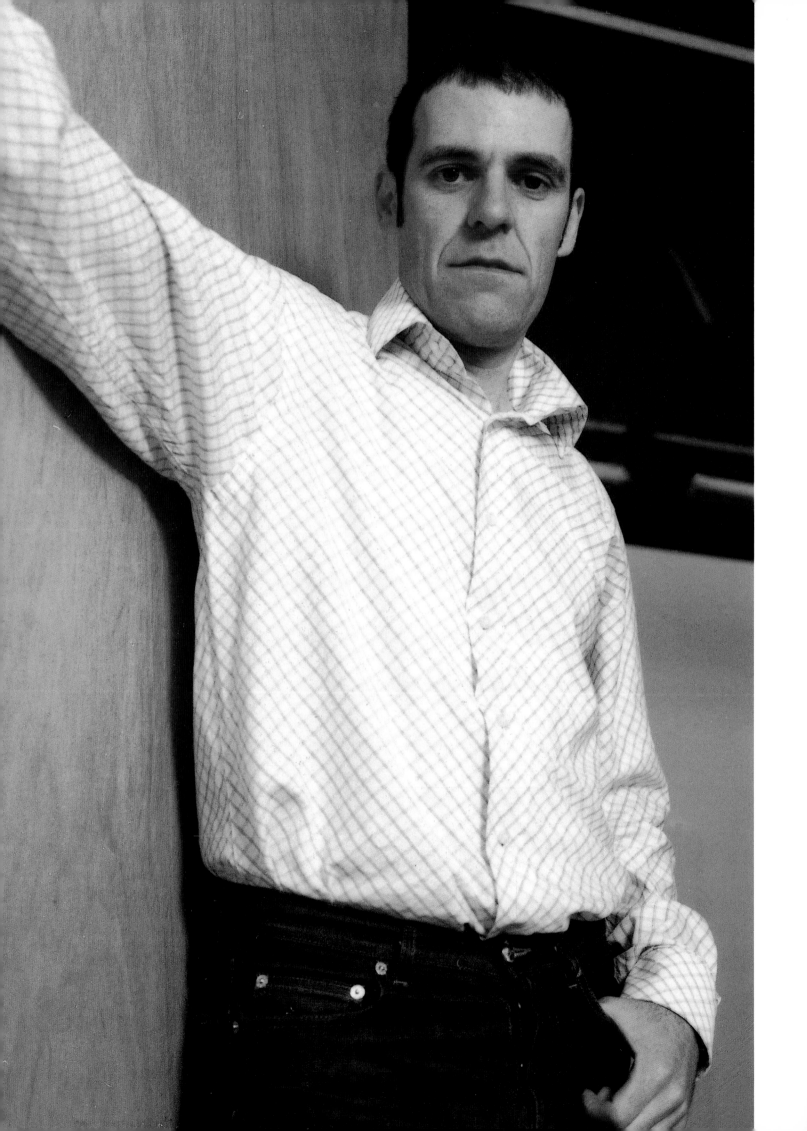

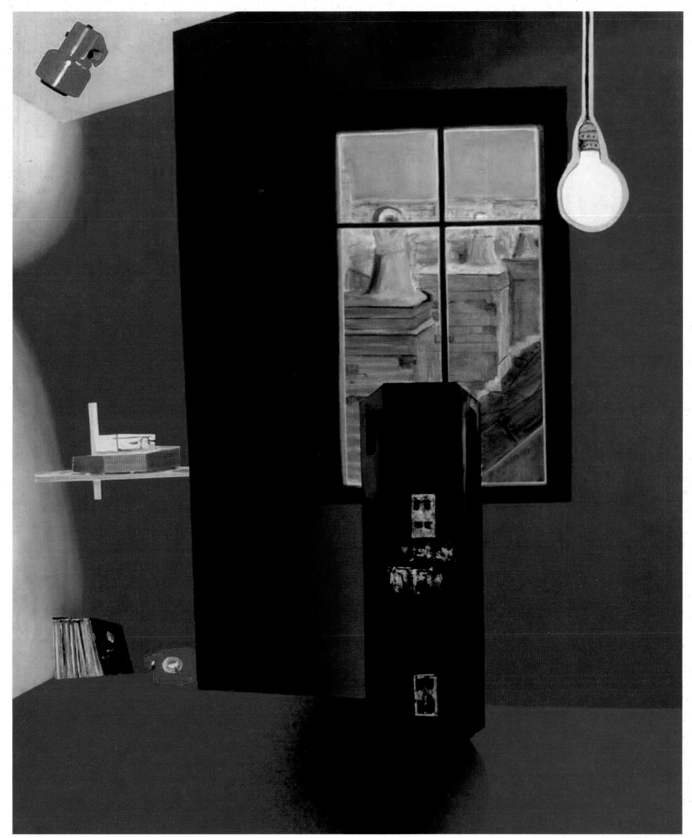

IAN CURTIS, 18/05/2000. OIL ON CANVAS, 208 X 175 CM.

IAN DAVENPORT

When Ian Davenport left college in the late 1980s, he was soon to become recognised as one of the most talented young painters in London. He brought beauty to contemporary painting without making it decorative. Using cheap, readily available household paints, he makes paintings that reference the concerns of the New York School artists of the 1950s and 1960s but can also exist alongside the work of his own generation. His paintings are not a critique or an attempt to compete with action painters such as Jackson Pollock, nor to replicate the cool approach of Ellsworth Kelly, but they share the same control over medium and basic gestures, giving them a similar physical presence.

Davenport has consistently maintained the same working process: he pours household paint onto board and enforces strict guidelines including the number of pours, deliberate repetition, and limited colour combinations. He chooses his colours from paint charts associated with fashionable home design, selecting deep blues and greens as well as sweet pastels, incorporating lifestyle luxury into serious painting. In his early works, he poured thin lines of paint through a watering can onto a flat, coloured ground, creating textured monochromes. He then made a series of paintings with stripes of bright colours that extended from one end of the canvas to the other. The process of pouring is used to eliminate any trace of the artist's hand, so the paintings appear unemotional and mechanical. The result is as much an outcome of chance and accident as it is skill in pouring. For the viewer, the human element can be seen in the small accidental details, such as rough edges, bubbles along the surface, and hardened drips at the bottom edge of the supports. But even these flaws must fit within Davenport's overall process and cannot be contrived.

His «arch» paintings from the mid-1990s are Davenport's best-known works; they incorporate two colours made in three separate stages. First he achieves a flat surface of colour, on top of which he pours a different colour so as to create a solid arch; he then takes the first colour and covers all but the curve of the arch, creating a slim, elegant line between the top and bottom layers. Like his stripe paintings, they recall geometric abstraction but sidestep its rigidity.

MARCH 21ST, 1.00, IAN DAVENPORT
Ian Davenport pours paint. I could see evidence of this. He had huge studios and an amazing collection of paints. A whole room was dedicated to his paint pots and it was a work of art. The floor was covered with splashes and his colour sense is strong. I didn't see him working, but Gemma says his technique of pouring paint is fascinating. He told me that Michael Craig-Martin was his teacher and helped create a number of young artists' careers at Goldsmiths. A.E.

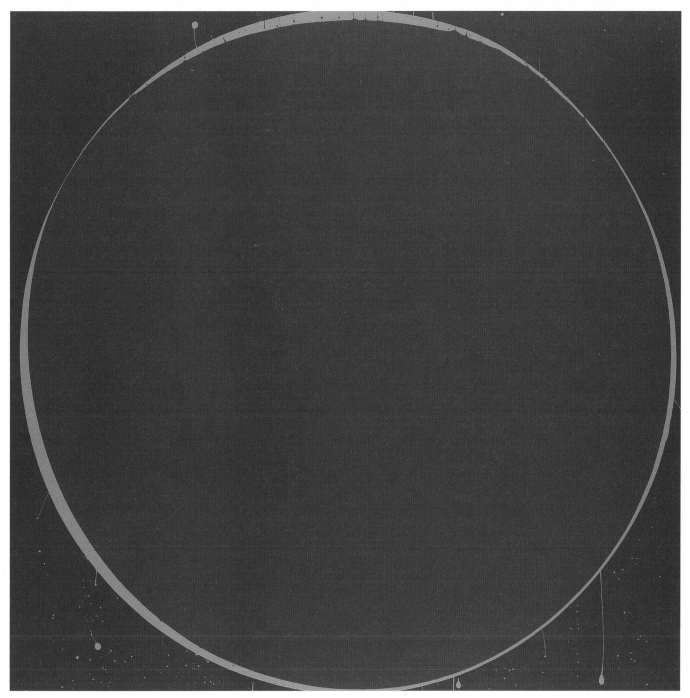

IAN DAVENPORT

UNTITLED CIRCLE PAINTING (RED AND DEEP PINK), 2002. HOUSEHOLD OIL PAINT ON MDF, 122 X 122 CM.

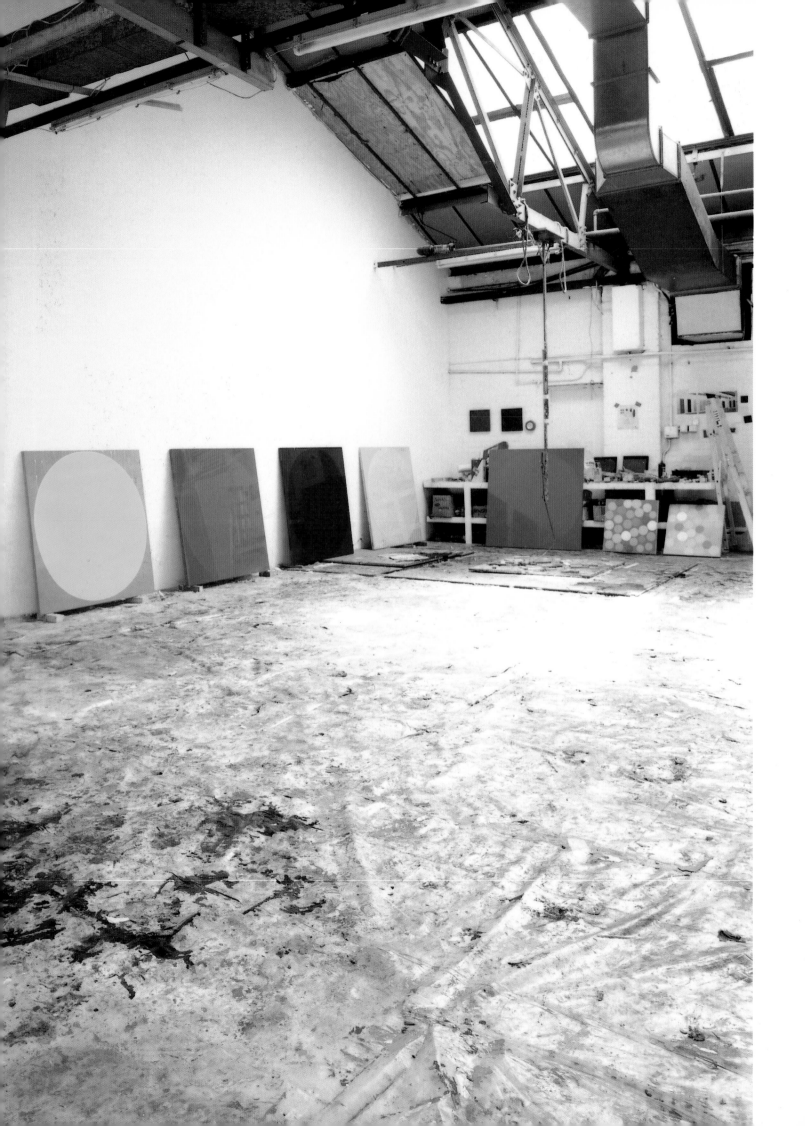

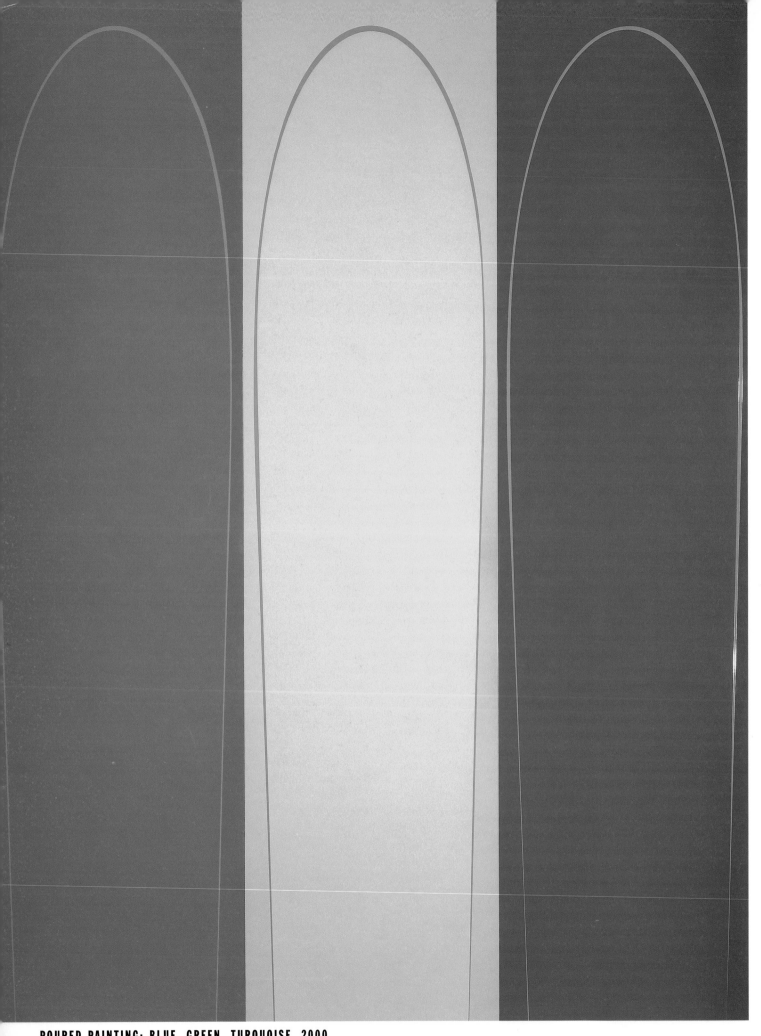

POURED PAINTING: BLUE, GREEN, TURQUOISE, 2000.
HOUSEHOLD PAINT ON ALUMINUM PANEL, 290 X 225 CM OVERALL (3 PANELS).

IAN DAVENPORT

POURED PAINTING: GREEN, GREY BLUE, GREEN, 1998.
HOUSEHOLD OIL PAINT ON MEDIUM DENSITY FIBREBOARD, 183 X 183 CM.

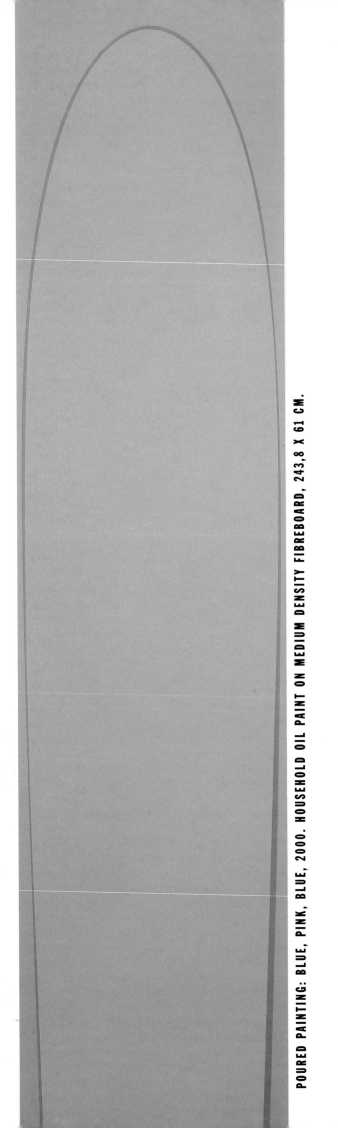

POURED PAINTING: BLUE, PINK, BLUE, 2000. HOUSEHOLD OIL PAINT ON MEDIUM DENSITY FIBREBOARD, 243,8 X 61 CM.

IAN DAVENPORT

PETER DAVIES

For Peter Davies, making art is all work, all play. His casual-looking paintings employ a handmade approach that is unrelenting in its labour intensity—from the drawing and filling-in of his small, coloured square-and-circle paintings to the writing in his text paintings, also filled in letter-by-letter. Despite his time-consuming working methods, Davies's Op Art style is intentionally clumsy compared to the slick paintings of Brigitte Riley. What his work does share with 1960s Op Art is an understanding of how to use pictorial illusion to create undulations and complex patterns. Davies often plays on the notion of objects being squeezed into the painting, for example in *Red Circles Painting* (2000-2001) the circles get smaller or skinnier the closer they get to the canvas edges. He turns geometric shapes into tangible objects, and solid grids into wavy lines. In doing this, his paintings become playful and show that he is borrowing ideas from, but not competing with, traditional formal abstraction. Davies's text paintings also show the influence of other artists, but are presented in a literal way. They follow how an artist navigates his or her way around art history, wanting to be a part of it, to the point where this obsession becomes the subject of the work. Davies made his first text painting after producing a long list of art that he liked for a *Lost in Space* exhibition catalogue. He decided to paint his list for a subsequent show using random changes of colour for each letter, which resembled his concurrent abstract paintings made from colourful dots and dabs on a white background. In 1996 Davies made *Text Painting,* which was included in *Sensation* at The Royal Academy in 1997. At first, what it says seems offhand and loudmouthed, but his attention to detail shows that the apparent spontaneity is a smokescreen, a way to quickly fit in a lot of information which he knows will be perceived in a slow, thoughtful way.

Davies's "list" paintings *The Hip One Hundred* (1998) and *The Hot One Hundred* (1997) come from a different angle—they are more provocative because he is giving himself the authority to lay down a scoreboard. He makes formal the informal charts that artists have, turning their discussions into sound bites on why something is "good." There is an element of boastfulness to Davies's work, simply because he reveals his extensive knowledge, but this is justified in the way he shows that he's worked out how to integrate it into both types of paintings. Although Davies's work is made up of references to the past, they respond to the contemporary art world, and in the future will become a record of now.

MARCH 14TH, 10.00, PETER DAVIES
Peter Davies makes text paintings and is completely and utterly charming. He has a great sense of humour about himself and is able to giggle whilst reading us his latest article in *Flashart* which says how clever he is. I definitely wanted to buy one of his paintings. He looks like a keep-fit addict and definitely eats healthily. He is the type who bicycles everywhere and wouldn't breathe in the fumes of a tube. Gemma says he is very serious, but I laughed with him all the time. A.E.

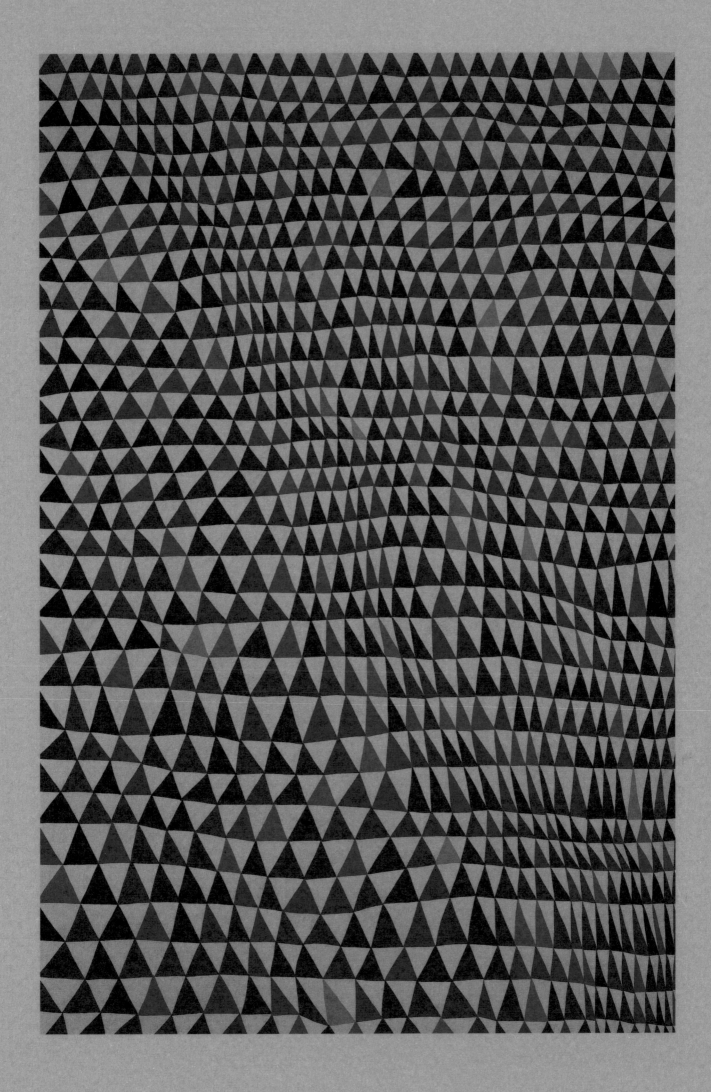

THE FUN ONE HUNDRED

#	Artist	Note		#	Artist	Note
1	PABLO PICASSO	he had a lot of the above		51	DONALD JUDD	boxing clever
2	MARCEL DUCHAMP	what a pisser		52	JOHN CURRIN	Renaissance man
3	SALVADOR DALI	Liked lots of checks (+ gold)		53	CECILY BROWN	orgy - tastic
4	M. KIPPENBERGER	good mood NAZI gas station		54	SUE WILLIAMS	fucked up
5	RICHARD PRINCE	you must be joking		55	GARY HUME	stadium rock
6	RENE MAGRITTE	Ceci n'est pas une blague		56	LOUISE BOURGEOIS	hilarious interview style
7	JEFF KOONS	shagging		57	BARRY LE VA	making a mess
8	PAUL McCARTHY	Santa Chocolate Schlop		58	JENNY SAVILLE	zombie flesh eaters
9	PHILIP GUSTON	very studio(us)		59	GEORGE CONDO	see number one
10	CY TWOMBLY	scribble		60	CHRIS OFILI	shit head
11	SIGMAR POLKE	magic mushrooms		61	CHRISTOPHER WOOL	American graffitti
12	ED RUSCHA	burn Hollywood burn		62	FRANCISCO GOYA	Hannibal the cannibal
13	G. MATTA CLARK	prime cuts		63	JESSICA STOCKHOLDER	assembly line
14	CHRIS BURDEN	shoot to kill		64	GUSTAV KLIMT	orna-MENTAL-as anything
15	BRUCE NAUMAN	fun from rear		65	ANTHONY CARO	not really funny!
16	DAVID SALLE	cavalier of the canvas		66	GILBERT + GEORGE	smashed
17	HENRI MATISSE	original formalist		67	CARL ANDRE	nice brickwork
18	J. POLLOCK	paint spill		68	CHUCK CLOSE	up close + personal
19	RICHARD SERRA	weight watcher		69	DIETER ROTH	trash the gaff
20	JOHN BALDESSARI	he's making no more boring art		70	KEN NOLAND	Oin Oin Oin Oin Oin Oin O
21	MIKE KELLEY	pant shitter and proud		71	MARIKO MORI	Temple of doom
22	ANDY WARHOL	Ass in hole(s)		72	UGO RONDINONE	sooper model wannabes
23	W. DE KOONING	dutch courage		73	PIET MONDRIAN	celebrity squares
24	ROBERT SMITHSON	a quake in a lake		74	LAURA OWENS	feel good art
25	DUANE HANSON	white trash		75	DAN FLAVIN	how many artists does it take to change a lightbulb?
26	J-M BASQUIAT	"The FUN's over"		76	TERRY WINTERS	space invader
27	CHARLES RAY	road kill		77	ROBERT GOBER	wall paper
28	GEORG BASELITZ	thats one way of doing it.....		78	ERIC FISCHL	bad boy
29	V. VAN GOGH	ouch! *@?		79	YVES KLEIN	blue movie style
30	RAYMOND PETTIBON	goth cartoons		80	JORG IMMENDORF	bar brawls
31	JASON RHOADES	total organised chaos		81	GLEN SEATOR	checks cashed
32	CINDY SHERMAN	dressing up		82	PIPILOTTI RIST	road rage
33	JULIAN SCHNABEL	plate rage		83	JAMES ROSENQUIST	stealth bomber
34	FRANK STELLA	very protracted		84	JASPER JOHNS	star spangled banner
35	NAN GOLDIN	fancy trannies		85	ANDREAS GURSKY	Nike Town
36	CAROLL DUNHAM	foam filled funk		86	DAVID HOCKNEY	pool attendant
37	PHILIP TAAFFE	snakes and ladders		87	ELLEN GALLAGHER	funny faces
38	ROY LICHTENSTEIN	wham		88	RITA ACKERMANN	get a job
39	STUART DAVIS	jazz bop		89	RICHARD HAMILTON	The Beatles; The Beatles
40	SOL LE WITT	interior decorator		90	ASHLEY BICKERTON	beach bum
41	VITO ACCONCI	what a tosser		91	JULIAN OPIE	virtual reality
42	SEAN LANDERS	'you cannot be serious'		92	ANDRES SERRANO	pissed christ
43	FRANCIS BACON	pissed and proud		93	PETER HALLEY	cell by date
44	ALEX KATZ	party time		94	TONY OURSLER	ventriloquist dummy
45	F. GONZALEZ-TORRES	candy man		95	ALBERT OEHLEN	portrait of A. Hitler
46	MATTHEW BARNEY	the man who fell to earth		96	DOUG AITKEN	Electric Earth
47	JOSEPH BEUYS	was he for real		97	MARTIN HONERT	tourist trap
48	PIERO MANZONI	shit happens		98	SARAH LUCAS	toilet humour
49	DAMIEN HIRST	silence of the lambs		99	JACK PIERSON	WHAT THE FUCK
50	KAREN KILIMNIK	Mrs Peel..... we're needed		100	VANESSA BEECROFT	hanging out

PETER DAVIES

THE FUN ONE HUNDRED (THE PINK TOP VERSION), 2000. ACRYLIC ON CANVAS, 15,2 X 10,1 CM.
ON FILM: TRIANGLES PAINTING, 2001. ACRYLIC ON CANVAS, 137,2 X 91,4 CM.

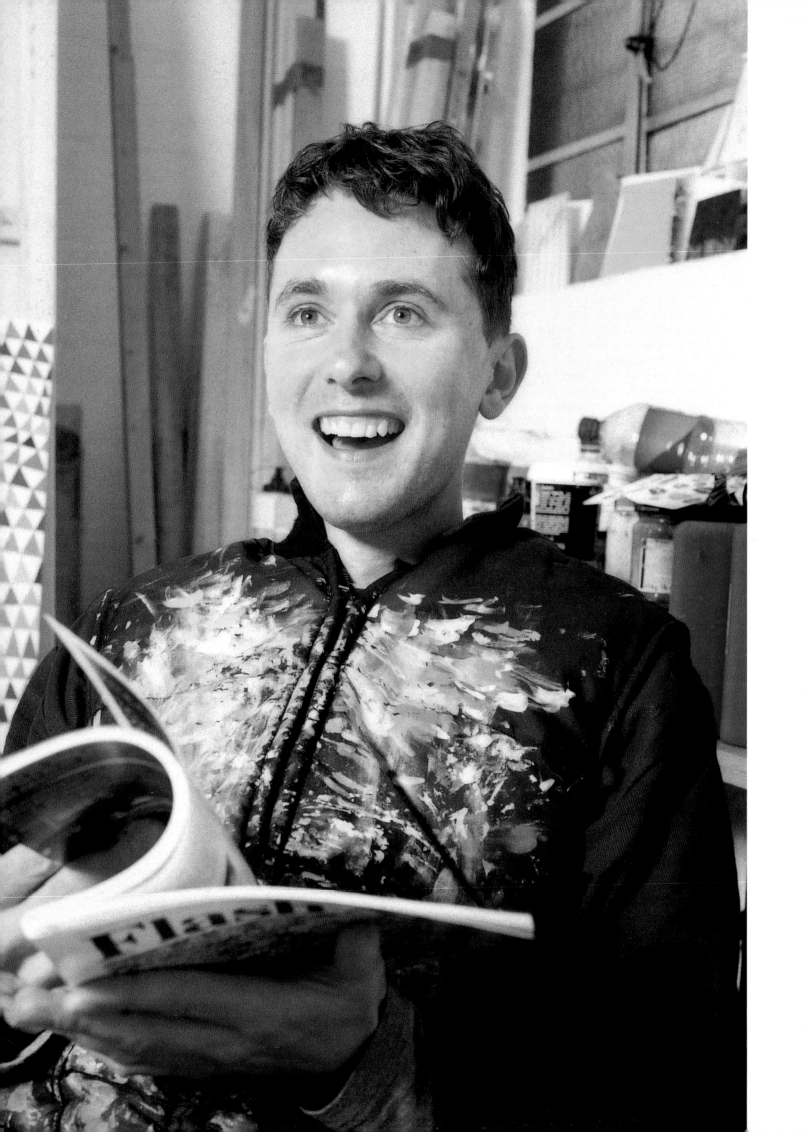

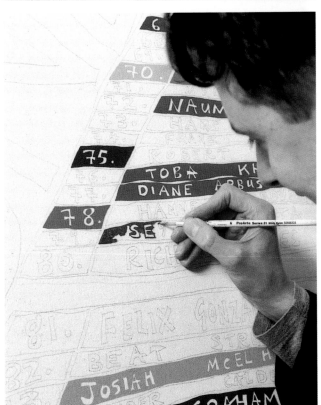

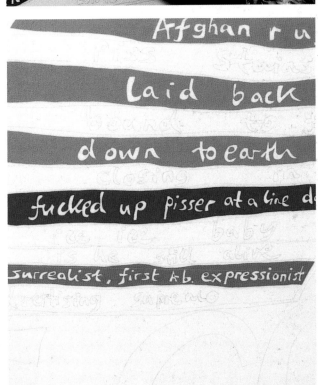

...like is Sean Landers the most important artist of his generation, so
...essive white male rage stuff, Mike Kelley he does everything, so trashy but we love
Damien Hirst he knows how to state the obvious big time with such panache, Jean Michel
...aint wah wah stylee Jimi Hendrix air guitar, Willem de Kooning like you spilt all your nursery
cool colours and swilled them around beautiful, Cy Twombly then you scribbled on the black
...rd when the teachers not looking + tried to rub it out, Picasso he just did whatever the fuck
wanted, Fiona Rae she puts it all together, Bridget Riley so complicated but such eloquent funky results,
...an Schnabel total audacious aggression yes please, Rachel Whiteread in contrast such tranquility and
...e but tuff enuff, Donald Judd wanted to take over the world don't we all, Peter Halley just what is
...wittling on about maybe he feels imprisoned or something, Caroll Dunham what a dude I can't believe
...e things actually exist they mean so much to me, Brice Marden scary monster, Gerhard Richter
...day of the living dead, Sigmar Polke super trooper up yours he's in total control, Joseph Beuys just
...some acid and I'll take his word for it more like Bugs Bunny, Agnes Martin now that is total terro vision
...ts deserts too, Gary Hume now that's for dessert blancmange meets Haagen-Daz, Jason Fox megaphone
...ne he's been reading Fat Freddy's Kat, Alex Katz its kind of timeless but oh those night scenes,
...Tuymans now I wouldn't like to meet him down a dark alley, Peter Doig ellesse super cool the
...ness of a downhill racer, Glen Brown oh when the saints come marching in repro classics, Sarah Lucas her
...hitting empowerment attitude, Louise Bourgeois tough tits she'll rip you to bits, Bernard Cohen kind of all the
...of the fair, Karen Killimnick after dark sheer black magic, Lily Van der Stoker Mutha Fucka, John Baldessari
...hand pointing stuff and also that writing he's like Bruce Springsteen - the boss, Gilbert + George now people say
...'re kind of risqué but they're so sincere, Antony Caro now he really is one mean badass M.F. S.o.B. Velasquez
...Versace for art lovers, Turner he's like some Byron/Shelley op M high, Sherrie Levine now that's got to be
...e tongue in cheek how else could anyone be bothered to do that shit, Andy Warhol my fucking headmaster now was
...trying to set an example or what, Josef Albers totally up to date if you want the funkiest thing he ci could get
...hands on today cheek this out, Richard Prince now this really is the greatest thing if ever there was bare
...d cheek it would be in this spirit (see the Blue Lagoon), Meg Cranston L.A. style funk + sexiness only with the
...is attached, Richard Patterson broom broom, Matisse he had no problems with some fucker telling him his
...k looked decorative, Pissarro logical progression but I say this guy is totally radical, Jenny Holzer she's
...a be like one of those stand up comedians who always manages to keep a straight face + does loads
...Karity work, Charles Ray he's like a fucking spoilt brat with his giant dolls + trucks + Run DMC style
...and sneakers, John Currin now if ever anyone turned a love for Metallica to their advantage, Paul
...thy guess he never saw Tiswas but he must've seen Texas chainsaw whilst eating a McDonalds (hello
...ld), David Salle he's kind of Tom Jones of the art world but I dug that stuff it was really clever, Ellsworth
...his work is just so wonderful it leaves me speechless but then I always liked Kites, William Tucker
...that's what I call music, Kiki Smith "Maybe when your life is close at hand, maybe then you'll understand
...on Maiden), Dave Hammons Yardbird suite ain't that neat, Ashley Bickerton word up Cameo meets Ray Petri,
...el Craig Martin you know immediately what he's on about, Richard Deacon another space case trip
...ger, Max Beckmann hey you the rock steady crew, Larry Clark now that's what I call stream of consciousness
...give a damn excitement, Jeff Wall he's got an eye for detail look at those fashion statements
...y disguised as history paintings, Dan Graham spiel spiel house + gardens meets Lawnmower man, Barnett
...mann tranquility, Frank Stella it's acid house, Constable total memorabilia, Juan Miro kind of tasteful rug
...ngs, Tatlin a complete + utter Fruit + nutcase, Aleksandr Rodchenko kind of art director over design,
...vich cool but kind of limited, El Lissitsky cool got better angles more Star wars, Beat Streuli kind of
...e, Bill Viola total smart Arse - gotta hand it to him, Oskar Kokoshka d'ya think he'd hang with Schnabel
...other life, Vincent Van Gogh young soul rebel, Claes Oldenburg combine harvester a bit of an alien life form,
...r Johns wins thru on its seductiveness, Mitja Tusek kind of the wicked witch of the West, Carl
...ndarp don't be fooled a total traditionalist, Kenny Scharf downright groovy, Chris Burden black humour, Vito Acconci
...tty boy sent to corner of classroom, Christian Schumann adolescent sniggering meets P funk, Andreas Gursky kind of
...tract qualities, Thomas Struth toughnut, Bernard Frize left over 60's hippy sentiments with 90's technology, Giuseppe
...ne lack of vision, Jannis Kounellis live animals, Thomas Grunfeld dead animals, Meyer Vaisman fake animals, Christoph

TEXT PAINTING, 1996. ACRYLIC ON CANVAS, 203 X 254 CM.

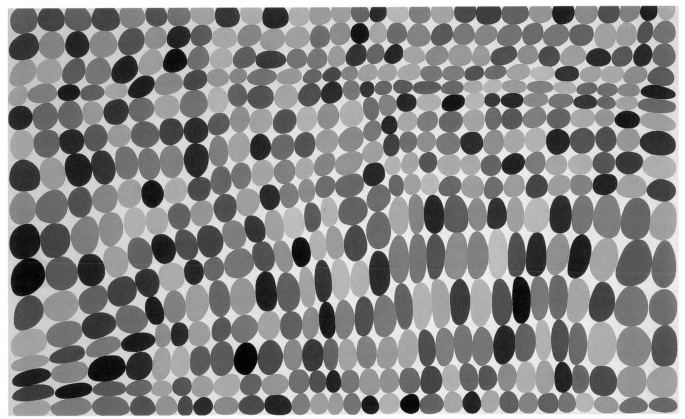

RED CIRCLES PAINTING, 2000-2001. ACRYLIC ON CANVAS, 121,9 X 203,2 CM.

PETER DAVIES

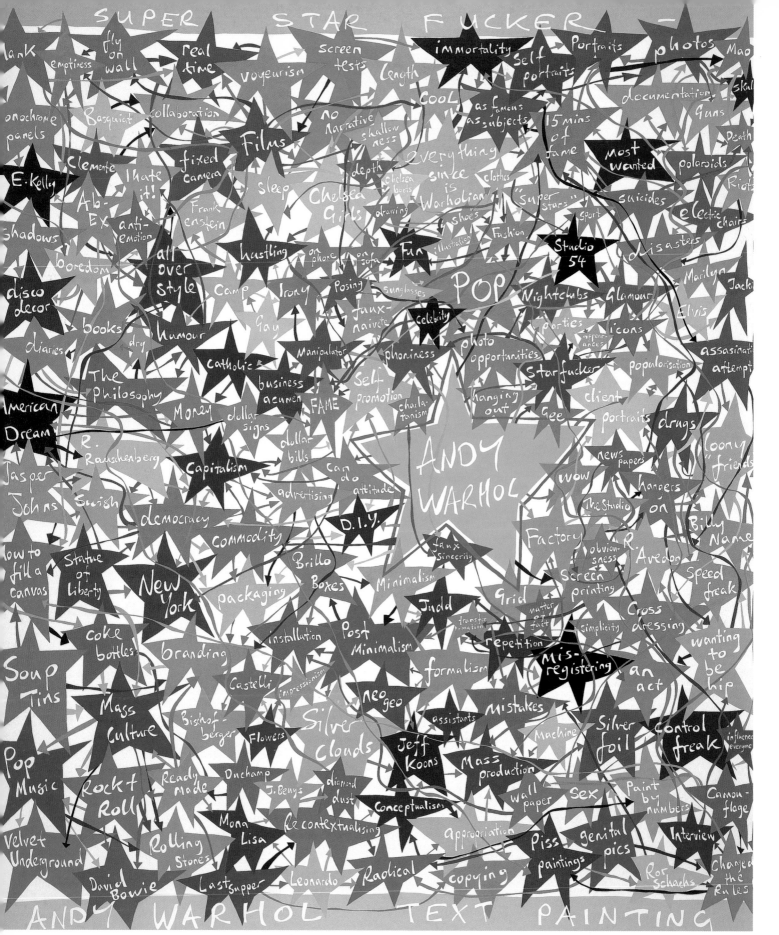

SUPER STAR FUCKER, 2002. ACRYLIC ON CANVAS, 254 X 213,4 CM.

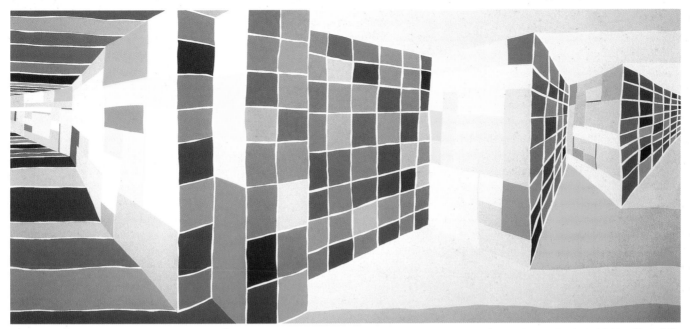

GREY AND MAINLY NEUTRAL COLOURS PAINTING, 1999. ACRYLIC ON CANVAS, 213,36 X 457,2 CM.

PETER DAVIES

TRACEY EMIN

In the past few years the tables have turned from Tracey Emin telling you all about herself to the British public wanting to know everything about her. She has become popular within and outside of the art world, appearing regularly in mainstream newspapers, magazines, and, on occasion, TV. Emin started making herself the subject of her work when she decided, "I was better then anything I'd ever made." Although she has commented, "This may not always be the case."

In her first exhibition at White Cube in London in 1993 she exhibited her "memorabilia"—small personal items from her life were shown in frames with accompanying handwritten text. These objects were the precursor to the media favorite *My Bed*. The exhibition was called *My Major Retrospective* and came as a surprise to the London art world, which was unaccustomed to seeing work that was emotional, confessional, and presented in an unassuming way. Also included in the show was *Hotel International* (1993), her first appliqué blanket that soon became her trademark style of work. Her appliqué blankets and, later, her tent *Everyone I Have Ever Slept With, 1963-95* (1995), formed part of a subsequent wave of London art that incorporated craft into contemporary art.

Emin uses her patchwork quilts to tell stories or poems, putting words together in a way that looks almost random. Everything in the story joins up, revealing enough to make it interesting without it having a distinct beginning, middle, and end. The intimacy and home-comfort associations of the quilts play off against the harshness and often aggressive sexual content of her stories, from teenage rape and promiscuity to abuse and the trauma of abortion. Emin is a visual storyteller—she gives you words you can read and look at. Whether it's in the handicraft of her blankets, neons, monoprints, drawings, or short films, you feel like she's letting you in, telling her story for you, as if you're reading an extract from her diary.

In her film *Why I Never Became a Dancer* (1995), Emin recounts the last leg of a dance competition in her hometown of Margate, when she was shouted off the stage by a group of boys. She tells us about her anger and humiliation, but by the end turns it into something inspiring for the viewer. Emin has always welcomed a direct relationship with her audience, from The Shop, which she ran with Sarah Lucas, to The Tracey Emin Museum, both of which were used as working studios and were also open to the public. She is now best-known for her installation *My Bed* (1998), which was shown in Japan, New York, the Tate Gallery (as part of the 1999 Turner Prize), and The Saatchi Gallery. It reconstructed an intense scene from her life where she'd lost control but lived through it. *My Bed* is an edited version of a real situation—in the Tate Gallery it stole the limelight, and while she may not have won the Turner Prize, she is the one that everybody remembers.

APRIL 16TH, 2.00, TRACEY EMIN
Tracey Emin, what can I say about her? Tracey is very private. She is the one that I would like to be friends with; number one, I love her diaries and, in fact, they inspire me to write mine. Her stories are horrific. I liked her because she's had the dramatic sexual relationships I would have liked to have had. I was jealous, and yet, without speaking, I felt very close to her. Her studio is very pretty in calm, cool, clean colours with huge rooms overlooking a roof terrace with lots of plants which her father was watering lovingly, it was a sunny day. He was very chirpy, and I took some photographs of him as he watered her plants. She was busy ironing in her room next door where there were great things on her table. I really wanted to be friends with her, but I was on her territory. When I left I said to her, «I'll send you a picture of your father.» That is when she started to warm up and offered me an Emin Beck's beer bottle, which I have kept to this day. Tracey is very endearing—you really feel she works hard and, if you speak to her for any length of time, she lightens up. I felt I could spend an evening with her. A.E.

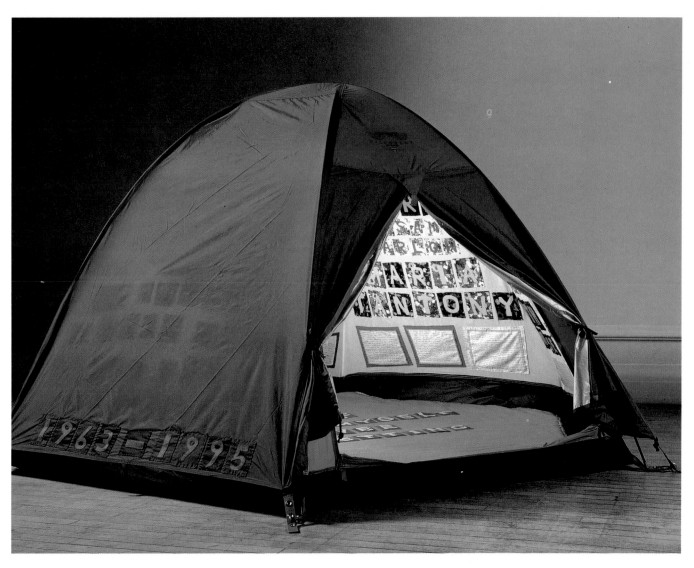

EVERYONE I HAVE EVER SLEPT WITH 1963-1995, 1995.
APPLIQUED TENT, MATTRESS AND LIGHT, 122 X 245 X 215 CM.

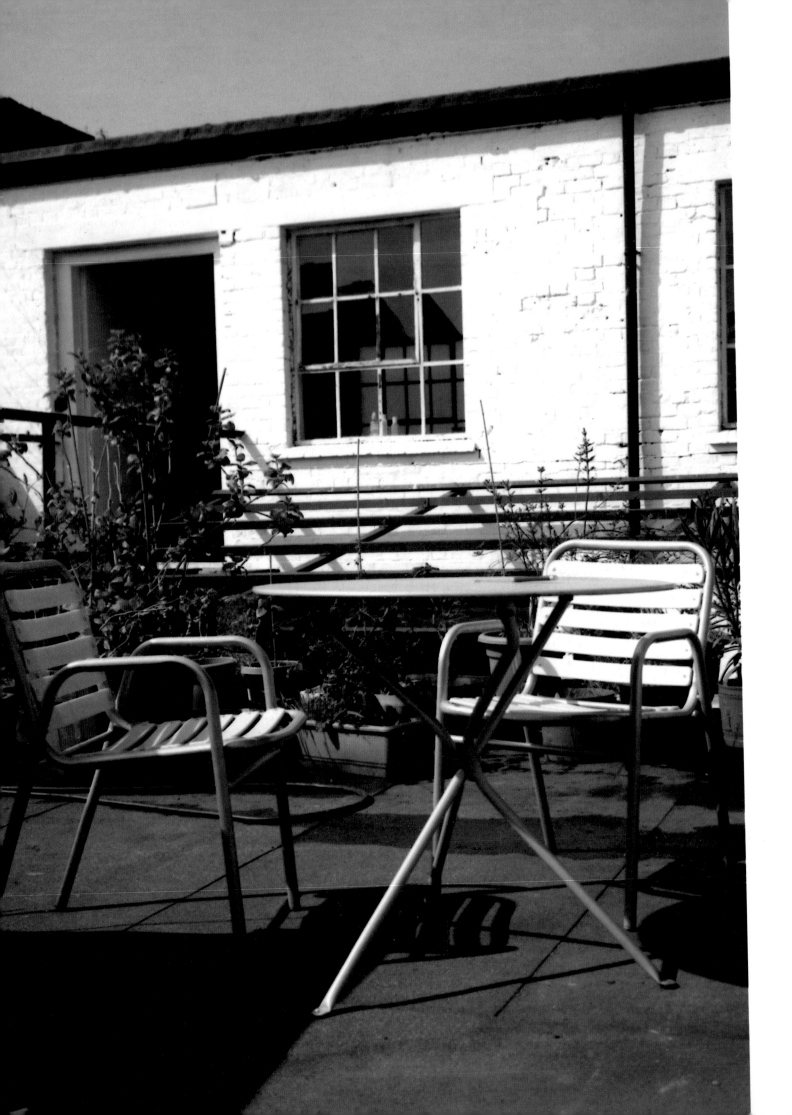

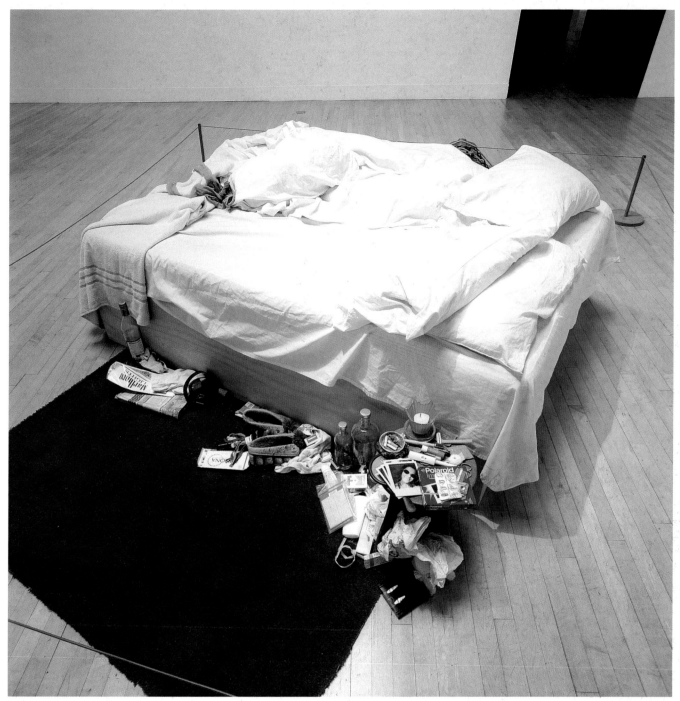

TRACEY EMIN

MY BED, 1998. INSTALLATION TATE GALLERY, LONDON, 1999-2000.
MATTRESS, LINENS, PILLOWS, ROPE, VARIOUS MEMORABILIA, 79 X 211 X 234 CM.

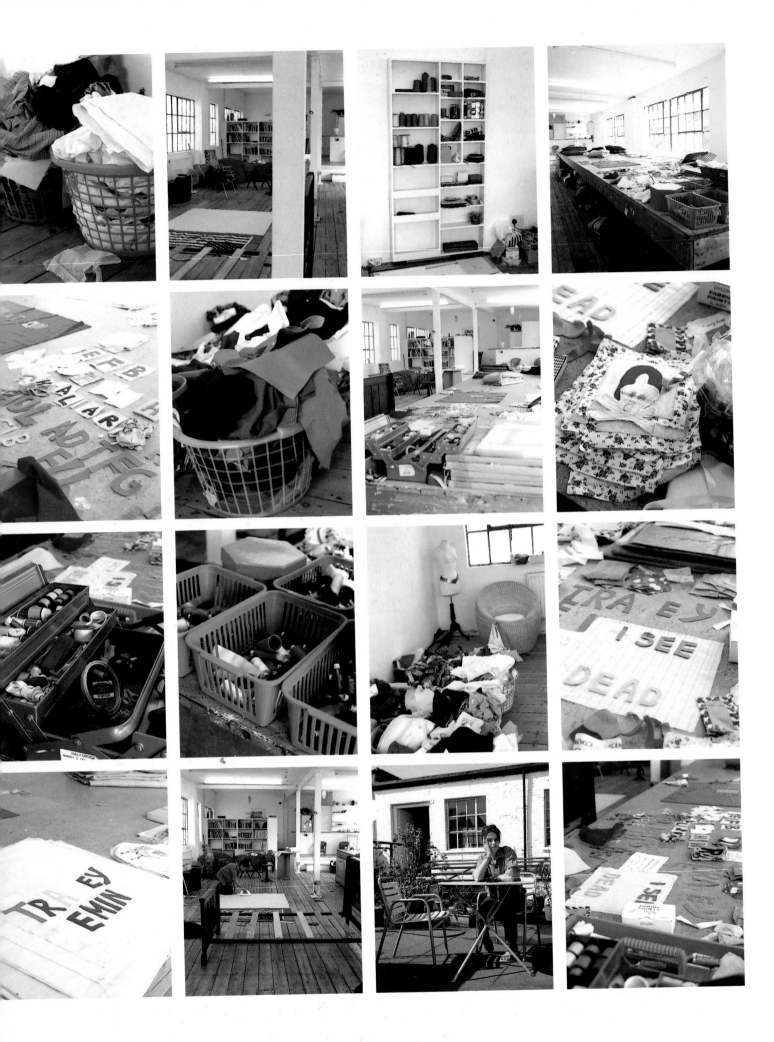

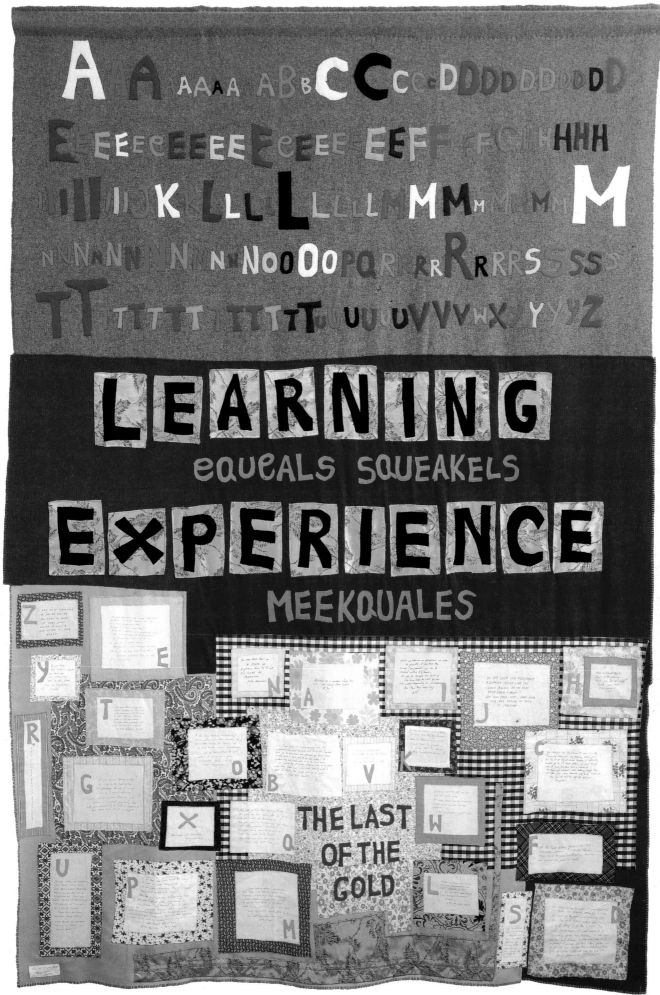

THE LAST OF THE GOLD, 2002. APPLIQUE BLANKET, 298 X 209 CM.

TIERNEY GEARON

I clearly remember the first time I met Tierney, it was in Venice and she was on the arm of Jean Pigozzi. It wasn't her wide doe-eyed face that captured my imagination but her straightforward American boldness. Zoom forward a decade and I run into Tierney at a cocktail party in London. She told me she had given up her career as a fashion model and had become what she described as "a bourgeoisie housewife and mother." We talked for a long time and she told me she was creatively frustrated and had taken up painting. She invited me to visit her studio, so I went along to Rossetti Studios and amid piles of magazines and boxes of old clothes and endless clutter she showed me her paintings. They were pretty and pastel and decorative. But then she showed me her photographs because she knew I was a photographer too. I thought they were powerful, full of emotion and frankly really good. Her work immediately reminded me of the work of Eric Fischl and his investigation behind the doors of suburban life. I asked her if she had seen the painting of Fischl, but she had never heard of him. It is great irony that when I finally convinced my then-husband Charles Saatchi to come and see her work that Eric was in town for his exhibition at Gagosian and he came along with us. Charles bought several images on the spot and suggested to her that she enlarge her prints. Less than six months later, her work got star billing in the Saatchi Gallery's *I Am a Camera* exhibition and her photo was on the cover of the exhibition catalogue. She became an overnight sensation.

Tierney photographs her large extended family and especially her children, Emilee and Michael. But these aren't just ordinary family snaps; they have a surreal and disquieting feel about them. Tierney is the beautiful daughter of a rich businessman and a mother whose life has been plagued by mental illness. I'm not exposing family secrets—Tierney tells everyone her story in your first five minutes together. She is not afraid to expose family secrets. She is not afraid to expose the intimacy of her family life in words or imagery, not unlike the brutal scrutiny that Richard Billingham uses in his work.

When her work was shown in *I Am a Camera,* she was condemned by the English tabloid press for what they called pornography and exploitation of her children. Tierney was horrified and hurt, and she escaped to St. Bart's until the furor died down. Although this press attention was shocking and intrusive to her, it made her a household name overnight. She was taken on by the powerful New York dealer, Larry Gagosian, who gave her a show in New York.

Tierney and I and our kids took a road trip in rural Texas. Tierney brought along masks and would stop people in these backwater towns and ask if they would put on a mask and she would photograph them. No one said no. It's really hard to say no to Tierney. This is how she works, she goes travelling, not only to escape, but to take her camera and make extraordinary images of the ordinary day-to-day stuff of life. K.H.S.

MARCH 21ST, 3.00, TIERNEY GEARON
Tierney Gearon arrived late, but when we left, my children said it was the best shoot they'd ever been to. Tierney took off all her clothes and proceeded to do somersaults. My usually lecherous assistant left the room, but my children were transfixed—although they attempted to have a pillow fight, they kept looking at her. She has a neurotic nervousness about her and you feel she could hurt herself one day. I have to say that I really liked her energy and that she takes risks with life. My warning to her is you never know if a mass murderer is in the room with you. A.E.

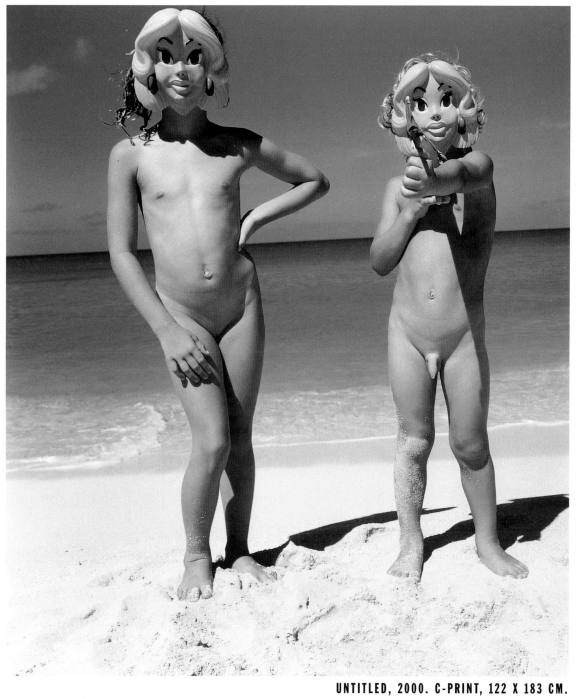

UNTITLED, 2000. C-PRINT, 122 X 183 CM.

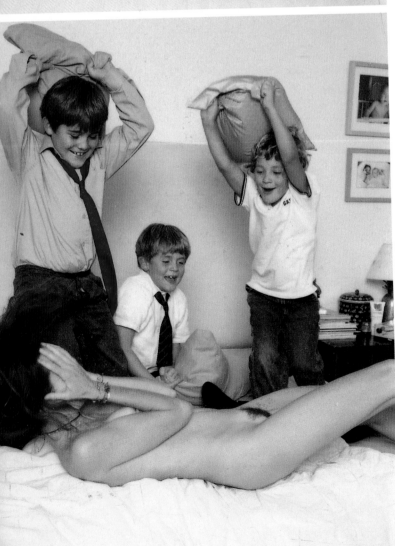

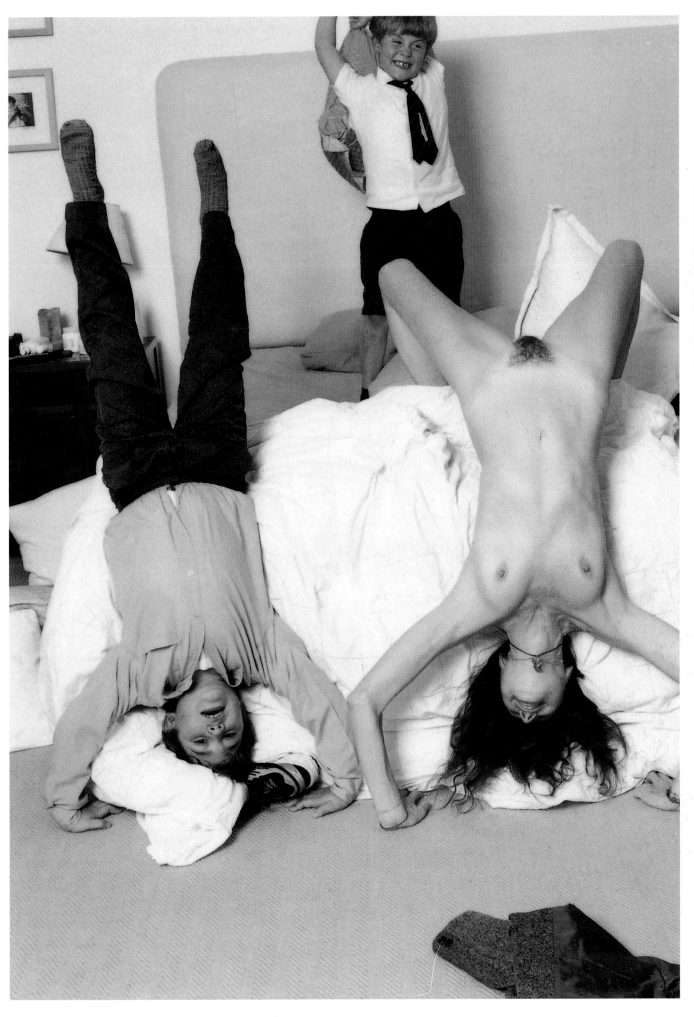

TIERNEY GEARON

UNTITLED, 2000. C-PRINT, 122 X 183 CM.

GILBERT & GEORGE

Gilbert and George are "two people and one artist." They met at St Martin's School of Art in 1967 and started working together, dropping their surnames and past lives, declaring everything they made and did sculpture. They were outside of the current trend, which veered toward monochromatic, formal abstraction, but ahead of their time wanting to make art about their everyday life that would extend to a non-art audience.

In the early days, after leaving college, they found it difficult to be accepted by galleries, partly because they did not have a product or slides of their work; to them sculpture was an activity, not an object. On hearing that the landmark touring exhibition *When Attitudes Become Form* was coming to the ICA, they were convinced they would be included, partly because they knew Charles Harrison who was selecting the additional artists for London. When they found out that they had not been chosen, they showed up at the opening and stood still in the gallery as *The Living Sculpture.* They wore identical suits and covered their faces with multicolored metallic paint to remove the idea of themselves as people, inviting the viewers to stare at them like objects. This was the first time they had exhibited *The Living Sculpture* in a gallery—it was polite anarchy and proof that they were serious. The public didn't know if Gilbert and George were part of the exhibition or not, but they were convinced by what they saw.

After this their career took off, first in Germany and later across the world. They almost never speak about their lives as individuals or outside of being «Gilbert and George,» making it impossible to understand where the performance ends and their lives begin. Everything they do as Gilbert and George is a part of being *The Living Sculpture* and vice-versa. Their appearance is ordered and methodical, from the way they walk to the identical suits they always wear. But beneath this respectable look are the prominent themes of their work—sex, money, race, and religion. Likewise their gallery works since the late 1970s are neatly presented and structured, put together in a grid to form an overall image made up of repeated subjects, including urine, sweat, blood, sex, dirt, and giant blown-up turds. They combine hand-colored photographs—usually of themselves but sometimes of other people and the urban world—with bright colors and thick black outlines around the images and text.

Gilbert and George have become the most established outcasts in British art. Despite huge success and a full schedule of international exhibitions, they remain adamant that they are still not a part of the real establishment.

APRIL 9TH, 3.00, GILBERT & GEORGE
Gilbert and George arrived an hour and a half late for their photo shoot; so I started to take photographs of everybody and anybody along the street who could possibly have been a couple. They live on a very smart street in the East End where they own two houses. When they arrived they couldn't have been more apologetic. You see, they had been to a funeral. I was shown round their collection of antique pots and turn-of-the-century furniture all crammed into their house. They were educating me on the late nineteenth century. Eventually they said they were late because they had been to the funeral of the Queen Mother, and I thought how grand, but I later discovered that they had watched it on a friend's television. It would not have been a surprise if they had been invited. The pair changed into identical Savile Row suits and looked like English country gentlemen. The studios at the back of their two houses were white and in stark contrast to the front of the buildings, which were definitely nineteenth century with dark wood floors and small dark rooms. They didn't look like artists, which surprised me; they obviously have split personalities. Their work is so different from their appearance. A.E.

WE ARE THE <u>MOST</u>
DISTURBED
PEOPLE WE EVER MET.

Gilbert and George
X X
X

WE ARE THE MOST
DISTURBED
PEOPLE WE EVER MET.

[signature] x

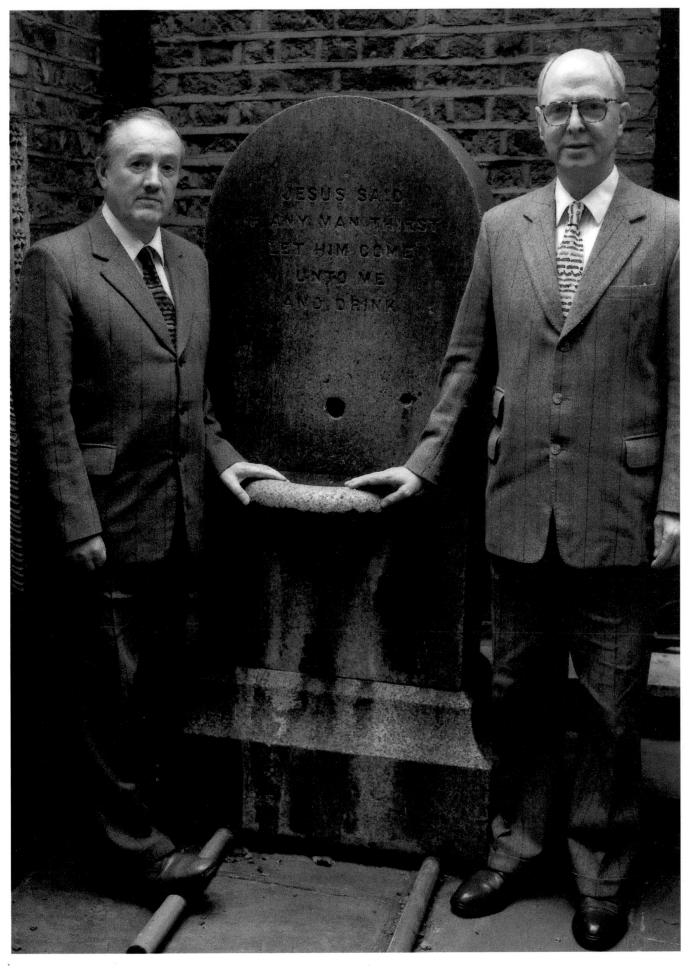

GILBERT & GEORGE

CHARBEL
IS BACK

Lebanese/Italian model,
6ft, tanned very defined
body. Versatile.
Out calls/overnight.
Call 07880 821134

JED IS BACK IN
TOWN

5ft 9" of prime XXX
equipped, tattooed British
yob, gives active type
service to the well
deserved. Into colours in
private playroom.
Call me on
0589 172 958
or forever wonder

BACK

2001

Gilbert and George

BACK, 2001. FOUR PANEL PIECE, 169 X 142 CM.

BODY BUILDER PAUL

5ft 9", 235lbs, 34, big powerful build, huge arms and back, thick neck, powerful legs, great behind. Offers active type service. Very straight-acting and friendly. Not your typical escort. Phone Paul
07931 591 675

BISEXUAL BILLY

(22) boyish, masculine lad, athletic body, washboard stomach, footballer legs, VW equipped. Central London.
In/out/nationwide.
0973 672 924

EURASIAN JEROME

23, mixed American Vietnamese, very cute. Come to my private flat in Covent Garden. If you are looking for a nice personality, call. 24 hrs.
In/out/nationwide
0171 240 8994 or 0402 302 700

LINGERIE DAVID

24 yo, 6 ft, slim, kinky blond lad dressed in sexy black fishnet stockings and suspenders, corset, gloves, and red PVC high-heeled thigh boots for your pleasure. Versatile and discreet.In/out/anywhere. 24 hours. Earl's Court/Central London.
020 7373 6253

INTERNATIONAL AL

Servicing the UK, 6ft 2" eyes of blue fair hair, tanned physique, straight acting professional, genuine, discreet, handsome, amazing. Out calls only.
0956 145 302
e-mail: allanhughes@ btinternet.com

WELSH LAD LUKE

24 yrs, sexy lad, athletic, good-looking, smooth and friendly. Unforgettable service. **XVWE**. South London. Will travel. Book by appointment to avoid disappointment.
Call 07989 040060
lukescort@hotmail.com

SPUNKY SEAN

20,slim, smooth and boyish, offers fun, versatile service. XVW equipped. In/out. 24 hours. Discreet apartment.
0958 202 137

ORIENTAL WAYNE

(Engineering Student) 21yo, 9st., 5ft 6", 28" waist, boyish looks, very cute, slim and smooth body, versatile, cuddly, full satisfaction, excellent massage, Euston luxury

EIGHT
0771 267 2697

2001

Gilbert & George

GILBERT & GEORGE

EIGHT, 2001. NINE PANEL PIECE, 253 X 213 CM.

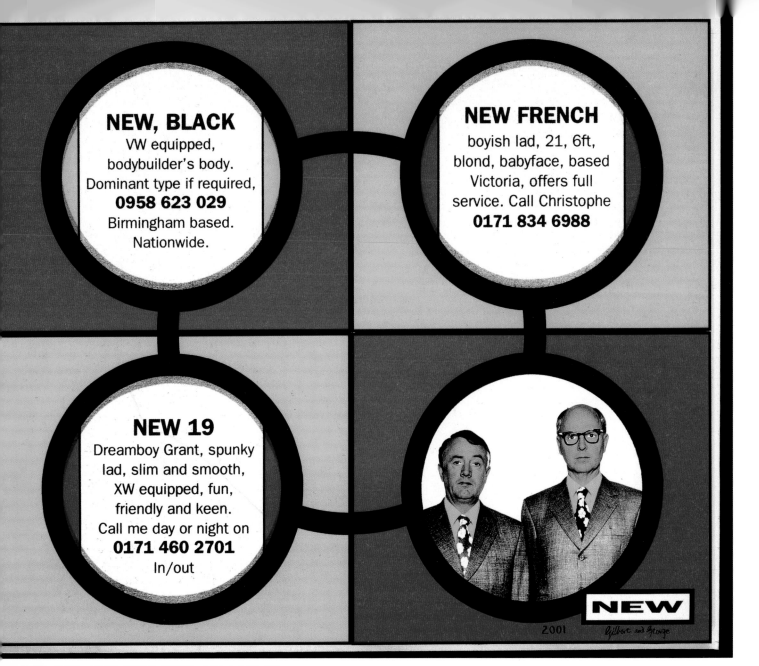

NEW, 2001. FOUR PANEL PIECE, 142 X 169 CM.

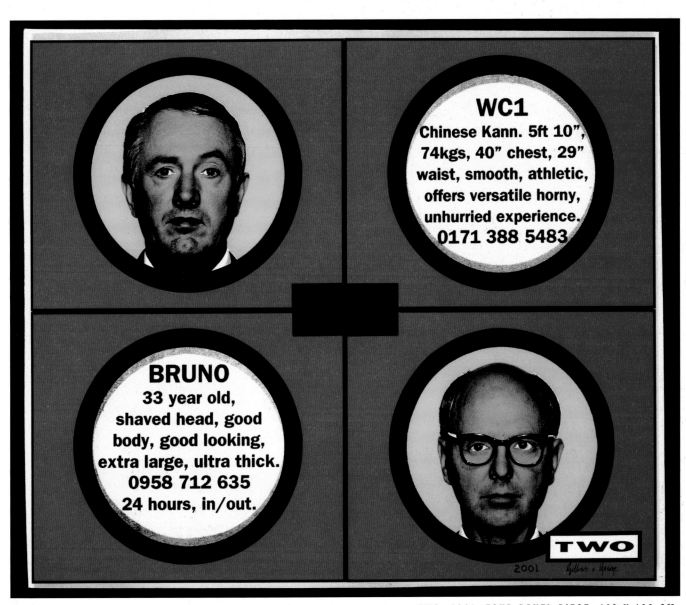

GILBERT & GEORGE

TWO, 2001. FOUR PANEL PIECE, 142 X 169 CM.

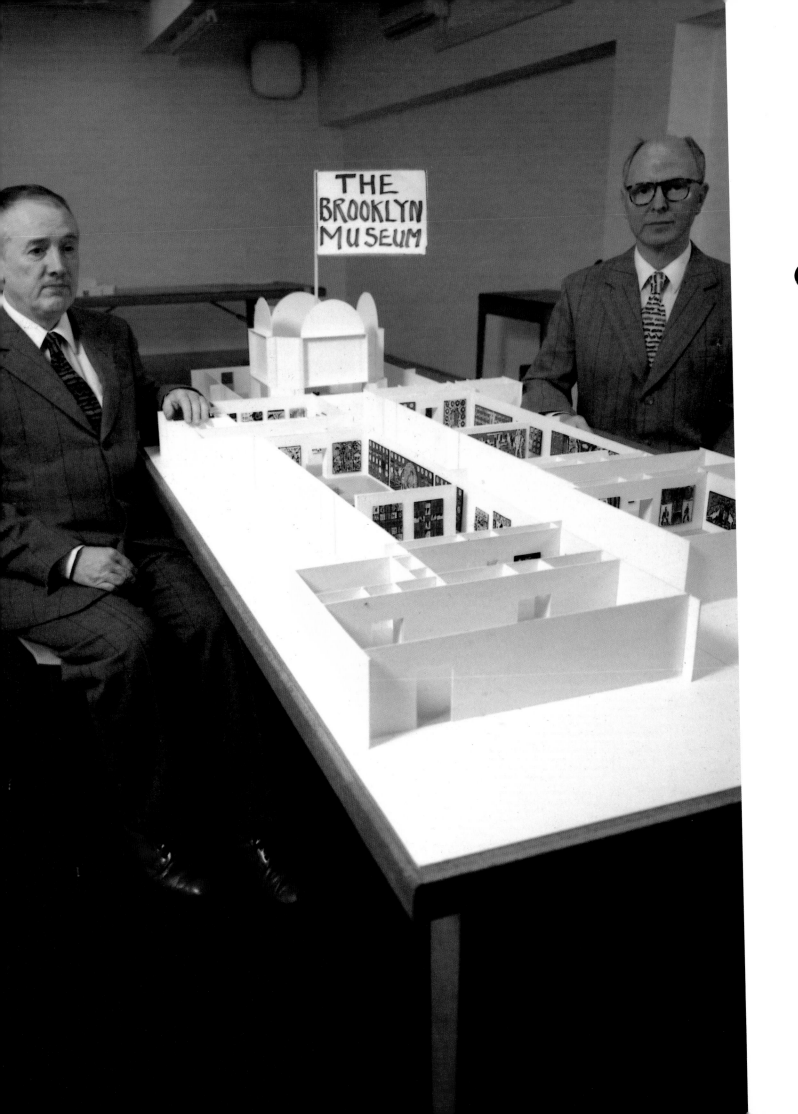

THE
BROOKLYN
MUSEUM

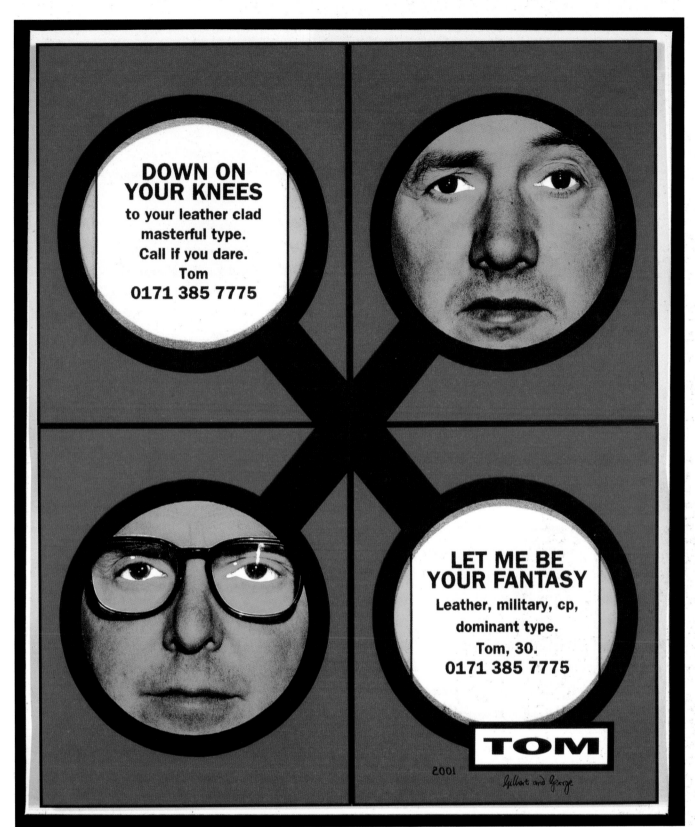

GILBERT & GEORGE

TOM, 2001. FOUR PANEL PIECE, 169 X 142 CM.

KIRSTEN GLASS

Flicking through a magazine, listening to music, and going clubbing all have a place in a Kirsten Glass painting. Glass begins each painting by putting together a collage using photographs of models cut out of style magazines. She chooses images that have been staged in such a way as to lure the reader, and uses this device in her compositions to entice her viewer, but toward something darker. The girls are set up in a more confrontational way, often as master and servant, rather than just hinting at girl-on-girl chic. She uses theatrics that would seem too over-the-top even for an attention-grabbing campaign in a fashion magazine, such as bodies cropped and sliced, heavy-duty makeup, and eyes that look as if they are bleeding with streaming color. Cropped figures are either outlined with fluorescent paint or morphed into an area of expressive painting. In doing this, Glass balances the superficiality of fashion and image against the painting styles that interest her.

Glass doesn't make an easily identifiable reference to her painting influences other than the black background and text running along the bottom edge of the canvas. The thickly painted background is taken from Jason Martin's process paintings that are based on the beauty of an isolated sweeping gesture, which Glass twists into a gothic backdrop. The exaggeration and distortion of these and other emphatic painting styles add to the drama and controlled hysteria of her work. The text at the bottom of the painting functions as a kind of slogan to set off a particular high-pitched feeling.

Voodoo Dolly, Mister Suicide, Deep Tissue are some of her paintings' titles—they do not describe what you are looking at but rather invoke the idea respectively of punky, aggressive, or ambiguous sexuality.

Glass keeps the figures, position of text, and black background as consistent elements in her compositions that, when mixed in one area, form a new energy and meaning. A Kirsten Glass painting shows an obsession with how different ways of looking "weird" have become absorbed into mainstream fashion. She takes these now-established styles and makes them even more extreme and exaggerated. Glass takes codes of dressing up and applies them to her paintings, showing how surface and image can be manipulated to signify their very opposite, how the superficial beauty of models in a photo shoot, or how the seduction of an abstract painting, can be turned into aggressive overload.

MARCH 12TH, 11.00, KIRSTEN GLASS
Kirsten Glass was totally different in her stripy tights, bright red lipstick, and white face. She had a look which is a mixture of 1930s aristocrat and 1980s punk. Kirsten could have been from Mayfair in the 1930s and now is in the East End of London in the year 2003. I immediately wanted *Voodoo Dolly* as I love magic. Kirsten is used for the cover of this book because she has street credibility and her paintings suit the image of the book. Kirsten is the kind of person who remembers to say «thank you,» and she likes to do two or three shows a year and works at a terrific pace. Her studio at the time was 9 by 10 feet and very messy. A.E.

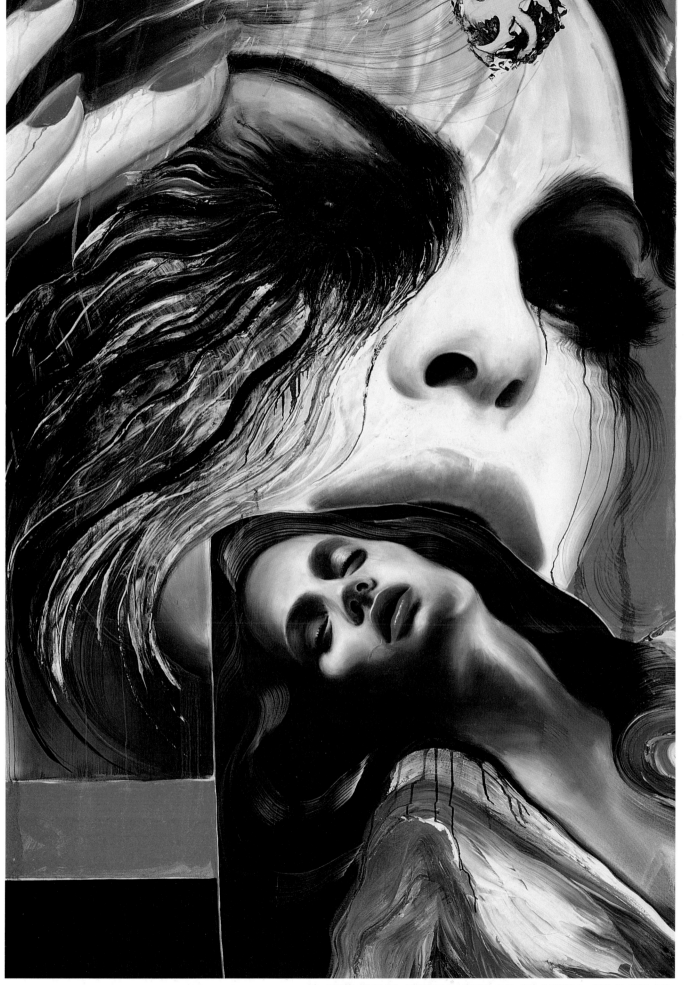

KIRSTEN GLASS

DEEP TISSUE (DETAIL), 2001. OIL ON CANVAS, 168 X 238 CM.

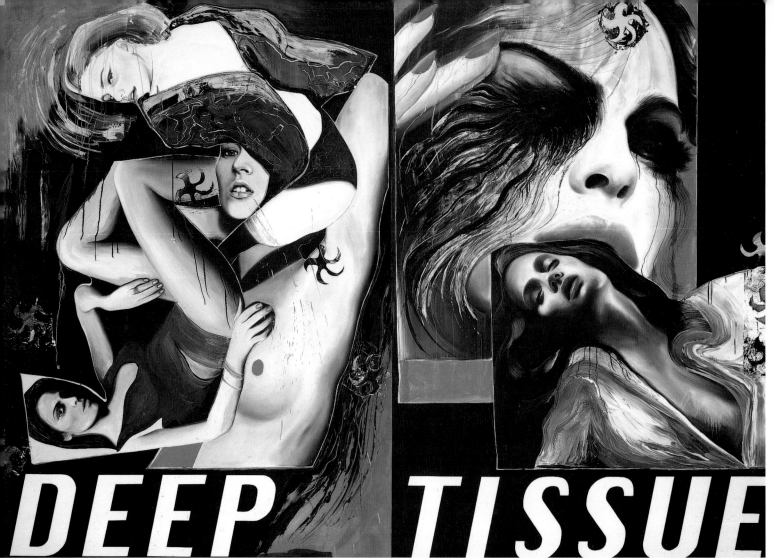

DEEP TISSUE

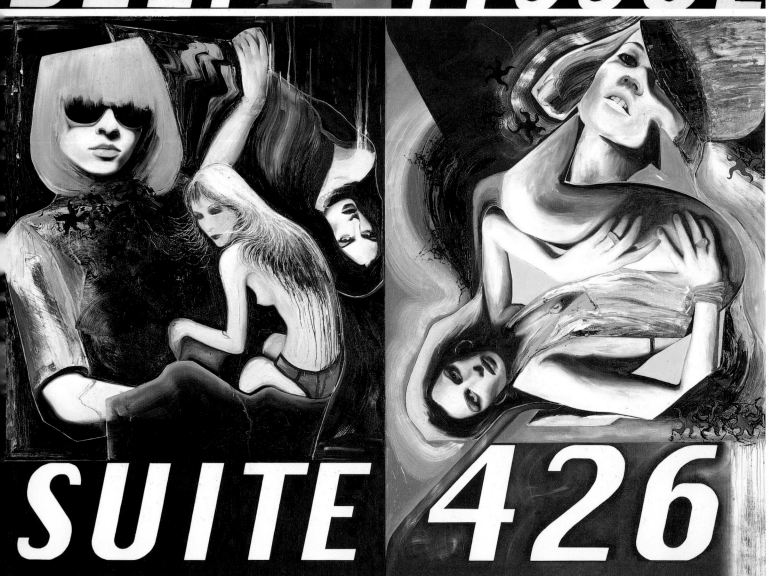

SUITE 426

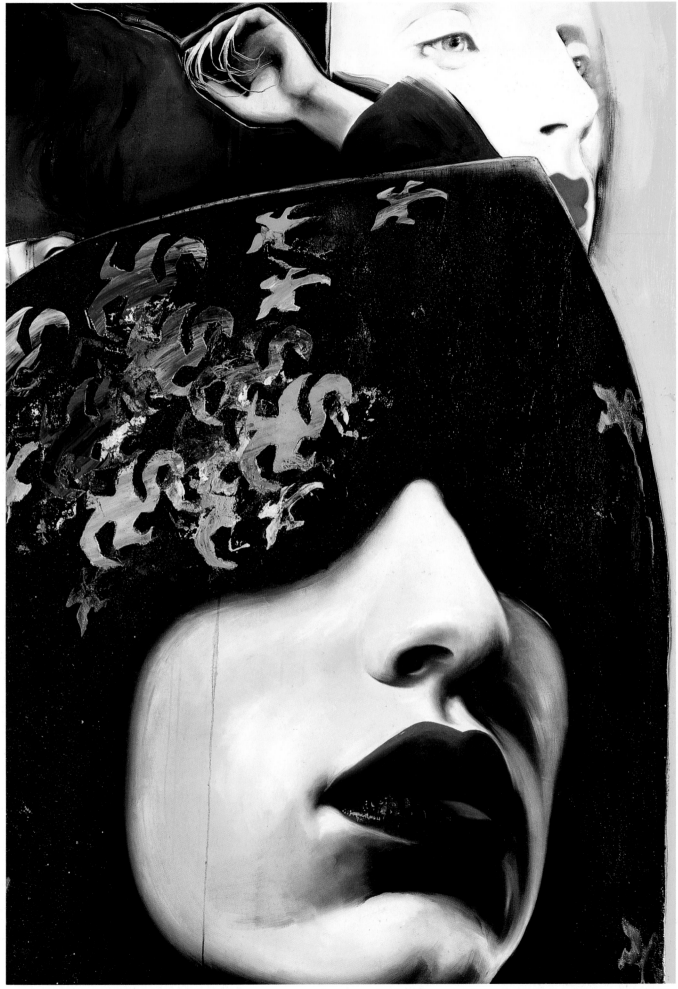

KIRSTEN GLASS

ABOVE: MISTER SUICIDE, 2002. OIL & MIXED MEDIA ON CANVAS, 3 PANEL TRIPTYCH, 504 X 238 CM (EACH PANEL 168 X 238 CM).
LEFT: TOP: DEEP TISSUE, 2001. OIL ON CANVAS, 168 X 238 CM; BOTTOM: SUITE 426, 2001. OIL ON CANVAS, 168 X 238 CM.

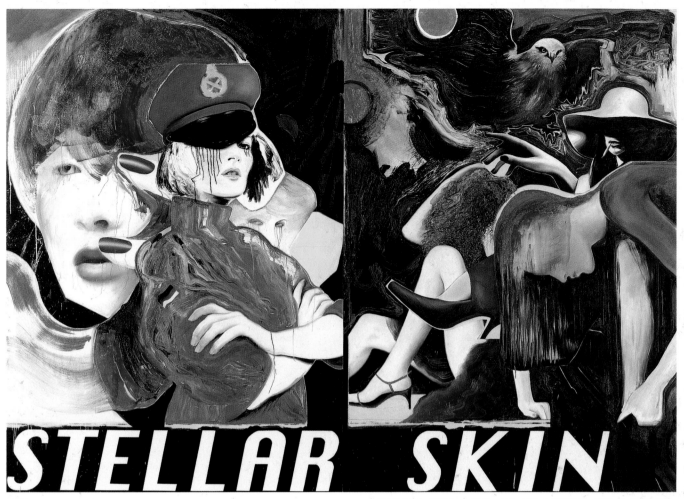

STELLAR SKIN, 2001. OIL ON CANVAS, 168 X 238 CM.

KIRSTEN GLASS

STEVEN GONTARSKI

Steven Gontarski moved to London in 1996 to complete an MA at Goldsmiths College. Born in 1972 in Philadelphia, he studied the history of architecture and art history at Brown University before taking a year out in New York. While holding down three jobs and hanging out in trendy bars and clubs, Gontarski was drawn to the unofficial uniforms of skaters, clubbers, and crustys. His early plastic, sewn figures borrowed the feeling of such urban subcultures; their pose and shiny stretched skin captured a feeling of youthful hedonism. With fetishistic details such as hair beneath the skin, these alien, androgynous figures stood on one leg or rose up into a tree of limbs and body parts as convincing abstractions of the human form. They were clearly handmade while having a futuristic, sci-fi appearance, combining the tradition of figurative sculpture and craft with a street-smart vibe.

When Gontarski had his first solo show at White Cube in January 2000, he introduced a significant shift in his use of materials and way of making his sculpture. He still referenced the body and morphing, but his figures were now made from plaster and cast in fiberglass. The figures stood or crouched in action poses adapted from skateboarding or snowboarding moves, and merged into a graffiti-covered plinth. The work had the look of an old-fashioned or corporate sculpture that had been vandalized.

In his recent work, Gontarski has followed how symbolism associated with certain religious beliefs and superstitions has filtered into contemporary culture. He uses details such as horns, masks, and cloaks, playing on clichéd ideas of evil and the "devil," looking at how these have been adapted into fashion and music, particularly through the theatrical dressing up of gothic and rock bands. Goth music fans that dress in black clothes and makeup are in uniform, but look like outcasts of society— their ghostly white faces and dirty fingernails romanticize an image of death and evil. Gontarski's *L.A.X.* (2001) stands tall and sleek. With one arm outstretched, he asserts the devil's-horns hand sign initiated by the heavy metal band Black Sabbath. Stylized and intentionally superficial, *L.A.X.* is an unemotional monument to youthful rebellion, signifying the need to belong without caring about the meaning behind the look. Combining his love of sculptors such as Henry Moore and Hans Arp with his passion for 4AD, guitar rock and gothic music, Gontarski's figures mix the formal language of sculpture with the twisted youthful desire to fit in.

MARCH 12TH, 11.30, STEVEN GONTARSKI
A very "preppy" artist, Steven Gontarski wore a pale blue shirt and black-rimmed glasses. He was in a hurry, and I had to be very quick. He was finishing a model of something that looked like Batman. Kirsten Glass and Steven share a studio in the East End opposite a mosque. A.E.

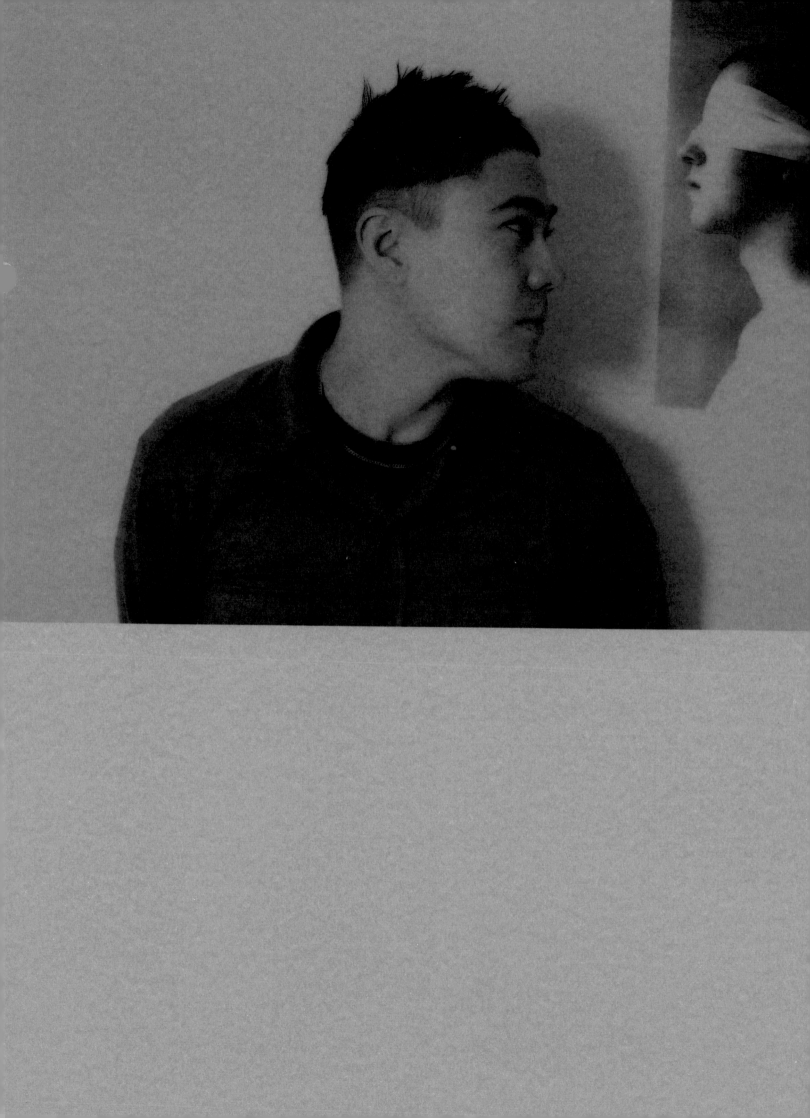

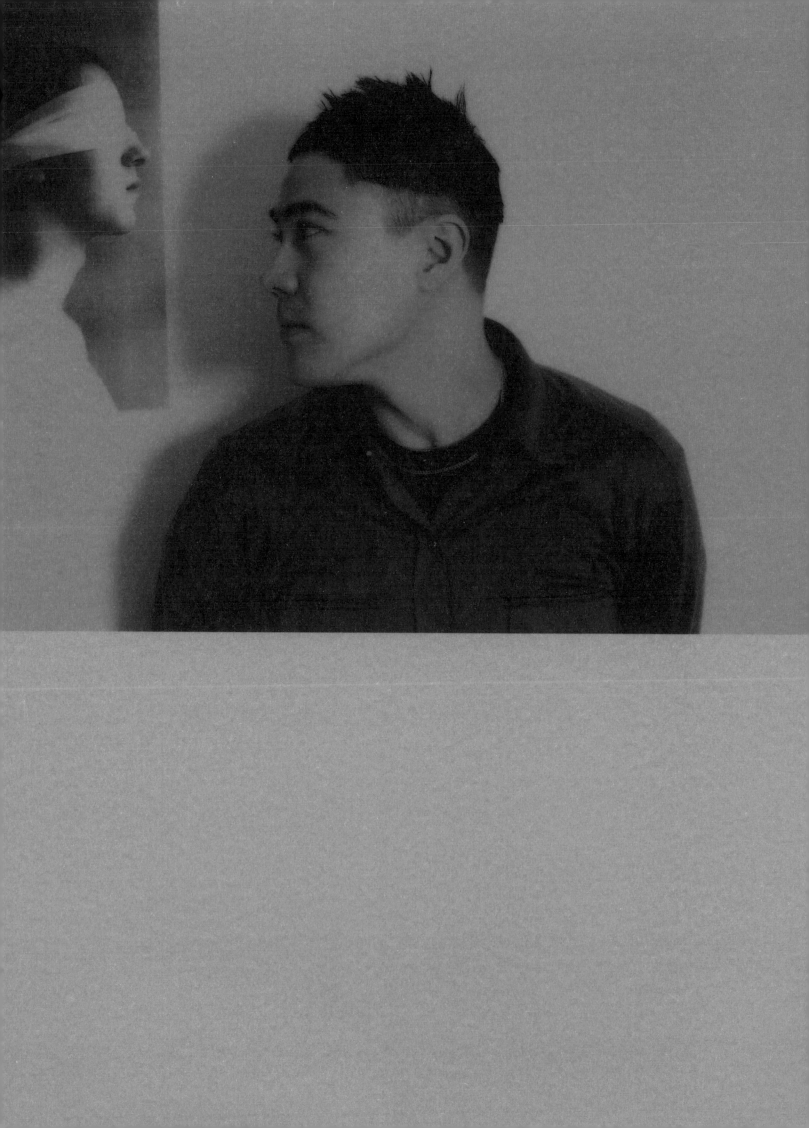

STEVEN GONTARSKI

GAMMA II, 2001. FIBREGLASS, 68 X 51 X 28 CM.

ANTONY GORMLEY

Standing twenty meters tall and visible from the A1 in Gateshead, the *Angel of the North* (1998) is considered to be Antony Gormley's greatest work. *Angel* is made from reinforced steel—a material that is sympathetic to the history of North East England—and is seen by many as a monument to the area's industrial heritage. *Angel,* though controversial when it was first commissioned, is now recognized as an icon of the North East landscape.

Gormley studied archaeology, anthropology, and art history at Cambridge University from 1968 to 1971. He then travelled hippie-style around a number of countries including Turkey, Pakistan, India, studying Buddhist meditation along the way, which influenced his life and the art he would later make. Gormley returned to Britain in 1974 and studied art at Central School of Art, Goldsmiths College, and the Slade. Throughout his college years Gormley's interest in the body set him apart from his contemporaries as the trend at that time was for non-representational art.

Gormley's sculptures of men have changed appearance many times over the twenty years he has spent obsessively making them. He is best known for his hollow body cases that are cast in plaster directly from his own body, which then becomes a mould to be cast in lead. He himself undergoes this process in an attempt to use his own existence and experience of being alive to explore what that means in relation to the world around him. Gormley does not use his own body because he is interested in portraiture or autobiography, but so that each cast, and in turn the final sculpture, carries a particular moment of his own time. His body is the closest connection he has to the outside world. He uses it to transfer a direct experience into an object that will then go on to have its own existence as an art object in or out of a gallery environment. Gormley often makes multiple casts, which take on different appearances depending on how and where they are positioned. For example, in *Testing a World View* (1993) he uses the distance between five identical body cases to draw attention to the isolation of the figures. But even when the figures are stacked, or placed very close together, as in *Critical Mass* (1995), they still feel isolated, emphasizing their individuality as objects in their own space, if not their likeness to each other.

In *Field for the British Isles* (1993), Gormley worked with a group of people to make 43,000 small terra-cotta figures with shapeless bodies and two large depressions for eyes. The figures had a cartoonish simplification and were so densely packed that they became a sea of eyes staring in the same direction. The evidence of the mass involvement that helped to create *Field* is part of its appeal and success, and on receiving the 1994 Turner Prize, Gormley thanked everyone who helped complete the work. In *Alotment* (1995) Gormley collaborated with another group of 300 people by taking their measurements, which he then transferred into concrete blocks and placed in a grid to represent a cityscape. *Alotment* explores the relationships that exist between us and the buildings we inhabit, how our skin contains our body, and how our homes become a second body.

JULY 23RD, 12.00, ANTONY GORMLEY
Antony Gormley has the most surprising studio I've been to because I didn't know what to expect. I walked through the door and there was a whole row of bodies waiting to be packed up in wooden coffins, and bodies in various stages. It was a mystical experience. It was slightly misty, about to rain, and out comes Antony. He's tall, lanky and looks like a scientist who studies the DNA of rabbits, and in a way he does because all around him are men in different stages of production. It just shows that in the art world you should be prepared for anything. He is very alert and helpful, and I wish I had gone with Kay to Australia to see his installation there. A.E.

GAMMA II, 2001. FIBREGLASS, 68 X 51 X 28 CM.

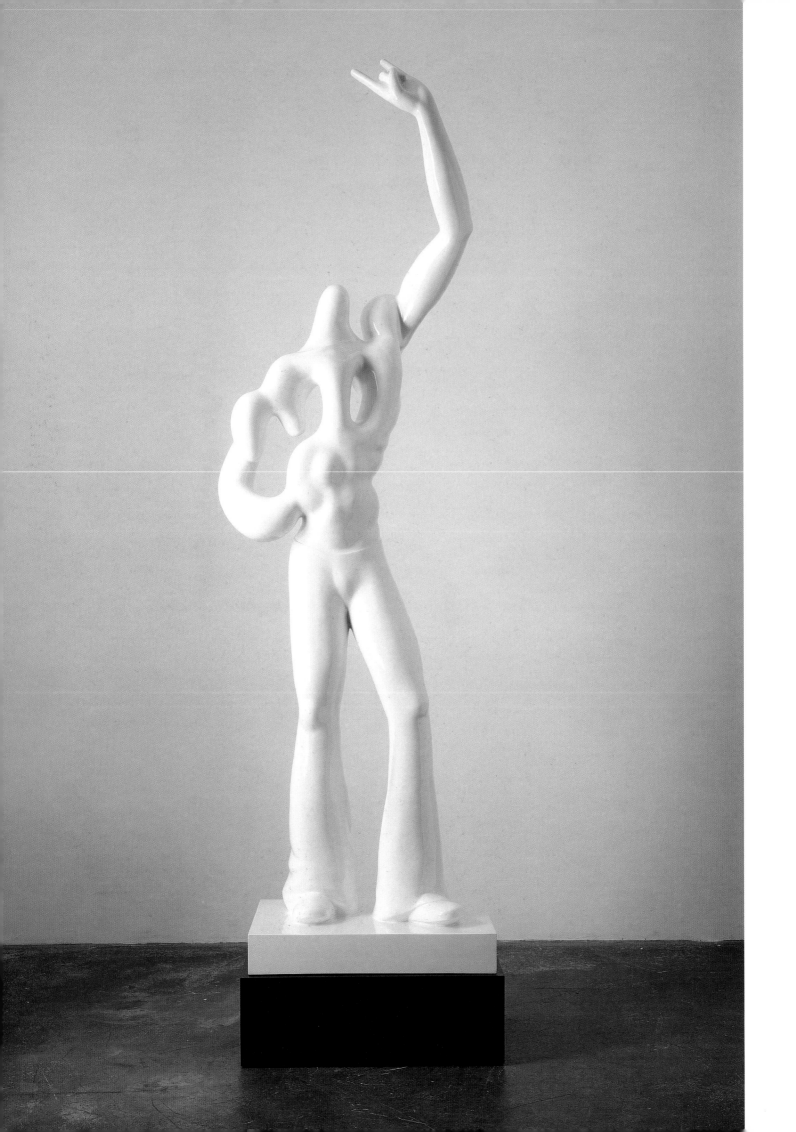

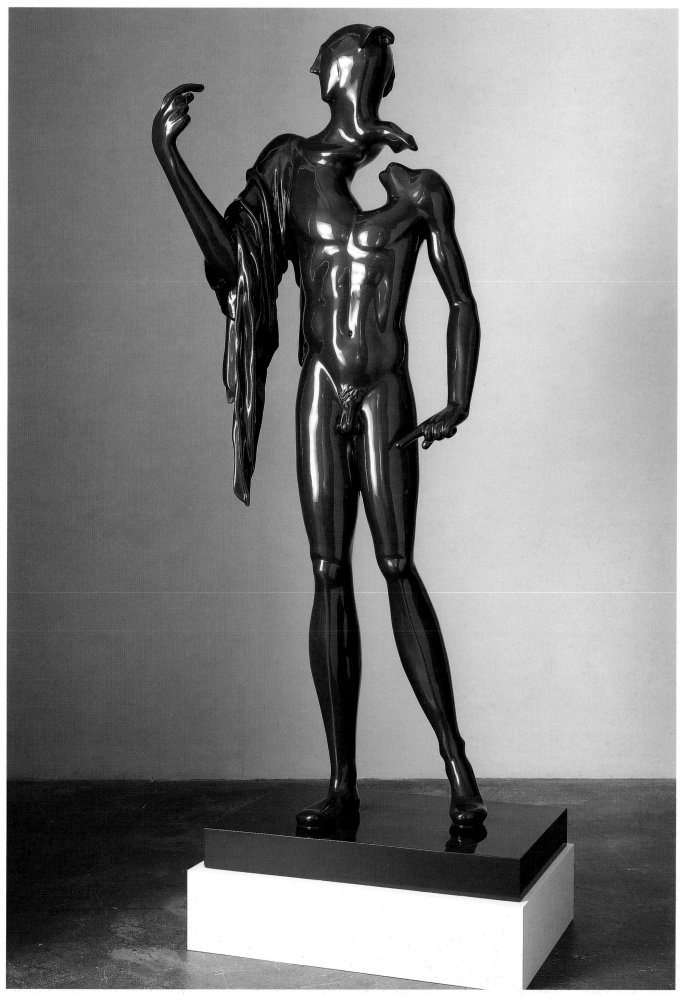

STEVEN GONTARSKI

ABOVE: THE PROPHET DOGWOOD AND THE ALPHA NUMERIC ORDER II, 2001.
FIBREGLASS, 218,44 X 86,36 X 58,42 CM.
LEFT: L.A.X. II, 2000. FIBERGLASS, 243,84 X 78,74 X 45,72 CM.

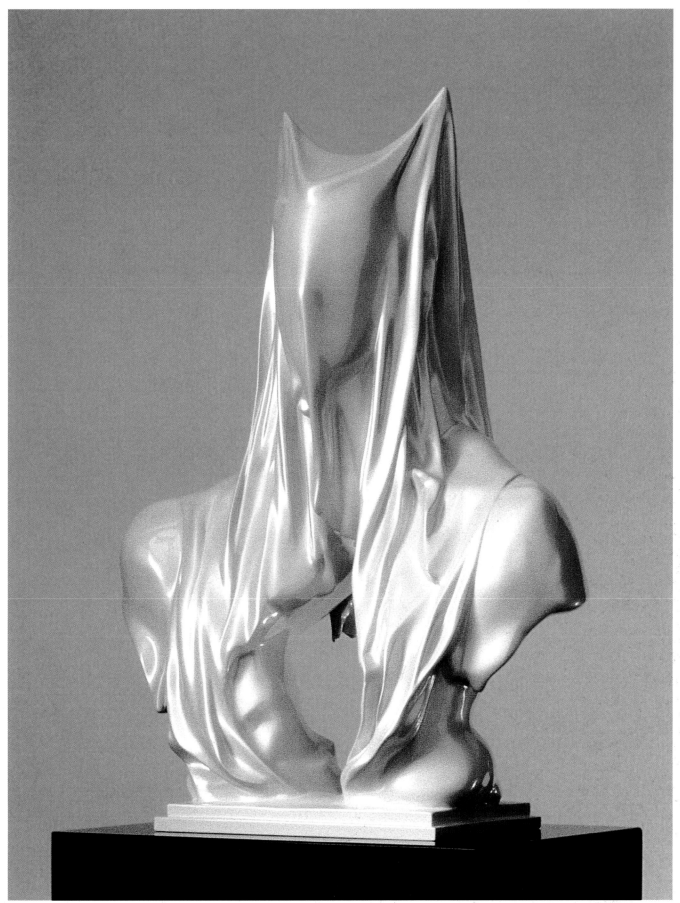

STEVEN GONTARSKI

ZETA III, 2002. FIBREGLASS, 72 X 50 X 30 CM.

ANTONY GORMLEY

Standing twenty meters tall and visible from the A1 in Gateshead, the *Angel of the North* (1998) is considered to be Antony Gormley's greatest work. *Angel* is made from reinforced steel—a material that is sympathetic to the history of North East England—and is seen by many as a monument to the area's industrial heritage. *Angel,* though controversial when it was first commissioned, is now recognized as an icon of the North East landscape.

Gormley studied archaeology, anthropology, and art history at Cambridge University from 1968 to 1971. He then travelled hippie-style around a number of countries including Turkey, Pakistan, India, studying Buddhist meditation along the way, which influenced his life and the art he would later make. Gormley returned to Britain in 1974 and studied art at Central School of Art, Goldsmiths College, and the Slade. Throughout his college years Gormley's interest in the body set him apart from his contemporaries as the trend at that time was for non-representational art.

Gormley's sculptures of men have changed appearance many times over the twenty years he has spent obsessively making them. He is best known for his hollow body cases that are cast in plaster directly from his own body, which then becomes a mould to be cast in lead. He himself undergoes this process in an attempt to use his own existence and experience of being alive to explore what that means in relation to the world around him. Gormley does not use his own body because he is interested in portraiture or autobiography, but so that each cast, and in turn the final sculpture, carries a particular moment of his own time. His body is the closest connection he has to the outside world. He uses it to transfer a direct experience into an object that will then go on to have its own existence as an art object in or out of a gallery environment. Gormley often makes multiple casts, which take on different appearances depending on how and where they are positioned. For example, in *Testing a World View* (1993) he uses the distance between five identical body cases to draw attention to the isolation of the figures. But even when the figures are stacked, or placed very close together, as in *Critical Mass* (1995), they still feel isolated, emphasizing their individuality as objects in their own space, if not their likeness to each other.

In *Field for the British Isles* (1993), Gormley worked with a group of people to make 43,000 small terra-cotta figures with shapeless bodies and two large depressions for eyes. The figures had a cartoonish simplification and were so densely packed that they became a sea of eyes staring in the same direction. The evidence of the mass involvement that helped to create *Field* is part of its appeal and success, and on receiving the 1994 Turner Prize, Gormley thanked everyone who helped complete the work. In *Alotment* (1995) Gormley collaborated with another group of 300 people by taking their measurements, which he then transferred into concrete blocks and placed in a grid to represent a cityscape. *Alotment* explores the relationships that exist between us and the buildings we inhabit, how our skin contains our body, and how our homes become a second body.

JULY 23RD, 12.00, ANTONY GORMLEY
Antony Gormley has the most surprising studio I've been to because I didn't know what to expect. I walked through the door and there was a whole row of bodies waiting to be packed up in wooden coffins, and bodies in various stages. It was a mystical experience. It was slightly misty, about to rain, and out comes Antony. He's tall, lanky and looks like a scientist who studies the DNA of rabbits, and in a way he does because all around him are men in different stages of production. It just shows that in the art world you should be prepared for anything. He is very alert and helpful, and I wish I had gone with Kay to Australia to see his installation there. A.E.

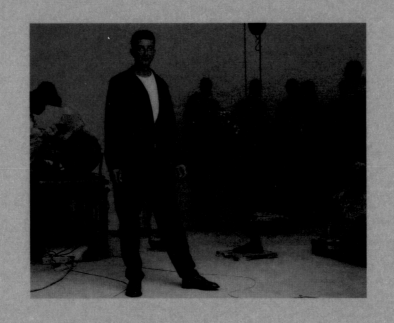

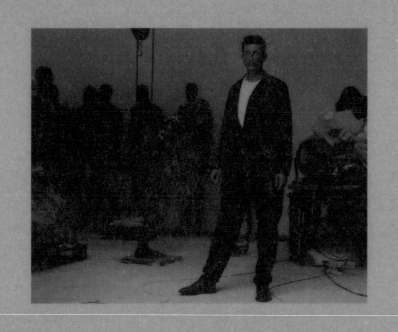

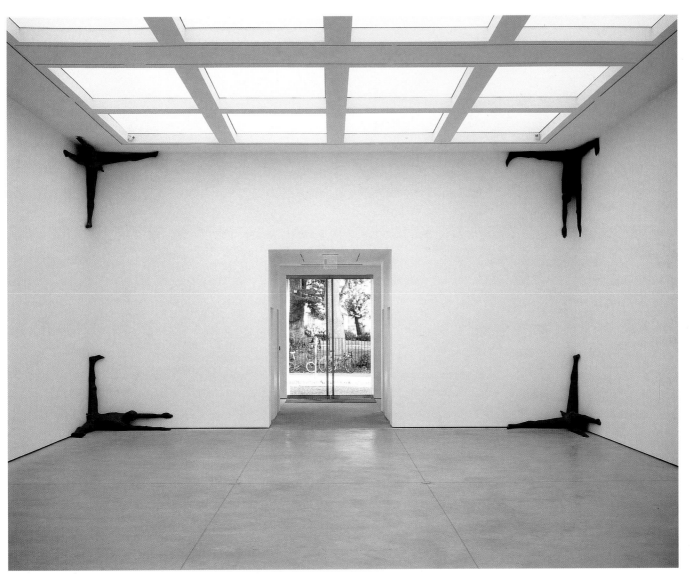

DRAWN, INSTALLATION WHITE CUBE, LONDON, 2000.
EIGHT CAST IRON BODY FORMS, EACH FIGURE 154 X 133 X 187 CM.

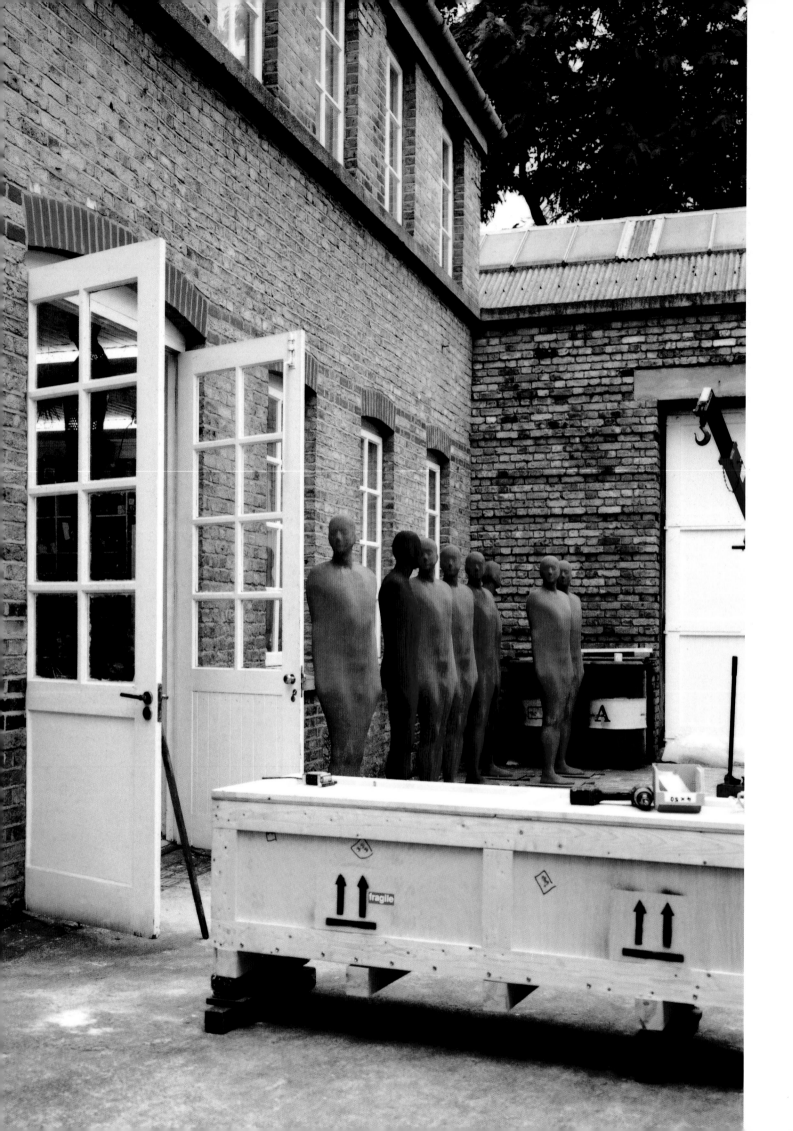

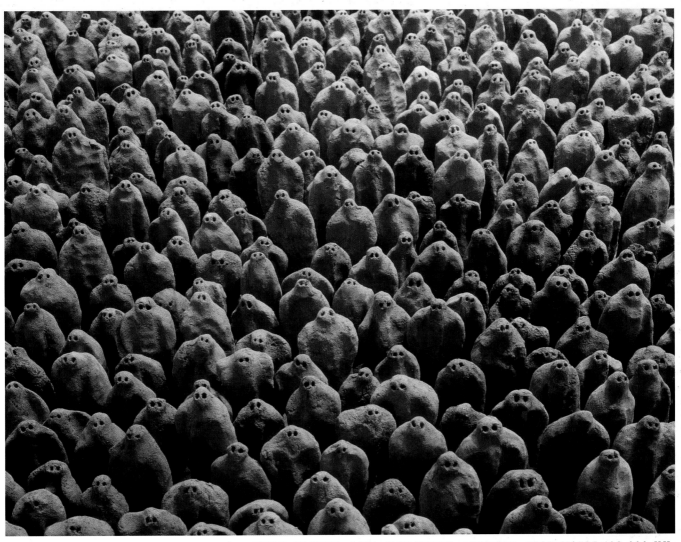

FIELD (DETAIL), 1991. TERRACOTTA, VARIABLE, EACH FIGURE 100-300 MM.

ANTONY GORMLEY

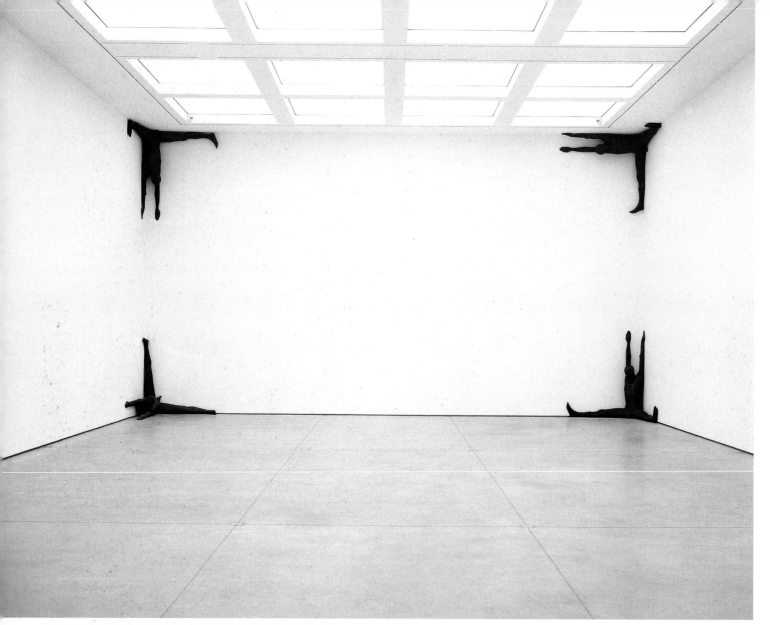

DRAWN, INSTALLATION WHITE CUBE², LONDON, 2000.
EIGHT CAST IRON BODY FORMS, EACH FIGURE 154 X 133 X 187 CM.

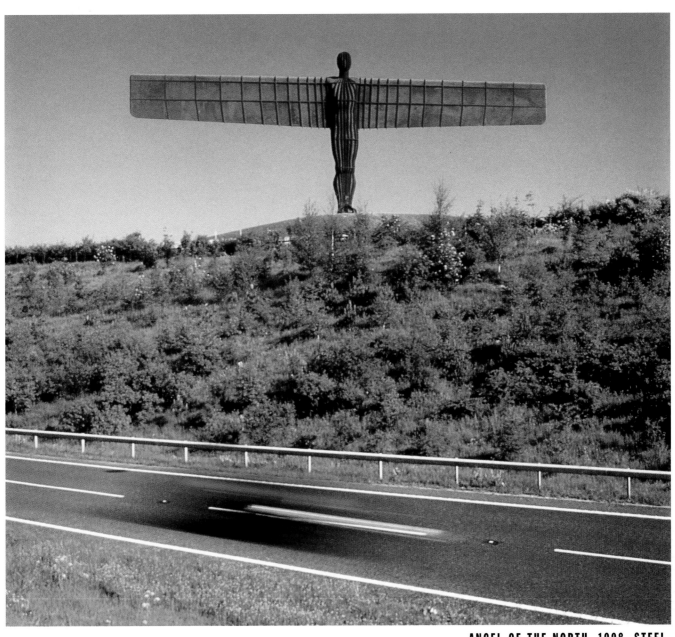

ANTONY GORMLEY

ANGEL OF THE NORTH, 1998. STEEL,
HEIGHT 65 FEET, WINGSPAN 175 FEET, ANKLE CROSS-SECTION 78 X 110 CM.

JUN HASEGAWA

Jun Hasegawa moved to London from Japan in the early 1990s as an art student. She became known for her painted cut-outs made from photographs of friends and pictures taken from style magazines, enlarged onto MDF board, and painted with household gloss. The illustrational simplicity of these early works was like cartoons or computer graphics and fit in to the mid-1990s hands-on, romantic approach to painting that explored art history through contemporary subjects. Hasegawa was influenced by the flat space in Alex Katz's paintings and cut-outs, and while her own cut-outs were essentially two-dimensional they occupied spaces as if they were installations or sculptures.

As her drawings and small gouache paintings became more intricate, Hasegawa felt restricted by the isolated nature of the cut-out, so in 1999 she began painting on traditional canvas. This change in direction opened up the possibility for her to include narrative and complex compositions while the traditional format offered her the opportunity to situate her work within the history of painting. She continued to use household paint to achieve a consistent, flat surface, which recalls nineteenth-century Japanese woodcuts, with strong outlines and large areas of flat color. To work out compositions, she often transfers her drawings onto a computer, using it as a means to make quick decisions about color and scale and to see the results instantly. This shows she is at ease with modern technology and gives her finished paintings a sense of virtual reality without compromising their handmade quality.

Hasegawa creates sophisticated compositions from a few basic elements, and the components she puts together include geometric shapes as well as images from popular culture. This mix of hard abstraction with pop imagery, along with her choice of desirable color combinations, updates traditional aspects of formalism. Hasegawa uses figures or landscapes as a motif in a similar way that color and form operate in geometric, abstract painting, taking them out of their original context and distorting the scale within the composition. Thus, she creates different areas of activity that form an overall image. In *Body 2* (2000) Hasegawa painted a girl in six different poses and on each, changed the girl's hair and dress color. Varying these colors makes it clear that the painting isn't about comparing one girl with the rest; it is to show how they all rely on one another to make formal color relationships across the canvas. Like many of Hasegawa's paintings, *Body 2* has the cool impact of abstraction, but the figurative areas within it add an emotional subplot.

MARCH 6TH, 2.00, JUN HASEGAWA
Her studio is a small space up some stairs and she works as many others do, from a computer. She was the second person I visited and she didn't say a word. She sat quietly in a corner, and you would think that she was almost dull, but when you speak to her she's a sweetie pops. I couldn't get anything out of her the first time I photographed her, yet she painted one of the most powerful images of a woman with her arms tied behind her, in blue, which has stayed in my mind. I loved this painting and I wanted to reshoot her because I felt I hadn't done her justice. I went back and tried to make her more powerful. A.E.

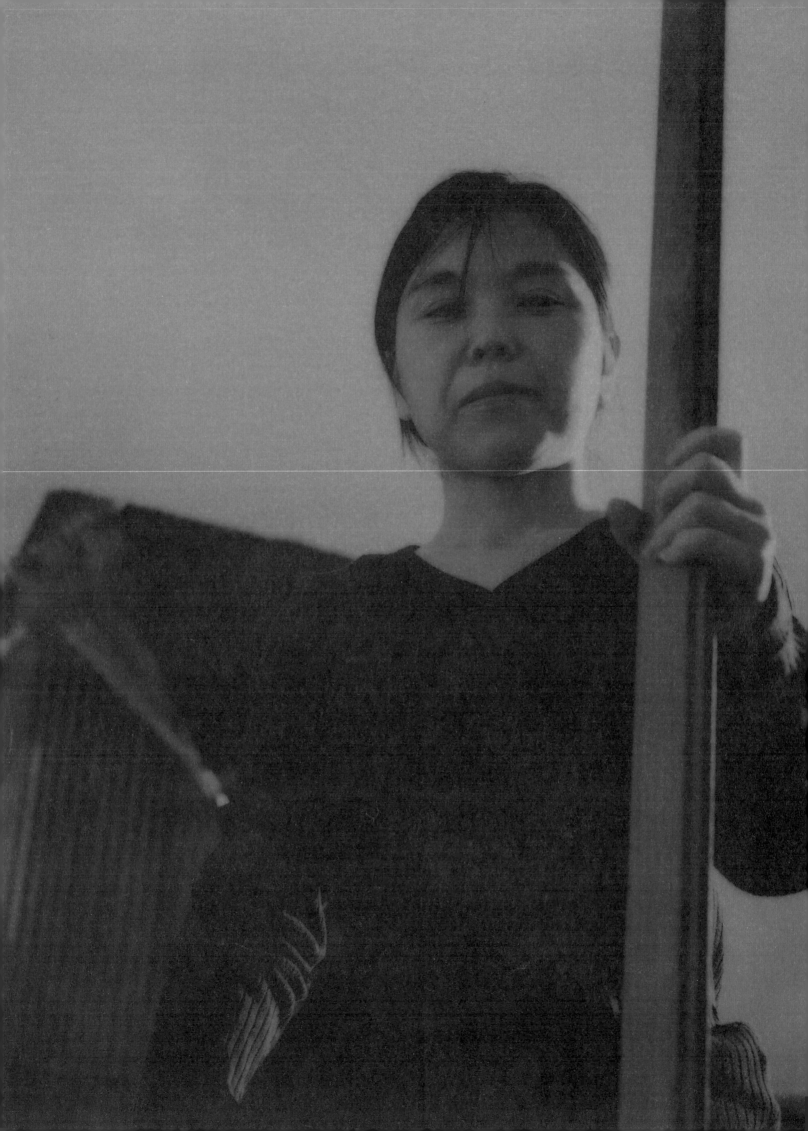

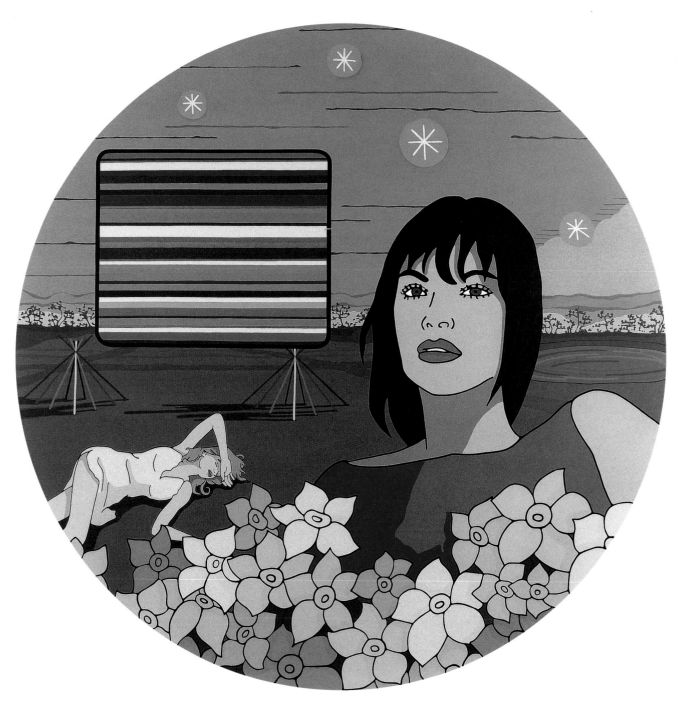

JUN HASEGAWA

THE TONDO GARDEN, 2002. HOUSEHOLD GLOSS PAINT ON CANVAS, DIAMETER 203 CM.

JUN HASEGAWA

AND, NOW YOU ARE, 2001. HOUSEHOLD GLOSS PAINT ON CANVAS,
244 X 366 CM (2 PANELS).

THE SCHOOL ALBUM, 1998. HOUSEHOLD GLOSS PAINT ON MDF, 152 X 210 X 10 CM.

JUN HASEGAWA

RED SQUARE PAINTING, 2001. HOUSEHOLD GLOSS PAINT ON CANVAS, 203 X 203 CM.

JUN HASEGAWA

BODY #2, 2002. HOUSEHOLD GLOSS PAINT ON CANVAS, 183 X 305 CM.

SOPHIE VON HELLERMAN

Sophie von Hellerman divides her time between working solo and as part of HobbypopMuseum, the collective she founded with fellow students at Dussledorf Academy. Hobbypop have shown widely in Britain and abroad, and as an artist in her own right, von Hellermann has had her own share of success. She graduated from The Royal College of Art in 2001, and in the same year, she had solo shows in London at Vilma Gold, the Saatchi Gallery, and at Marc Foxx in Los Angeles.

Von Hellerman's paintings are quickly painted in acrylic washes, but with enough emotion to give the viewer an idea of their intended mood. Her earthy, gray palette adds to the dreamy, sketchy, unfinished quality of her subject matter, which ranges from film scenes to portraits of friends and imaginary subjects. The expressive brushstroke lends her paintings the look of oversized watercolors, where the figures, objects, and landscapes are hinted at rather than fully described. Her sweeping gestures and wavy lines give the audience the impression that everything is blowing in a gust of wind and add a sense of movement to the image.

This particularly suited her *Vusering Hites* series in which she painted events along the lines of the torrid romance between Cathy and Heathcliff. After she completed the paintings she chose the titles for them by randomly selecting lines from the Emily Brontë novel *Wuthering Heights.*

In *When he Came* (2001), two men are pictured eating off a woman and in *These things happened last winter, Sir* (2001), a girl lies across the steps of a church amongst a scattering of petals crying her eyes out while a man watches her from arms' length. Without explaining the story she injects the dramatic themes of battles, love, and loss into her work.

MARCH 21ST, 12.00, SOPHIE VON HELLERMAN
I am sure Sophie von Hellerman is an aristo-crat. She doesn't say anything, sits elegantly with her long blonde hair, is very calm and cool, and has just been given a show by Charles Saatchi. She works from a huge studio along with many other artists who do completely dif-ferent work. It has a good feeling, and she drinks real coffee. We were actually offered a drink. A.E.

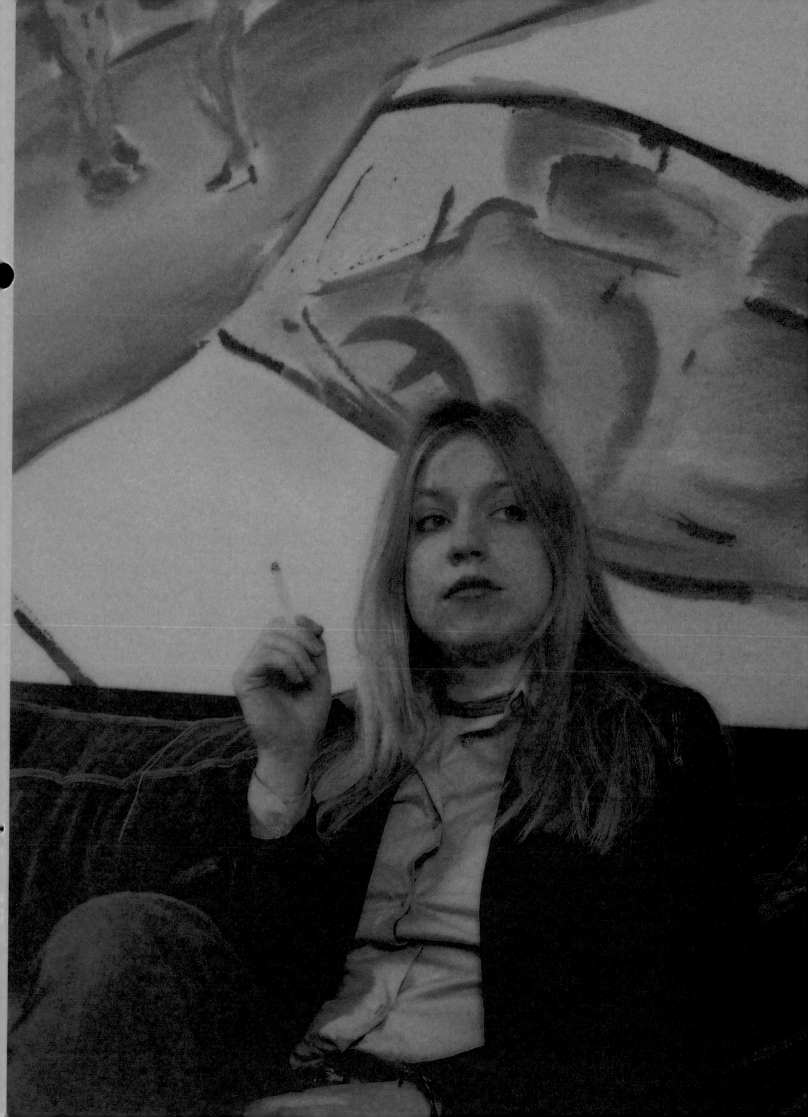

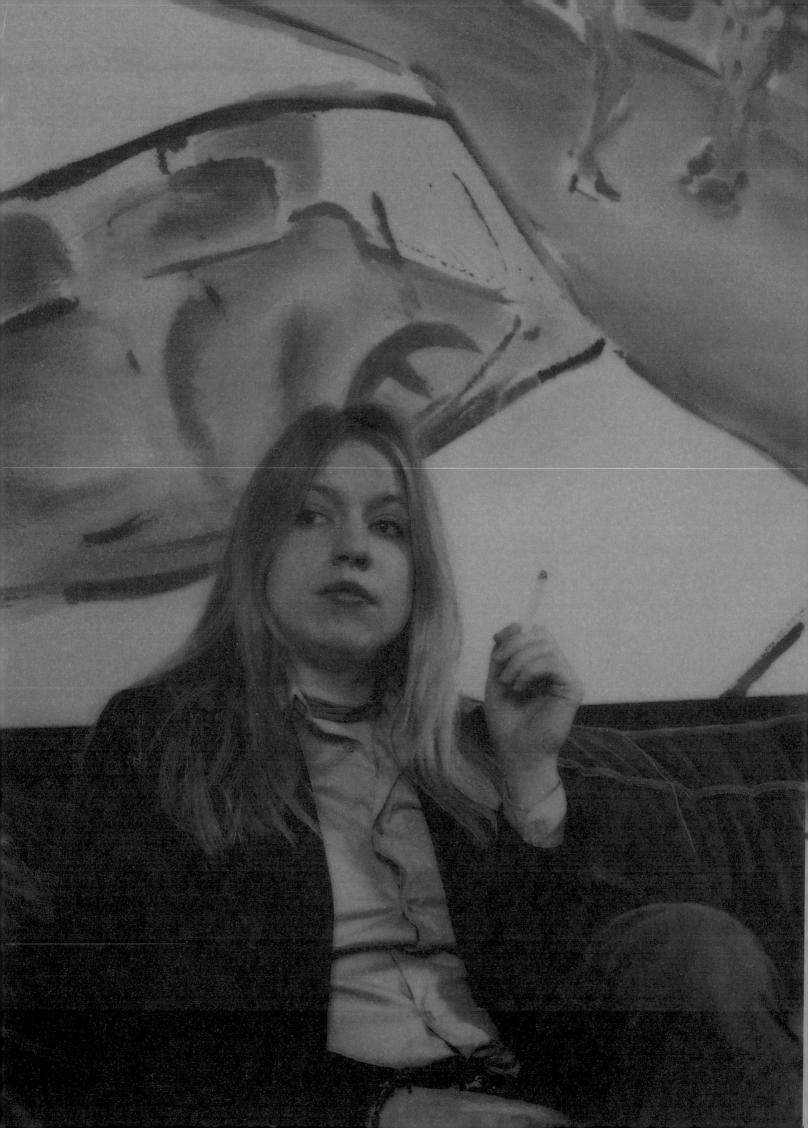

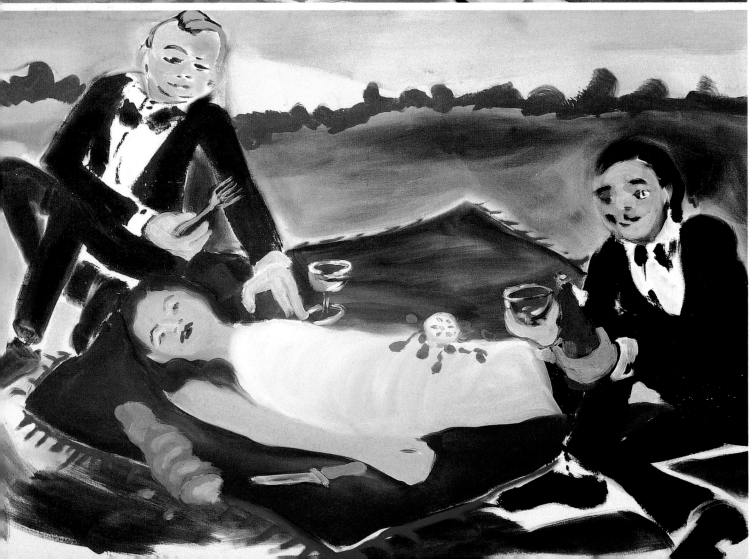

ABOVE: CANAL, 2002. ACRYLIC ON CANVAS, 270 X 150 CM.
BELOW: THE HOUSE, 2002. ACRYLIC ON CANVAS, 240 X 185 CM.

SOPHIE VON HELLERMAN

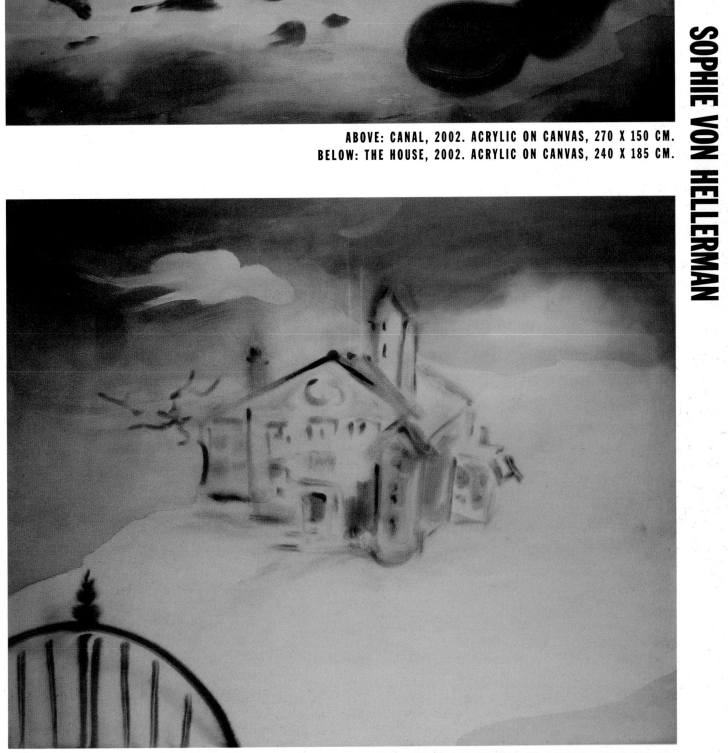

LEFT: TOP: THESE THINGS HAPPENED LAST WINTER, SIR, 2001. ACRYLIC ON CANVAS, 170 X 230 CM;
BOTTOM: WHEN HE CAME, 2001. ACRYLIC ON CANVAS, 180 X 260 CM.

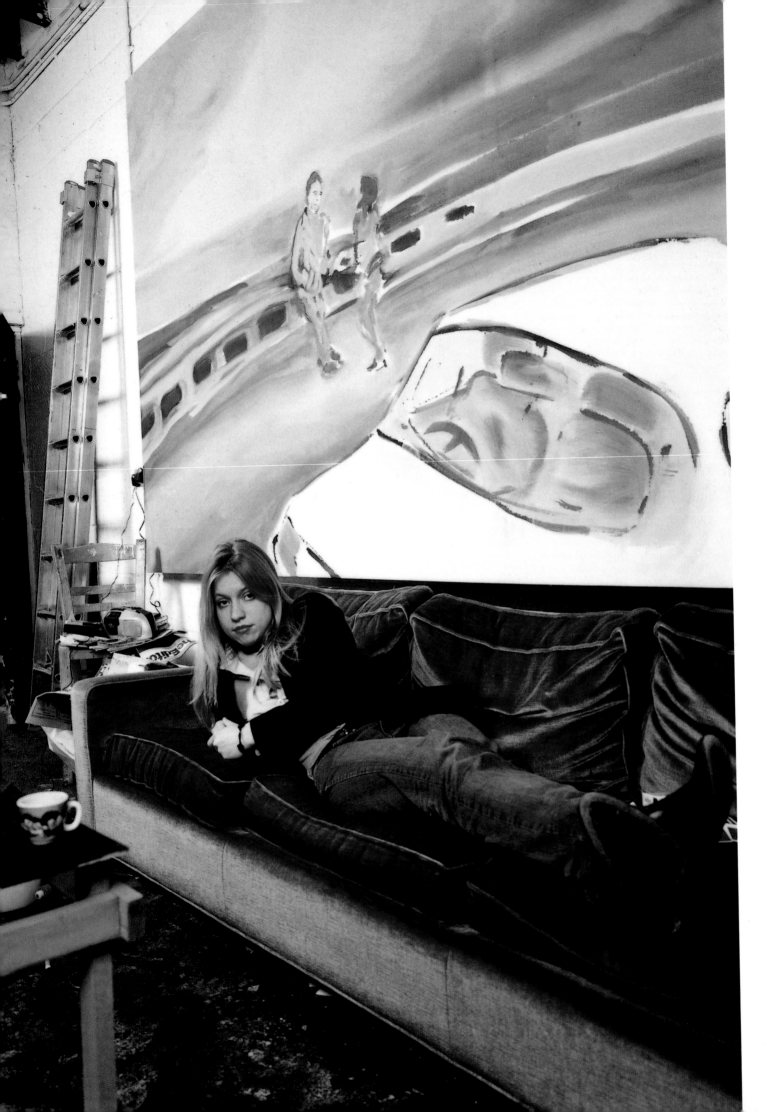

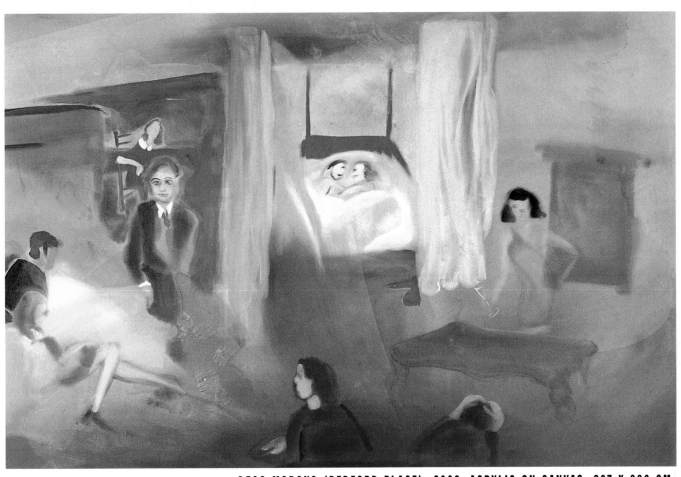

DECO MORONS (BEDFORD PLACE), 2002. ACRYLIC ON CANVAS, 267 X 366 CM.

SOPHIE VON HELLERMAN

HOWARD HODGKIN

In 1988, when I was working in the contemporary art department of Waddington Galleries, Leslie Waddington asked me to make a visit to Howard Hogdkin's studio in preparation for the artist's upcoming show. I had met Howard a few times at art openings, but only briefly. I deeply admired his work and was fortunate to have several of his paintings in my home. The morning of the visit, I awoke with butterflies in my stomach—I was going to view his new paintings and what would I say to him? I collected my nerves and jumped in a taxi. Howard greeted me with a warm smile and asked me into his home/studio. Everything was beautiful and precise and intimate. I noticed his collection of Indian paintings right away, and we talked about his trips to India and his early passion for collecting. After a while, he asked if I'd like to see his work. The jitters returned and my excitement was clearly visible.

His large white studio was bathed in sunlight, and I felt as though I was entering a cathedral. All was quiet, and the paintings were facing the walls. Slowly Howard turned them for me to view. He told me the title of each work and a little about the history of making it, and then we both stood in silence and looked at them for a long time. I still can't decide what was more intimate, standing next to him or seeing his emotions made by paint.

Howard explained that he works slowly and each painting is a product of hours, often years, of reworking and changing it until he has captured the feeling of the memory from which he is modeling the image. He sometimes works on several paintings at once. He told me that he paints on wood because of its resistance; the paint doesn't sink in and allows him to create illusionistic space.

This whole experience remains in my mind, not unlike an imaginary visit to a precious gem dealer in a secret place, who carefully unwraps brilliantly colored stones.

Howard's rich, resonant palette is like gemstones. One of my favorite of his paintings, *Waking Up in Naples,* is resplendent in its lusty pink blotches, raw wood left naked, and lush thick paint strokes that denote the aquamarine Mediterranean Sea beyond. It's a memory made real, actually hyper-real, in its emotion. I could taste and smell and touch that warm morning. It's one of the most sensual paintings I've ever seen and I always feel slightly voyeuristic when I look at it.

Working closely with Howard on his exhibition remains one of the most memorable experiences of my art career. For more than eight years, his painting *A Henry Moore at the Bottom of the Garden* hung in my study at home and gave me daily delight. It was almost as good as sitting and talking to Howard, but not quite. K.H.S.

NOVEMBER 13TH, 11.00, HOWARD HODGKIN
I was really excited that we were given the honour of photographing Howard Hodgkin. Kay said that he was absolutely charming, that he was a great friend, and if he likes you he would show you his pictures. He did not. So there we are! He told me to be quick and not to photograph his brushes. His studio is white, and all the paintings are turned round the wrong way. It was just light and bright. He said very little; the message was clear, I'm not Kay. A.E.

HOWARD HODGKIN

OLD SKY, 1996-1997. OIL ON WOOD, 39,4 X 43,8 CM.

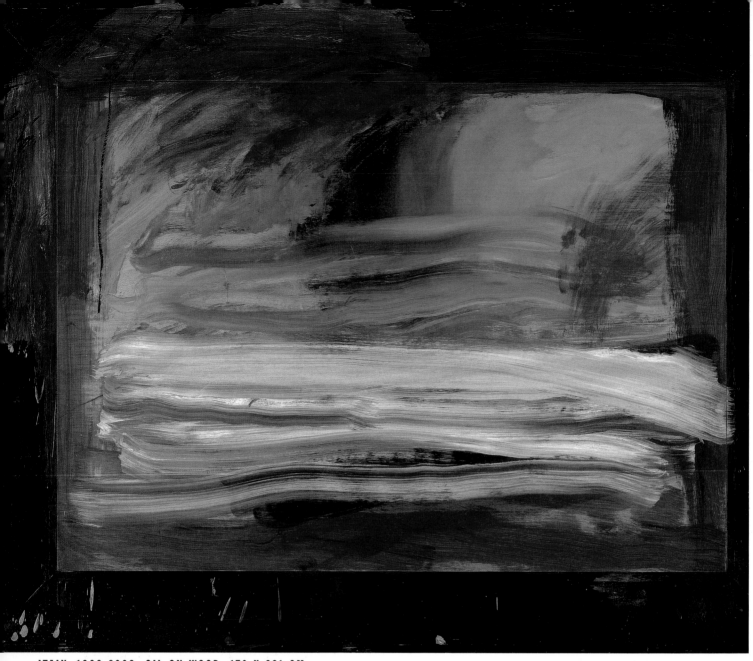

ITALY, 1998-2002. OIL ON WOOD, 170 X 221 CM.

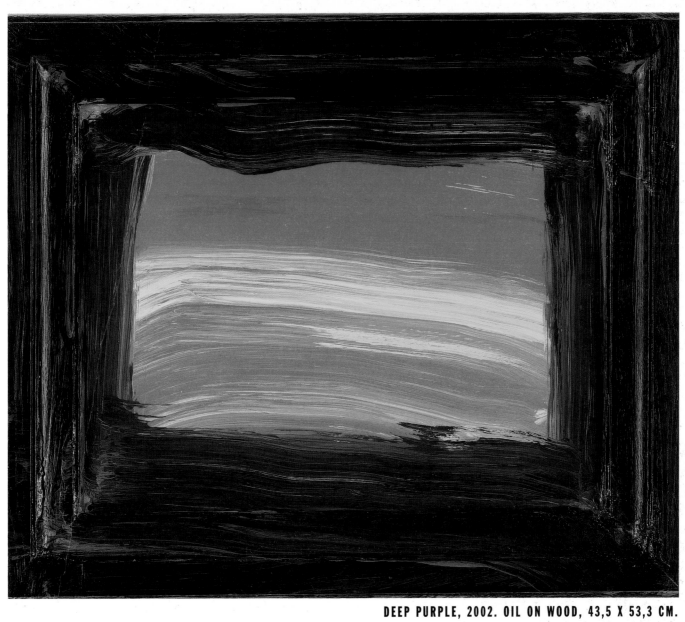

HOWARD HODGKIN

DEEP PURPLE, 2002. OIL ON WOOD, 43,5 X 53,3 CM.

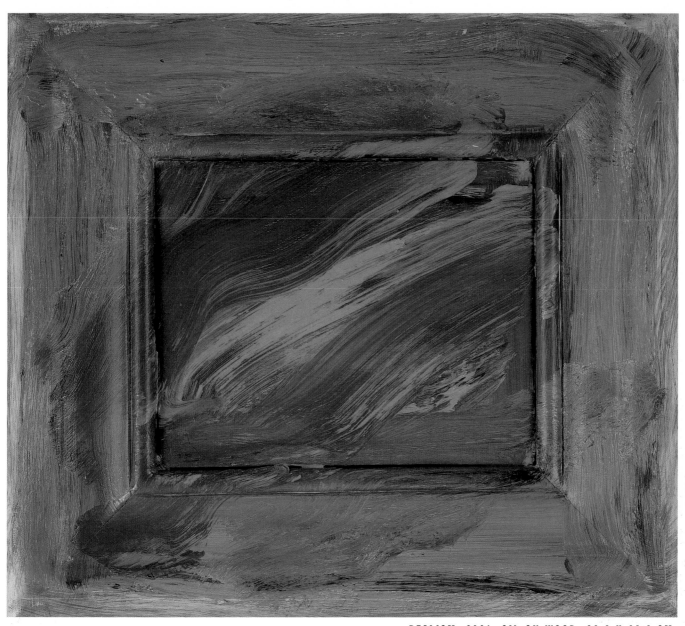

REALISM, 2001. OIL ON WOOD, 39,3 X 44,4 CM.

RACHEL HOWARD

Although Rachel Howard graduated from Goldsmiths College in 1991, she didn't start to gain serious attention until the end of the 1990s. She showed in Vienna in 1997, then at both the Saatchi Gallery and in New York in 1998. Howard makes highly seductive abstract paintings from richly coloured household gloss. She has developed a working process by which she allows the pigment and varnish to separate in the can, and then uses them as pure entities, manipulating their individual quality. Her painting style and approach follows on from the abstract colour field process painting that was prominent in the early '90s and particularly reflects the work of Callum Innes and Ian Davenport. There are also references in her use of layering to the work of 1960s New York painter Clyfford Still.

In her 2001 show at Anne Faggionato, Howard showed a new body of work that concentrated on deep vibrant reds counterbalanced by pale hues. The two contrasting tones appear to be pulling in different directions, giving the paintings an added sense of fluidity. These paintings are the outcome of three or four separate pours resulting in physically dense and visually intense curtains of colour. Their luminous, fluid appearance is at odds with the reality of their brittle varnished surface. This division of colour on the canvas, and the sheets of pigment and varnish, gives Howard's paintings a strong physical presence as the viewer is able to examine how the layers of the painting have been built up. While the look and feeling of Howard's paintings are elegant and seductive, there is a strong element of control in the way that they are made, which gives them a tough, detached quality.

MAY 29TH, 11.00, RACHEL HOWARD
Rachel didn't want to have a photograph of her eating a banana, but she looked good, so I took it and I'm using it. Sorry. She has a couple of children, works hard, is a good mother, and manages to paint. Her studio is multi-coloured. She has a bath in the corner where she mixes paint and she is happy in a cowboy hat. A.E.

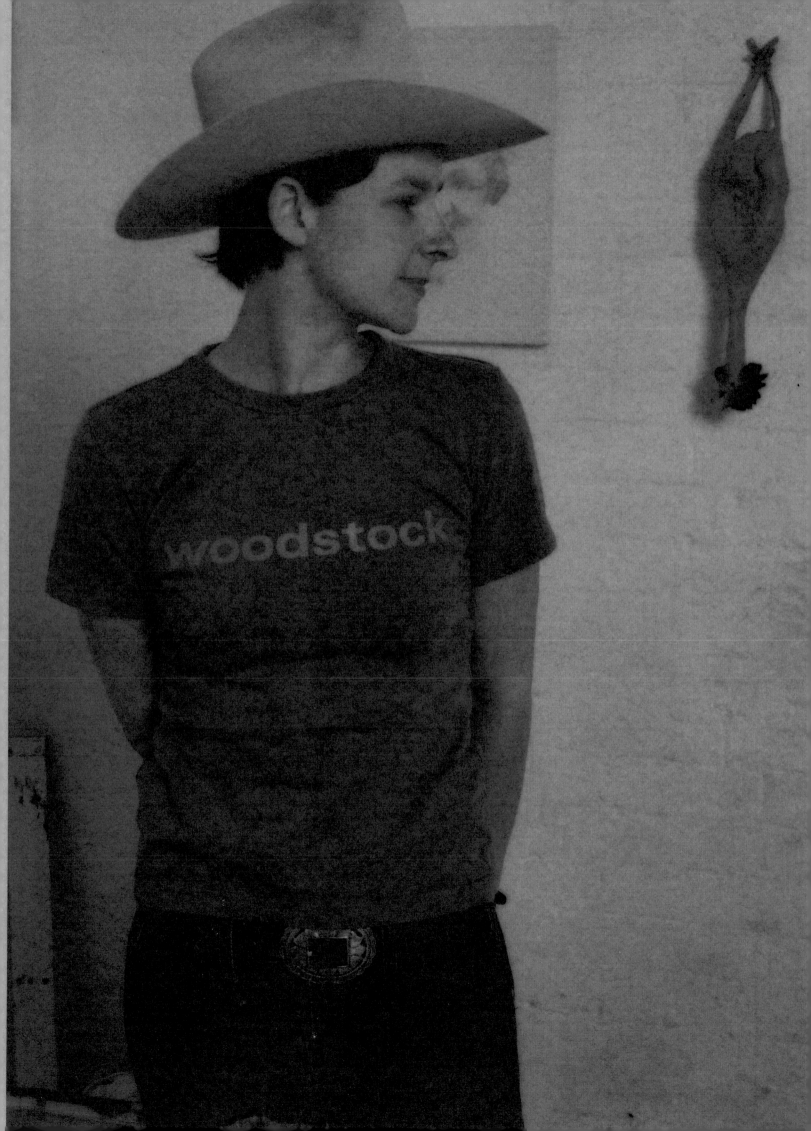

RACHEL HOWARD

ORANGE & GREEN, 2002. HOUSEHOLD GLOSS PAINT ON CANVAS, 60,9 X 60,9 CM.

MORIBUND, 2002. HOUSEHOLD GLOSS PAINT ON CANVAS, 213,3 X 213,3 CM.

RACHEL HOWARD

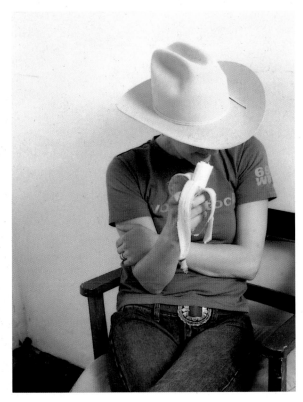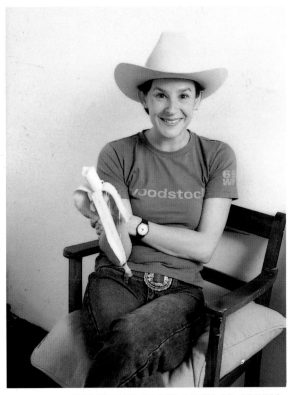

HOUSEHOLD GLOSS PAINT ON CANVAS,
30,4 X 30,4 CM (EACH).

GARY HUME

Gary Hume first became known in the late 1980s for painting the kind of utilitarian swing doors you find in hospitals, painted to scale using industrial paints and colours. He painted them as flat surfaces, so the round windows and rectangular fingerplates resemble the motifs in geometric painting. The doors were more of a conceptual idea about representation than image-based work. They brought him success, but by 1992 he felt constrained and wanted to explore other ideas, which led Hume to move to the next stage in his career, a new range of subjects, and a figurative style.

Hume continued using household gloss paint, but altered his subject matter from an unrevealing, deadpan prosaic style to an intuitive, coloured luxury of interchanging shapes and patterns. He abandoned the large colour-fields and hard shapes that referenced the detached intellectualism of Minimalist abstraction for the no-go area of beauty and decoration.

One of the first major shows to include these new paintings was the *Unbound* exhibition at the Hayward Gallery in 1994. *Tony Blackburn* (1993) and *Patsy Kensit* (1994) were portraits of well-known but almost forgotten British celebrities who are also a bit tragic. Hume chose personalities with whom the viewer could empathise as victims of the media, and celebrated them in his paintings using sickly sweet peach, pink, and yellow. He exposed himself as wanting to make decorative paintings, and his gamble paid off.

Hume's paintings consist of a few consistent elements: a strong outline, simple colour arrangements, and flatly painted household gloss. Their success comes from his precise handling of scale and unorthodox combinations of colours. Hume works from his own photographs or those taken from magazines, which he traces onto acetate and projects on aluminum panels. His paintings move elegantly between abstraction and figuration, playing on loose descriptions of emotional subjects rendered in an unemotional way. The colours look synthetic and modern. Taken from Dulux paint charts they refer to the fashionable colours of the day. Like the 1960s Pop artists, Hume chooses everyday images—pop culture icons such as Kate Moss or Michael Jackson—he also paints more traditional subjects from the history of art, working within the genres of portraiture, flowers, animals, and birds.

Hume has made several series of works, including his *Water Paintings*, which were shown in the 1999 Venice Biennale. These were made by overlaying the same linear image in different scales on top of a flat base colour, which gives these paintings the appearance of movement, distorting the picture plane, and causing the viewer's eye to jump from one image to the next.

APRIL 16TH, 3.00, GARY HUME
Gary Hume wears black sunglasses, and you immediately want to climb into bed with him. There were several huge rooms that you can tell he uses all the time and about five people working for him. The studio is behind Tracey Emin's so you have to go through one door to get to the other. Well, I think that's what I did. Anyway I didn't feel like staying long, not because I disliked him, but he kept his glasses on and hid his eyes. A.E.

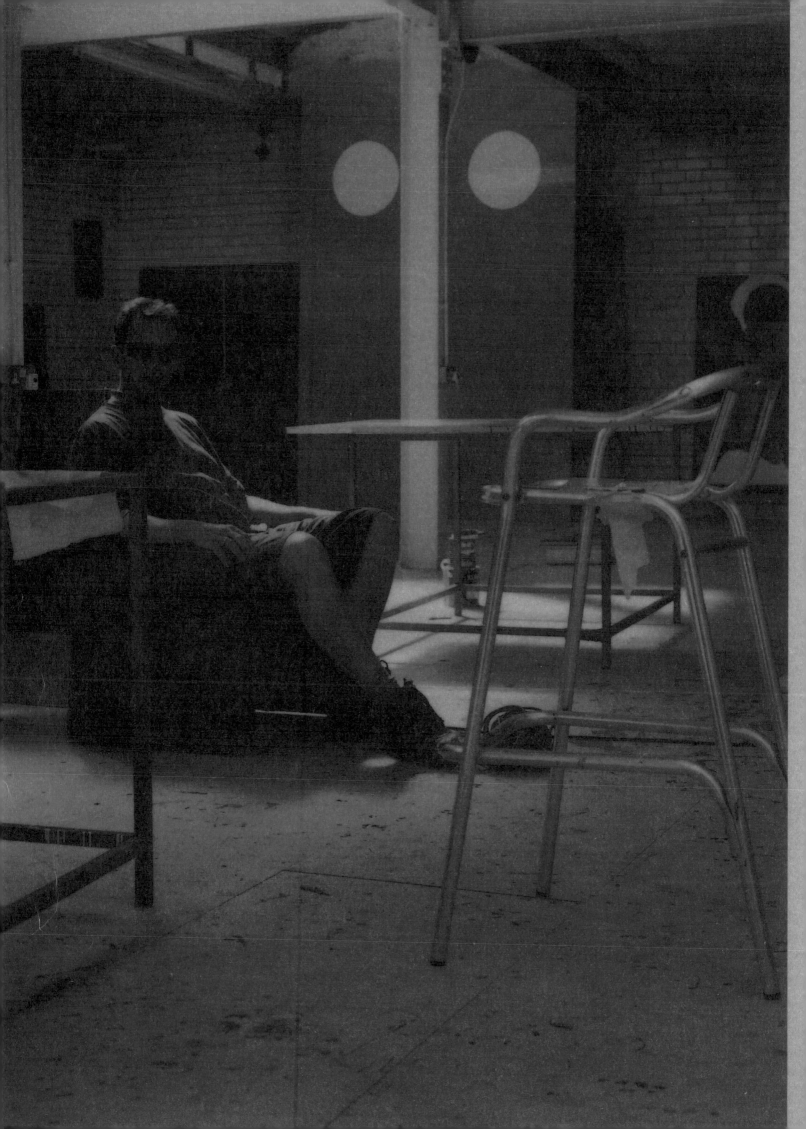

GARY HUME

WORK IN PROGRESS.

GARY HUME

ABOVE: YELLOW WINDOW, 2002. GLOSS PAINT ON ALUMINIUM, 135 X 98,1 CM.
LEFT: THE MOON, 2002. GLOSS PAINT ON ALUMINIUM, 138 X 99 CM.

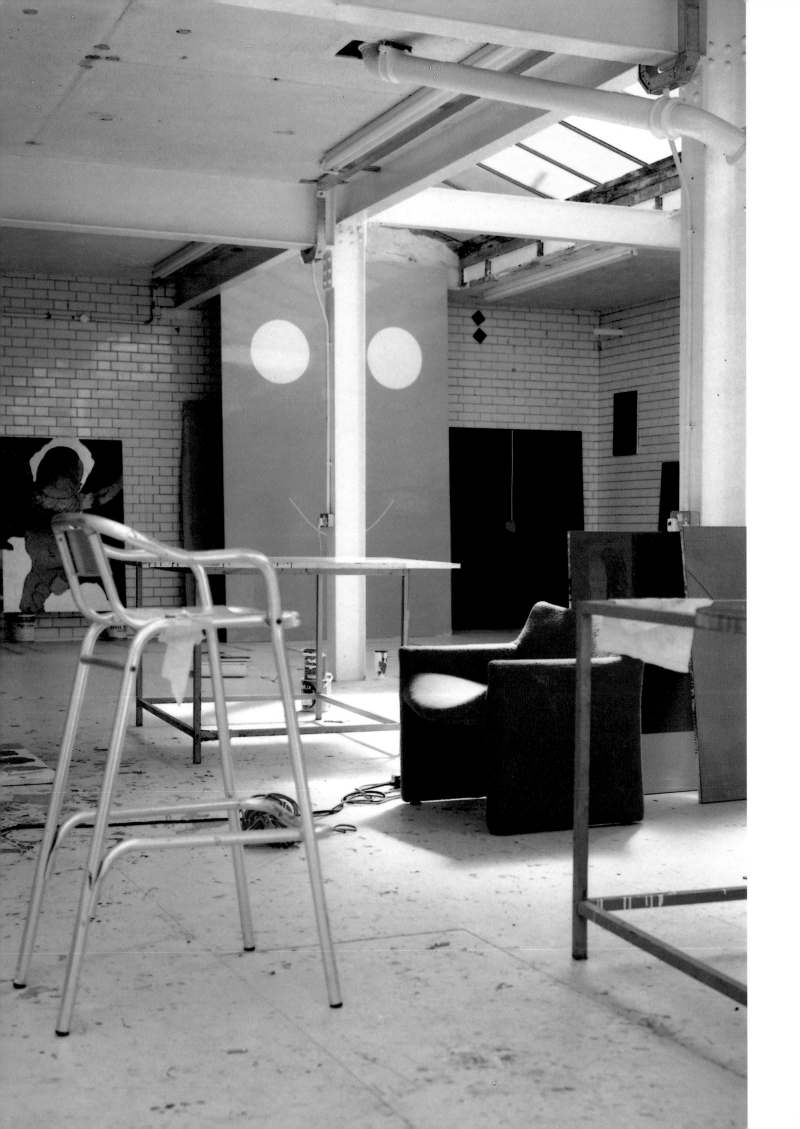

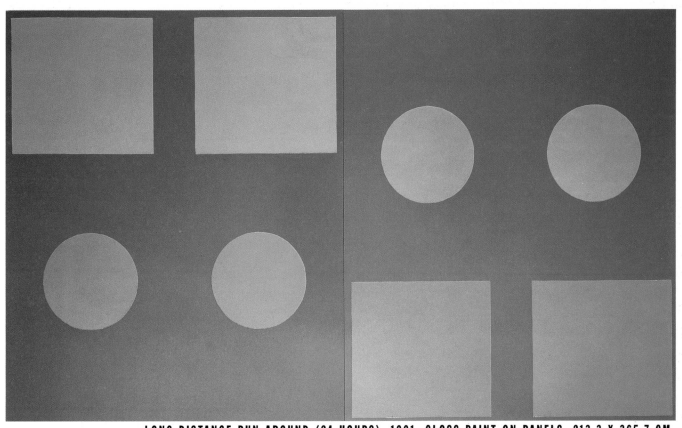

LONG DISTANCE RUN AROUND (24 HOURS), 1991. GLOSS PAINT ON PANELS, 213,3 X 365,7 CM.

GARY HUME

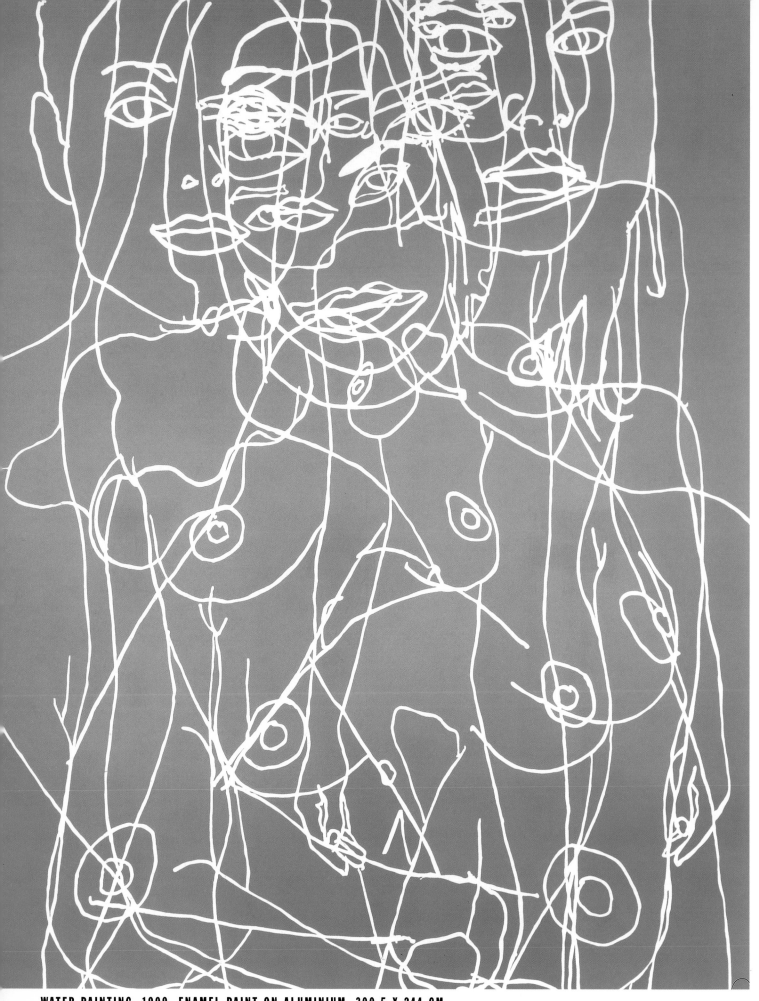

WATER PAINTING, 1999. ENAMEL PAINT ON ALUMINIUM, 300,5 X 244 CM.

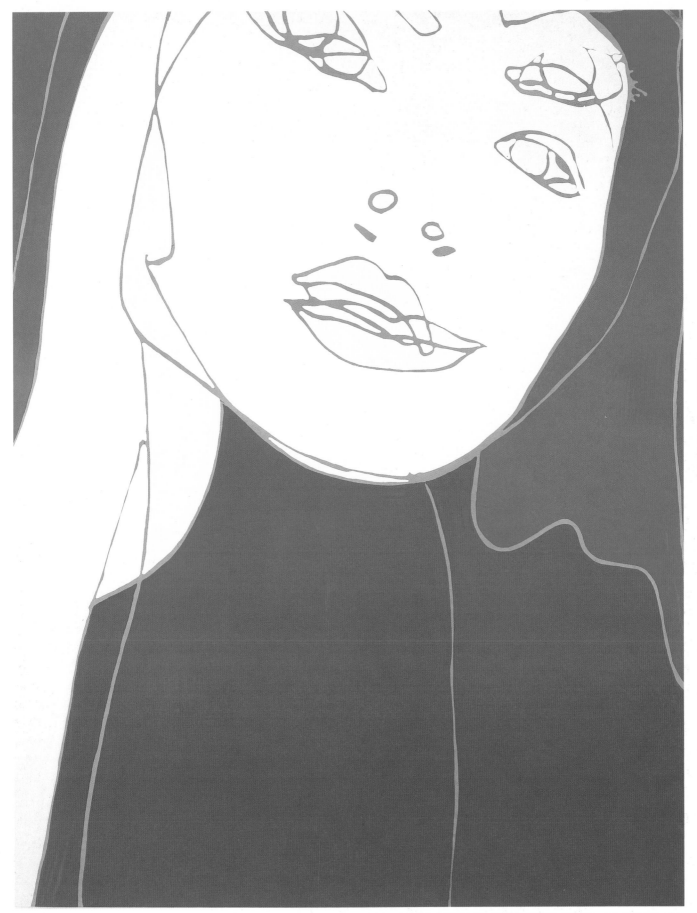

GARY HUME

WOOD MARI, 1999. GLOSS PAINT ON ALUMINIUM PANEL, 94 X 73,5 CM.

RUNA ISLAM

Runa Islam works in a range of media concentrating on film, video, and photography. She creates large single- or multiple-screen installations that examine different cinematic languages and styles from throughout the history of film. Islam is interested in the way in which narrative is constructed to imply meaning through filmic devices. She often dismantles moments from existing films—particularly those with a heightened emotional tension between characters—in an analytical way.

In *Tuin* (1998) Islam remade a pivotal scene from Fassbinder's film *Martha* (1973), in which a man and a woman walk up to and then past each other without making any physical or verbal contact. Islam initially chose to remake this passage of film to experience the way in which a 360-degree method of filming is employed to revolve around the couple as they cross paths. As part of the final installation, Islam shows on an adjacent wall a black-and-white video projection filmed by the two actors as they walk toward and away from each other. This additional material reveals how the scene is set up. Islam has demystified the camera trickery of a filmic moment, and this deconstruction of the original scenario is as important to her as the process of reconstruction.

In her 2001 solo show at White Cube, Islam showed *Director's Cut (Fool for Love)* (2001). To make the installation, Islam set up a group of actors and a director rehearsing scenes from Sam Shepard's play *Fool for Love.* She presented two screens alongside each other that show various views of the stage, moving between the actors, the director, and the understudies. The dual screens provide different interpretations of what is happening as the relationships build between the actors through their role-playing, and simultaneously between the actors and the director as he shapes their characters. The cross-relationships increase the emotional stress as does the repetition of certain scenes and dialogue. In one instance the actress and her understudy shout, "I love you! I love you!" as the actor and his understudy echo emphatically with, "I hate you! I hate you!" *Director's Cut (Fool for Love)* is tightly controlled by the artist, but the viewer, consumed with following the relationships and the evolving story in an apparently straightforward rehearsal, is oblivious to the fact that Islam is the real director.

APRIL 3RD, 11.00, RUNA ISLAM
Runa Islam is a beauty, and I felt for her as my assistant was so in love with her that he was bright red during the whole of my shoot. He said he could have stayed all day. I couldn't stay, the place was too small, there were piles and piles of film on a bunk bed in the corner. I wanted to get out, she was too pretty. Glances were exchanged and she scribbled him a note in a book. A.E.

RUNA ISLAM

DIRECTOR'S CUT (FOOL FOR LOVE), 2001. MULTIMEDIA PROJECTION, DIMENSIONS VARIABLE.

RUNA ISLAM

PROP, 2001. NEON, 19 X 57 X 15,24 CM.

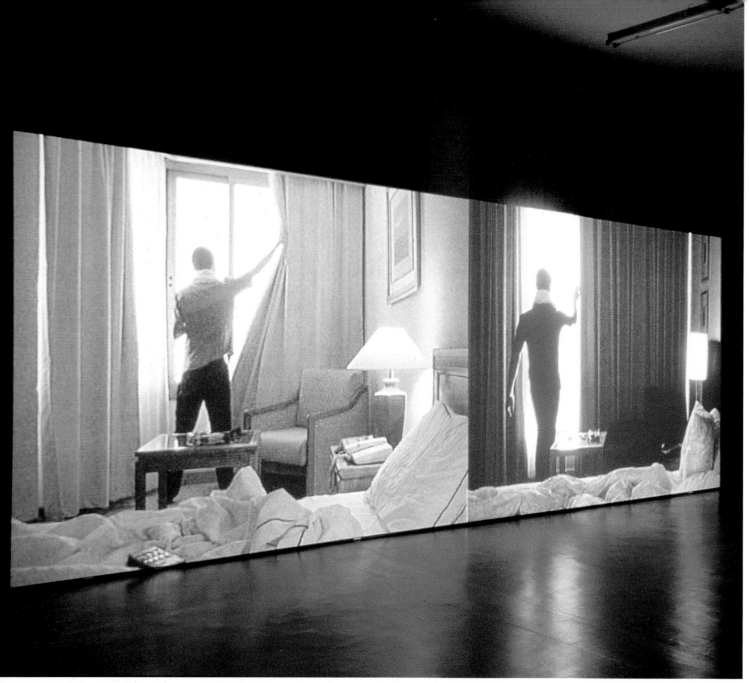

PARALLEL, 2001 . DVD (2 SCREEN PROJECTION), DURATION 31 MINUTES 8 SECONDS.

RUNA ISLAM

TOP: TUIN (DETAIL), 1998. 16 MM FILM, VIDEO (DVD) AND SOUND (CD), DURATION 6 MINUTES LOOPED.
BOTTOM: DIRECTOR'S CUT (FOOL FOR LOVE) (DETAIL), 2001. MULTIMEDIA PROJECTION, DURATION 17 MINUTES.

CHANTAL JOFFE

Chantal Joffe is a graduate of The Royal College of Art and a traditional oil painter working in the genre of portraiture, but her subjects and compositions owe more to modern film and photography. Joffe first became known in the mid-1990s for her small-scale portraits and porn paintings. She painted her subjects in a fluid, expressive way, verging on caricature. While most artists make large paintings to attract attention, it was the small size of Joffe's paintings that got her noticed. Her work had a strength in numbers presence.

Although they appear to be simple oil sketches, each of Joffe's paintings describes a different person with a strong personality coming through. Her subjects are united through her expressive style—every girl, boy or adult is described with what seems like minimal effort. Their informal poses are summed up in a matter of a few strategic brushmarks. Seen together, these portraits of strangers become a visual roll call of anonymity and false nostalgia. Joffe also uses images from pornographic magazines to make her paintings. They are like short, sharp flashes that look as if they have been ripped out of magazines and painted over in quick gestures, then arranged in a grid. The energy and fluidity of her painting style masks the tackiness of the original imagery and gives it a glamorous feel similar to a sexy Dolce & Gabbana advertisement. She examines ideas about female beauty by using explicit porn and its blank, faceless female bodies to contrast with a sophisticated painting style that covers up the grim reality with seductive brushmarks and color arrangements. Joffe shares the small scale and sketchy naive painting style used by American artists Elizabeth Peyton and Karen Kilimnik without romanticizing her subjects. There is something more sinister at play in Joffe's work. Recently she has moved toward larger paintings of informal group portraits set against collaged landscapes, which adds a storybook narrative.

APRIL 9TH, 1.30, CHANTAL JOFFE
Chantal Joffe's studio was the opposite; her floor was a mixture of dog food and newspaper. Her paintings that day were completely different from the paintings in this book, and it was interesting to see work in progress. Chantal felt very Notting Hill Gate, she was cuddling her Yorkshire Terrier and trying to be cheerful, but you felt it was fake, and I thought, "Thank God artists have the same mood swings that I do." A.E.

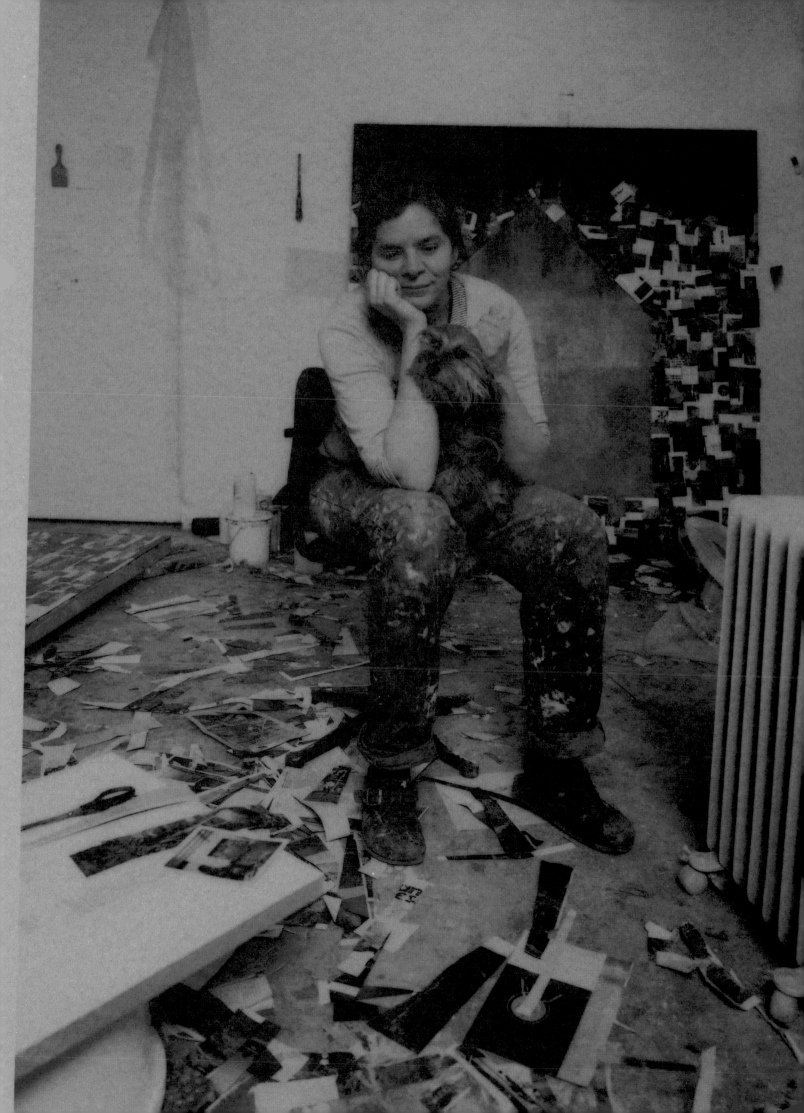

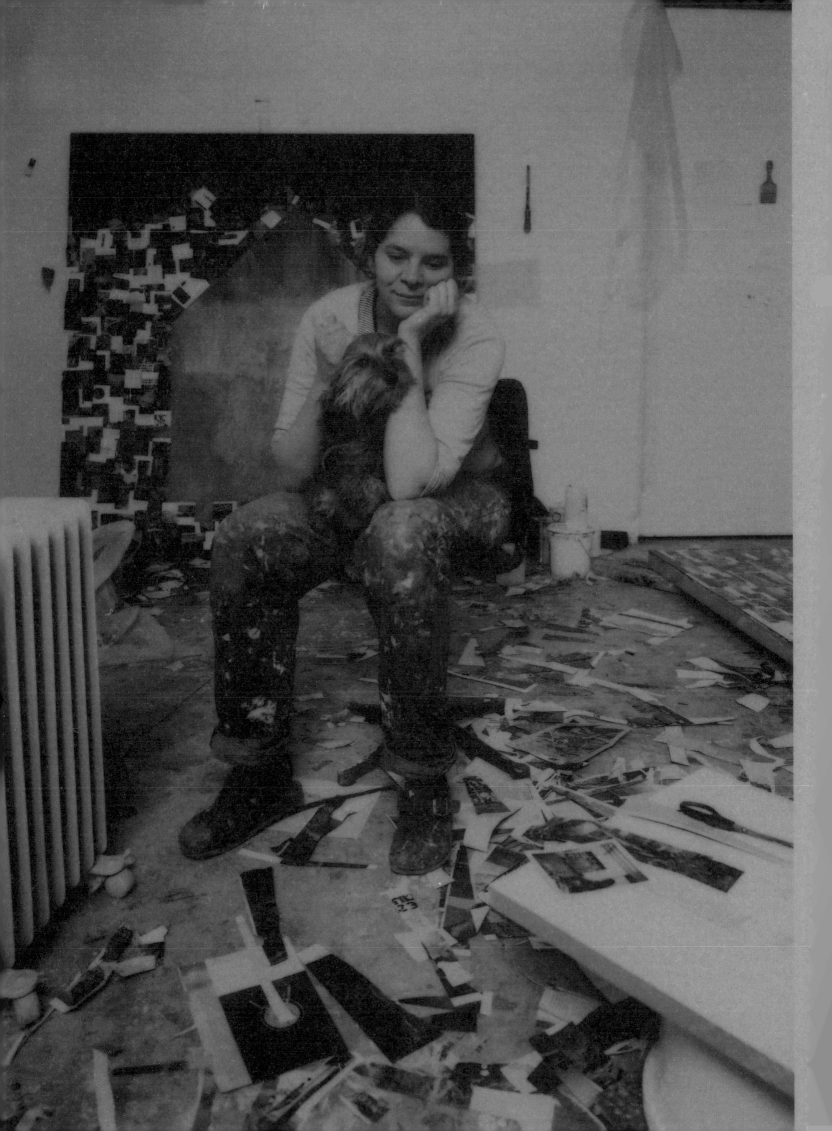

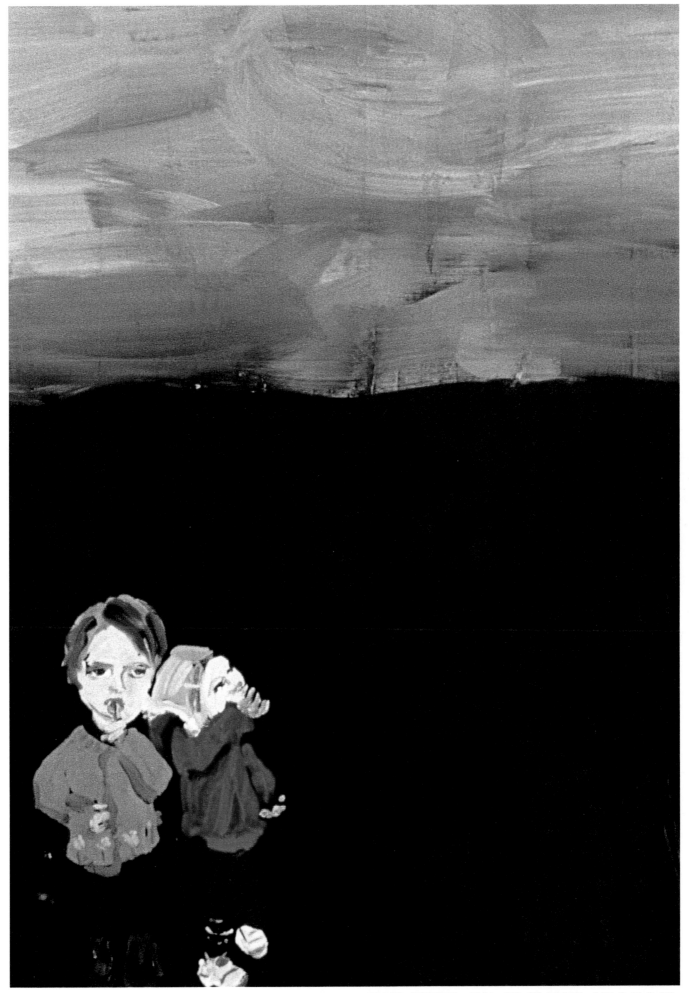

CHANTAL JOFFE

NORTH (DETAIL), 2001. OIL ON BOARD, 305 X 91,5 CM.

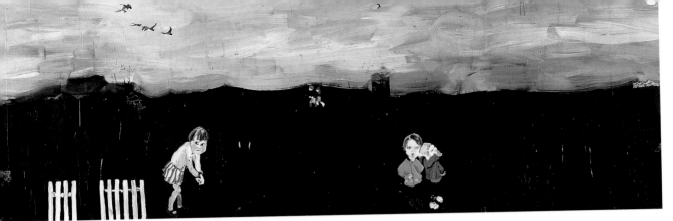

NORTH (DETAIL), 2001. OIL ON BOARD, 305 X 91,5 CM.

DON'T LET GO, 2001. OIL ON BOARD, 111 X 172,5 CM.

FIGHT, 2001. OIL ON BOARD, 111 X 172,5 CM.

ROAD, 2001. OIL ON BOARD, 305 X 91,5 CM.

CHANTAL JOFFE

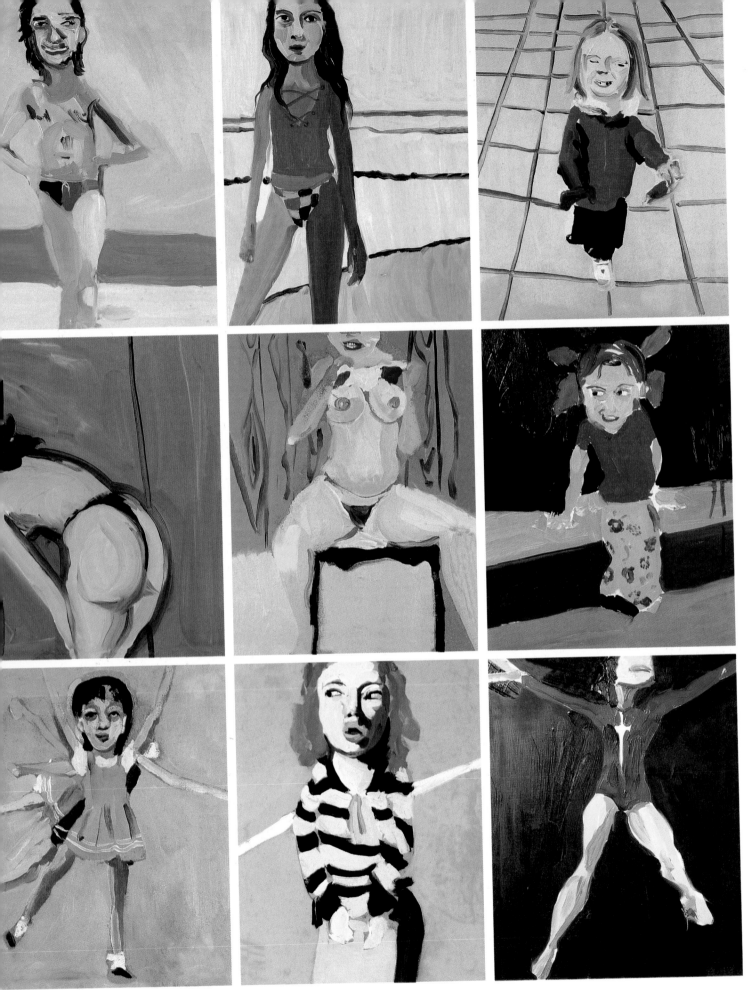

FROM LEFT TO RIGHT, FROM TOP TO BOTTOM : OILS ON BOARD.
UNTITLED, 1999 (22 X 29 CM); UNTITLED, 2001 (46 X 30 CM); UNTITLED, 2001 (21 X 29 CM);
UNTITLED, 1999 (22 X 29 CM); UNTITLED, 2001 (21 X 29 CM); UNTITLED, 2001 (22 X 29 CM);
UNTITLED, 2001 (21 X 29 CM); UNTITLED, 2002 (21 X 29 CM); UNTITLED, 2001 (21,5 X 29 CM).

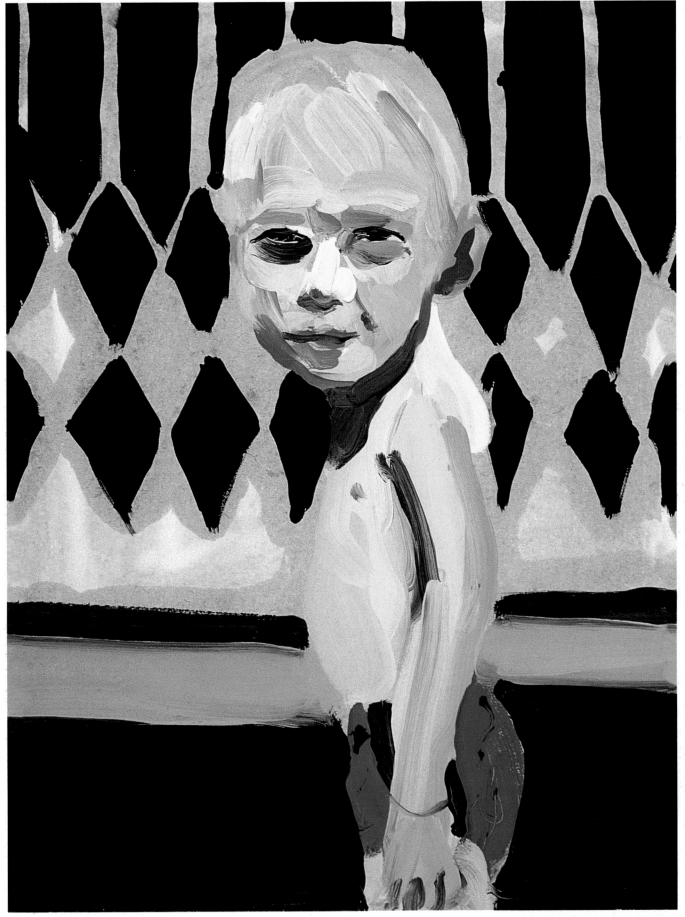

CHANTAL JOFFE

UNTITLED, 2000. OIL ON BOARD, 29 X 22 CM.

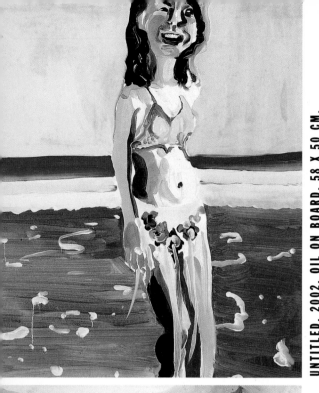

UNTITLED, 2002. OIL ON BOARD, 58 X 50 CM.

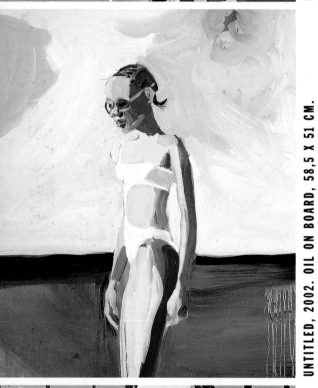

UNTITLED, 2002. OIL ON BOARD, 58,5 X 51 CM.

UNTITLED, 2001. OIL ON BOARD, 30 X 30 CM.

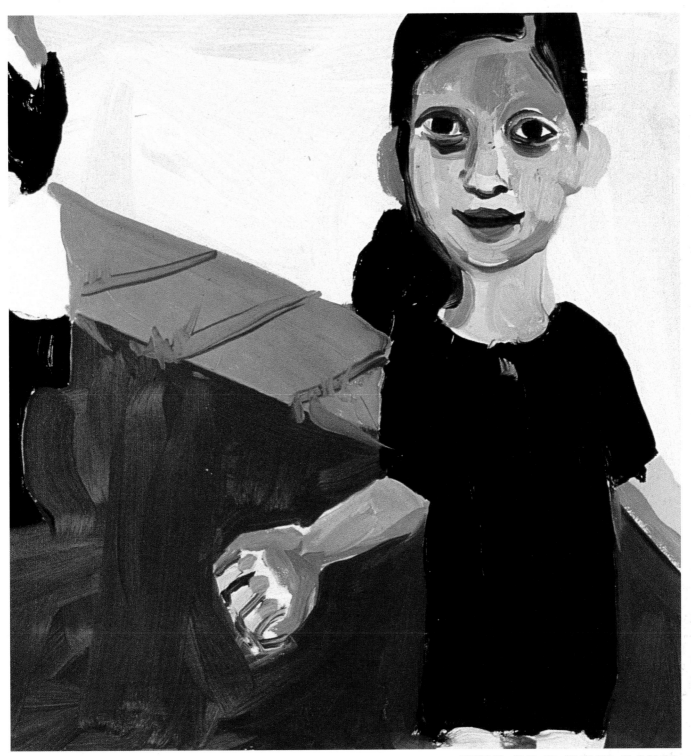

CHANTAL JOFFE

UNTITLED, 2001. OIL ON BOARD, 30 X 30 CM.

SARAH JONES

Sarah Jones graduated from Goldsmiths College with a BA in 1981 and returned to complete an MA from 1994 to 1996. She is best known for her photographs of girls standing, sitting, leaning, or lying in posh houses. They look like bored middle-class teenagers with shoulder-length hair and drab clothes. She treats these figures as objects by using them as formal components in highly arranged compositions. The girls take on the inanimate quality of an item of furniture. Influenced by the Canadian photographer Jeff Wall and the Dutch artist Rineke Dijkstra, Jones has found her own way of showing the vulnerability of pre-pubescent girls and adolescents through photographs that explore narrative and portraiture.

Jones is interested in looking at traditional art genres in a contemporary way. In photographs such as *The Dining Room (I)* (1996), *The Dining Room (II)* (1996), and *The Dining Room (III)* (1996), she reconsiders the subject matter of English eighteenth-century paintings of the daughters of the landed aristocracy but adds a touch of the languid quality of John Singer Sargent. These photographs have a static, graphic quality that Jones achieves through sharp focus. Their saturated colors are intense and give her images an atmosphere of artificiality. They offer, perhaps, a Marxist critique of wealth or a feminist attack on the confined role allocated to upper middle-class women.

Jones likes to capture the moment when something is about to change, and asks her viewers to notice the subtlety of that. She doesn't tell us very much in her photographs. In *Consulting Room (Couch A)* (1996), a psychiatrist's couch has had its cushion dented by an unseen patient. You have to speculate about the relationship between the person and the things pictured. Jones is intrigued by the uncomfortable moment and the relationship between sitter and setting. The rigour of her thinking is hidden—but while Jones shows an interest in the stylized, staged image, the deadpan look, and the blend between documentary and fiction, she has more to offer than just summing up the collective look of photography now.

APRIL 11TH, 11.00, SARAH JONES
Sarah Jones never said a thing, I didn't know what to make of her. One of my assistants worked for her and said it was an experience and that she was slow. Her environment made me want to join the queue for her psychiatrist's couch. A.E.

SARAH JONES

THE PARK (II), 2002. C TYPE PRINT ALUMINIUM, 130 X 170 CM.

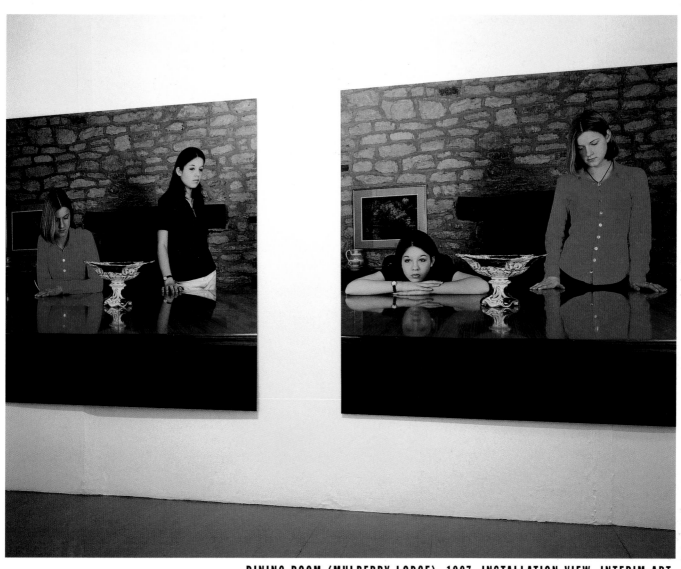

DINING ROOM (MULBERRY LODGE), 1997. INSTALLATION VIEW, INTERIM ART.

SARAH JONES

ANISH KAPOOR

Anish Kapoor was born in India in 1954. He moved to London to study art and attended Hornsey College of Art from 1973 to 1977 and Chelsea School of Art from 1977 to 1978. When Kapoor emerged as a sculptor in the 1980s he was soon recognized as a key figure in contemporary British art. He showed with the Lisson Gallery, represented Britain at the 1990 Venice Biennale, and won the Turner Prize the following year.

He is best known for his elegant, unfussy sculpture which combines solid materials with soft edges. He has used materials such as stainless steel, stone and fibreglass, and often saturates his work with pure pigments, creating three-dimensional monochromes. In doing this he gives cold materials the appearance of sensuous objects rich in colour. In 1998 Kapoor presented a major exhibition of his work at the Hayward Gallery. The most impressive work on show was *At the Edge of the World II* (1998), a dark red dome eight meters in diameter. Visitors stared up inside the work, unable to see beyond a certain point. Like much of his work, this piece demonstrated Kapoor's interest in how objects that fill space in a certain way can spark a psychological response in the viewer. Titles such as *The Fear of Oblivion*, or *At the Edge of the World II* (1998), refer to physical voids as well as psychological space. Each work is incorporated into the floors or walls or stands alone in a space and has to be negotiated in a particular way, whether walked round, looked up or down at, or peered into. Rather than describe a sublime experience, Kapoor's aim is to involve his viewer with his work.

Kapoor has made a number of public sculptures in which he is able to reconstruct the intensity and physical presence of his gallery works on a vast scale. He appears to be as comfortable working in large scale as he is in small. In 1999 Kapoor made *Taratantara* for the Baltic Centre for Contemporary Culture in Gateshead before the site had been renovated. He filled the building with a 35 by 50 meter deep red PVC structure, taking the opportunity to follow the architecture of the space rather than place an object inside it. This work was matched by his even more ambitious *Marsyas*, which was made for the Turbine Hall at Tate Modern in 2002. *Marsyas* comprises a specially created red plastic fabric connected to three steel rings. Kapoor has said of this work that he wanted the material to represent a bloodlike membrane as a way to recall the body. The fleshy "skin" of the work also relates to the title. In Greek mythology Marsyas was flayed alive by the god Apollo.

JULY 23RD, 10.00, ANISH KAPOOR
Anish Kapoor has four or five studios that are so huge you don't know where to start. Vast sculptures lie around and look like vaginas and on his shelves are spiritual books. Clearly he likes to have a deep understanding about life. He has a whole army of people working for him, and I wish he would be given the job of building a playground for children because I have a huge desire to slide down his piece in the Tate Gallery. But maybe they are too sexual because they certainly leave you with a desire to make love. He is a leader and I'm sure a friend of Deepak Chopra. A.E.

ANISH KAPOOR

AT THE EDGE OF THE WORLD II, 1998. FIBREGLASS AND PIGMENT, 800 X 800 CM.

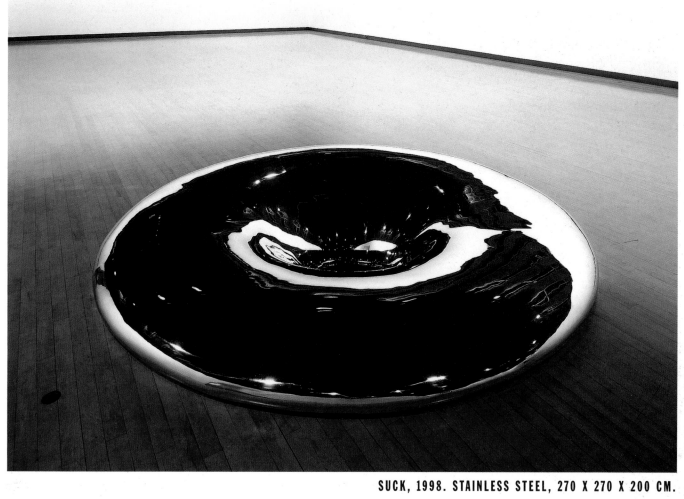

SUCK, 1998. STAINLESS STEEL, 270 X 270 X 200 CM.

ANISH KAPOOR

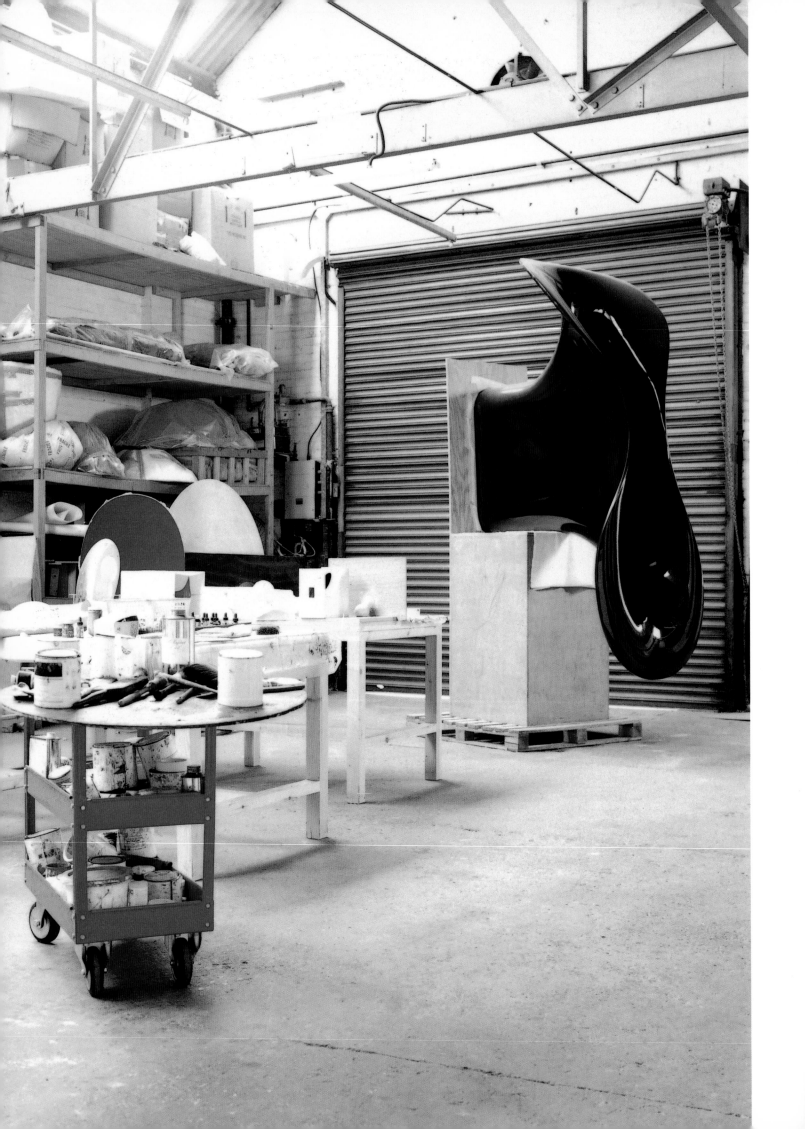

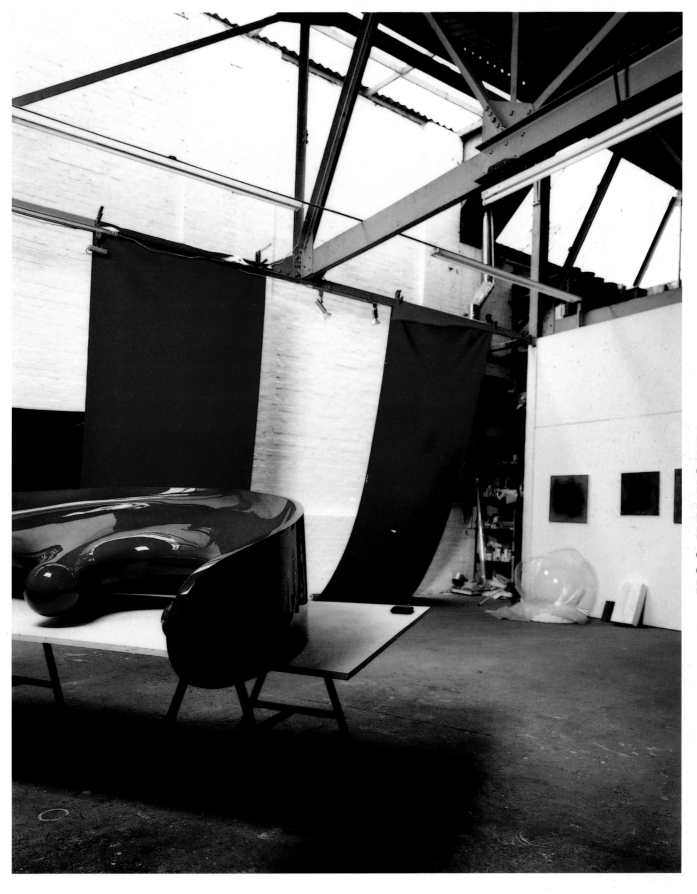

JIM LAMBIE

After playing in bands and hanging around with artists, Jim Lambie decided to go to art college himself and studied sculpture at Glasgow School of Art. There is a direct reference to the influence of music on his work which he brings into his practice without letting it take over to become art about music. Lambie's work has a kind of "bedsit" aesthetic where everything is made from second-hand shop style memorabilia. He makes sculptures out of things you might collect, such as belts, records, buttons, beads, speakers, or album covers. The result is the ready-made remade, it's a bit punk, a bit indie-kid, and a lot 1960s psychedelia.

There is always something lo-fi in the work, even when he makes video. In *Ultra Low* (1998) what at first looks like a light-manipulated piece is actually made from overlaid images of Lambie lighting cigarettes and smoking in the dark. It's as if he's bypassed technology, in the "cds will never replace vinyl records," nostalgic kind of way. The viewer identifies with Lambie's work through the materials and everyday objects he uses and recognizes these before having to think about the artistic connotations. For example, in *She's Lost Control* (2002) he placed eleven colored speakers of varying sizes in a row along the wall at a certain height. The work reflects upon the ideas of Minimalism, but is made from modern functional objects.

Lambie's most well-known work is called *Zobop* (showed in Scotland, London, and New York), in which he took brightly colored vinyl tape and laid it around the gallery floor, working from the outside in, following the architecture of the space. It existed like a flattened sculpture as well as a painting on the floor, and the vibrant colors and zig-zagging lines combined Op Art with installation. *Zobop* is his way of filling a space without putting an "object" in it. Lambie's works have an authenticity that cannot be faked, in part because he has used existing objects, but mostly because he turns them into something completely new.

APRIL 25TH, 11.00, JIM LAMBIE
Jim Lambie does not have a studio in London; he has moved to New York. He had just had a show at the Sadie Coles Gallery and when I saw him he was busy being photographed. He looked like Iggy Pop. A.E.

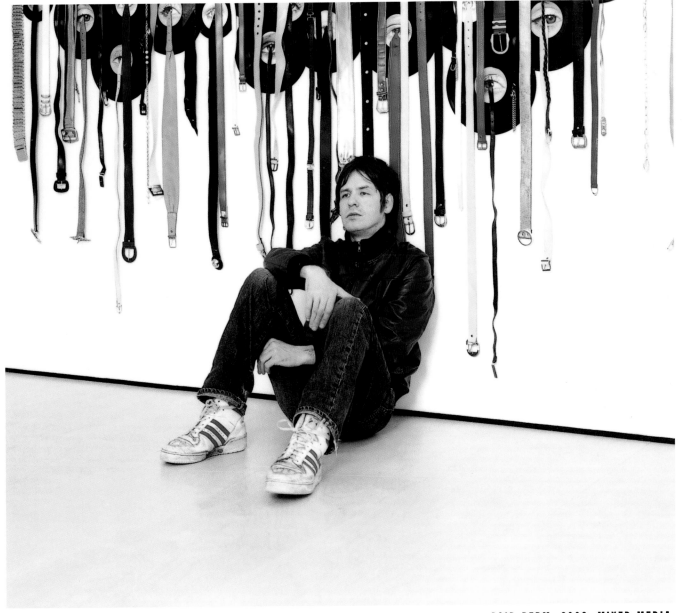

JIM LAMBIE

ACID PERM, 2002. MIXED MEDIA.

TANDOORI NIGHTS, 2002. ALICE BANDS AND GAFFER TAPE, 109 X 76 X 50 CM.

JIM LAMBIE

ZOBOP, 2002. GOLD, SILVER, BLACK AND WHITE VINYL TAPE, DIMENSIONS VARIABLE.

BED-HEAD, 2002. MIXED MEDIA, 94 X 190,5 X 20,8 CM.

SHE'S LOST CONTROL (DETAIL), 2002. SPEAKERS, FABRIC, MIRROR PLEXIGLASS, 56 X 259 X 19,8 CM.

JIM LAMBIE

PETER LIVERSIDGE

From the carpeted floor, shelves lined with *National Geographic* magazines, and cactuses along the windowsill to the sound of obscure alt-country music playing, Peter Liversidge's studio is a home from home. This domesticity and quirky setting suits the scale and subject matter of his work. Made on small off-cuts of board or aluminum, Liversidge's paintings describe the ideal duty-free extravagance: expensive watches, diamond rings, and Nikon, Polaroid, and Pentax cameras. He also paints airplanes, which he copies from advertisements; his clumsy renditions are wonky and out of proportion, the airline logos are practically sliding off the tail. Each painting's title is taken from the slogan that accompanies the ad. *Representing the Best This Country Has to Offer* (1999) depicts the tail of an Air Canada plane, and *The Impeccable Seiko Commitment to Total Quality* (1999) shows a flashy wristwatch that, in his hands, resembles a free toy from a Christmas cracker.

Liversidge mocks both his own failings as an artist and the claims made by corporations selling the luxury lifestyle. He plays on his inability to produce grand-scale painting as his way of making a critique of corporate identity. Liversidge removes the appeal and desire for such extravagant objects as he infuses their slick graphic quality with the sensitivity of the handmade. He shows the contradiction between simultaneously wanting and hating the decadence of expensive lifestyle accessories. He is a bedroom dreamer playing out the lyrics of his Will Oldham songs in his art. He fights capitalism yet admires adventure and glamour.

Liversidge studied film and photography at Plymouth University from 1993 to 1996 but only started making painting and sculpture in 1997. While his paintings look like those of a talented teenager, his subject matter reveals his intentions are those of a clued-up contemporary artist. Tapping in to the look of the work in Jim Shaw's thrift-store painting collection, Liversidge's work has an obvious self-conscious naivete in how they are made rather than the confident brushwork found in abstract painting or photorealism. In his more recent work, Liversidge has painted landscapes of the northern plains of Montana, a scenic area near where he lived while studying in America, but that he never actually visited. His depictions are filled with imaginary atomic explosions and UFO abductions, as well as natural disasters and animals that don't actually exist in that area. Because of his regret that he never went to the northern plains, the paintings are even more sentimental. This series broadened his range and provided him with additional subject matter, which he tries to transform into what ever he wants it to be.

APRIL 9TH, 11.00, PETER LIVERSIDGE
Peter Liversidge has had several interviews in magazines. He is the sort of guy you sit and have cups of tea with on wet Monday afternoons. I am sure he knows all about black-and-white movies and Bach. A.E.

Darkness is the cover for all kinds of evil on the North Montana Plains

Darkness is the cover for
all kinds of evil on the
North Montana Plains

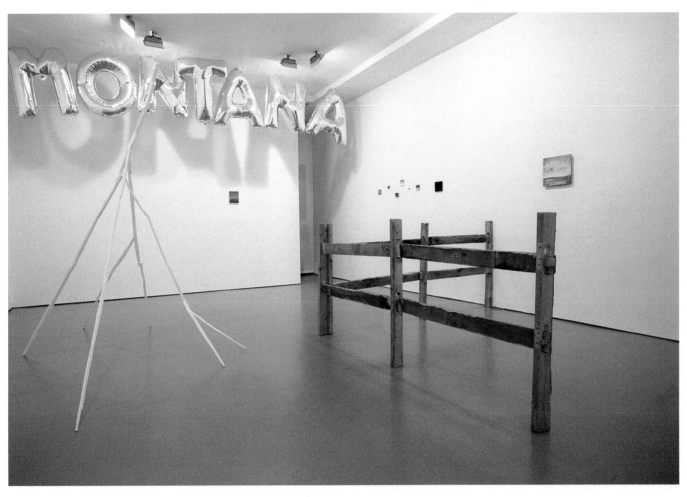

INSTALLATION AT RARE, NEW YORK, 2001.

MADE IN GERMANY, 2001.
WATERCOLOUR MPF, EMULSION, 46 X 46 CM.

PETER LIVERSIDGE

MIDDLE: IN HIDING ON THE NORTH MONTANA PLAINS, 2000, 2,5 X 4 CM; APPROACHING DANGER ON THE NORTH MONTANA PLAINS, 1999, 66 X 89 CM. BOTTOM: ALL IS QUIET ON THE NORTH MONTANA PLAINS (2 DETAILS), 2002, 38 X 42 CM. ALL: WATERCOLOUR MPF, EMULSION.

THE PERPETUEL EXPLORER, 2002. SPRAY PAINT, PERSEX ACRYLIC, ACRYLIC PAINT, 22 X 18,4 CM.

PETER LIVERSIDGE

KODAK INSTAMATIC, 2001. CARD, HOT GLUE, ACRYLIC PAINT, 9 X 12,9 X 7 CM.

MARTIN MALONEY

Shortly after Martin Maloney left Goldsmiths College in 1993 he set up his own gallery in his house, Lost in Space, which ran from April to December 1995. The work he selected to show reflected his interest in a hands-on, romantic approach to making art, including diverse work by up-and-coming graduates alongside his own. Setting up an alternative space is a path that rarely leads anywhere big; but for Maloney, his understanding of contemporary art mainlined him into London's West End public and commercial spaces. Lost in Space led to guest-curator positions for Maloney at Karsten Schubert, the ICA, and Anthony d'Offay galleries. His Goldsmiths education had taught him how to judge art; he knew what constituted success and failure and how to put together a show that had a look of its own. In his teaching methods, Maloney transferred the skills he had learned from Michael Craig-Martin and helped his students find their potential. He was also recognised as a critic—he wrote for a number of international art magazines in a refreshing, no-nonsense way.

Frequent visits to New York as a student had given Maloney an advantage over his British contemporaries as he tapped into trends that hadn't yet surfaced in the UK. Maloney liked the work of New York painters Sue Williams, John Currin, and multimedia artist Karen Kilimnik and found inspiration from the ways they approached figurative imagery. Maloney employed gestural expressionism sincerely and seriously, knowing it was not the norm and that people saw it as retrogressive. His work looked emotional and slightly dysfunctional in its awkward drawing style, but was made in a very clear, understandable way.

In *Genre Painting* in 1997 Maloney showed a series of works inspired by seventeenth-century Dutch genre painting. His paintings depicted single figures engaged in daily activity—watching TV, dressing, cooking, or reading. He turned the traditional format of an informal portrait into the life story of a single thirty-something professional. The paintings invite you into someone else's world with the reality of a documentary photograph. His subjects mix the comic and tragic in compositions made from simple color arrangements, a few selected details, and the controlled freedom of expressive and intuitive painted gestures. In 1998 Maloney's series of paintings titled *Sex Club* shocked an audience who were used to seeing his portraits, flowers, cats, and sideways looks at Poussin through the eyes of pop. *Sex Club* was shown at the Saatchi Gallery as part of the *Neurotic Realism* exhibition and featured full-on male action with his trademark details emerging from a dark palette.

In his d'Offay exhibition in 2000, Maloney showed formal and informal group portraits, working from newspaper photographs of varied groups, such as school children, teenage mothers, and sports teams. He created strongly realized personalities from banal source material, transforming anonymous images into his own characters. He moved away from using only flat color to introduce a broader range of mark making and decorative patterns. *New Labour* at the Saatchi Gallery in 2001 marked a change in his work, as Maloney presented a group of collages *Slade Gardens SW9, 1995,* (2001) made from vinyl and smaller works in gouache.

APRIL 10TH, 12.00, MARTIN MALONEY
In his studio, which is 3000 square feet, you always want to go to the furthest-away canvas and pull it out to see what it's like. He says no, but I like to do this because you never know what you will find. He has books on various subjects including gardening. Huge piles of newspapers lie around. Martin has two floors. Upstairs he creates lamps out of plastic red ketchup bottles and buckets. Downstairs are huge canvases and vinyl collages. A.E.

TOTAL DEVOTION, 2000. OIL ON CANVAS, 200 X 168 CM.

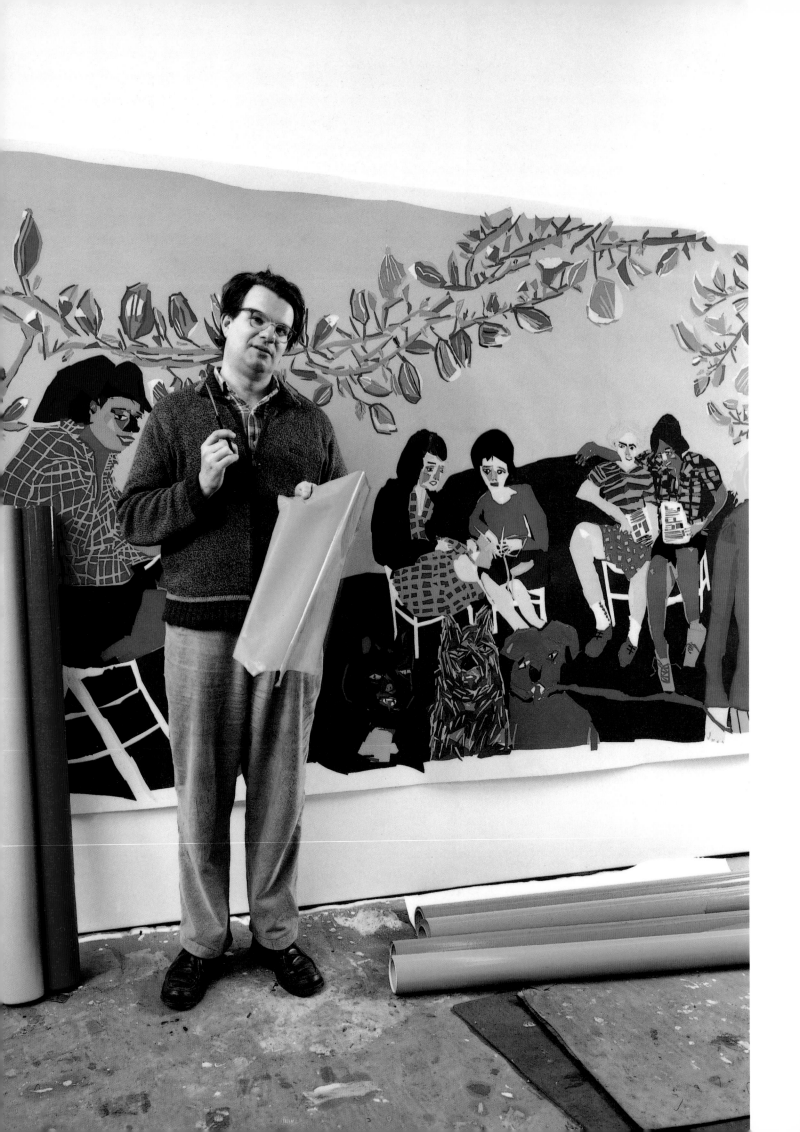

CALENDAR BOY, 2000. COLLAGE ON PAPER, 12 SHEETS, EACH 29,2 X 20,3 CM.

MARTIN MALONEY

THE PRODIGAL SON ENTERTAINING HARLOTS, 2000.
OIL ON CANVAS, 274,3 X 304,8 CM.

MARTIN MALONEY

DAYDREAMER, 2000. OIL ON CANVAS, 127,7 X 80,3 CM.

MARTIN McGINN

Martin McGinn paints from his own photographs of anonymous, impersonal interiors, such as supermarkets, convenience stores, or laundrettes. The viewer's experience of these places gives the paintings a familiarity without revealing their identity. At first they seem recognisable, but you soon realise they could be any number of the same chain of shops.

Occasionally spotted by lone figures, these spaces provide a melancholy portrait of daily urban existence. The blurred paint, emptiness, and artificial lighting of *Late Night Shopping* (2001) and *Samosa* (2001) suggest either an early-morning trip to the supermarket, or a petrol station kiosk after a night clubbing, or an insomniac's salvation. Until 2001, McGinn had painted the strip lights found in parking lots, supermarkets, and airports. These paintings were like cubic tunnels receding into the distance and existed somewhere between representation and Minimalist Abstraction. McGinn was attracted to the sinister mood created through lighting and started to complete the picture. He shifted the emphasis from detached Minimalism to commonplace settings and painterly marks. Although he is now incorporating more detail and brighter colour in his work, the spaces retain their disconcerting, hazy quality.

In *Iceland* (2001) the boxed goods on the shelves are not presented in the way Andy Warhol used Brillo pads and Cambell's Soup cans. The branding is blurred into mid-tones and even bright oranges and yellows are dulled into submission. McGinn uses the aisles for lines of perspective and the rows of boxes as formal colour blocks to build structure in the painting. Similarly, in *Laundry* (2001) he turns the grubby, tiled floor of a laundrette into a decorative study of earth colours. In *Curry's* (2001) the painting is horizontally split between a description of kitchen appliances and a muted, panelled ceiling with block lighting. He paints through the eyes of a person whose life is without specific feature or optimism. There is an urge to relate and identify these interiors, to be able to connect with the paintings, but McGinn deliberately takes away our possibility to do that. These paintings are denied the visual excitement of Pop art and the virtuosity of photorealism. McGinn does not choose to rely on logos to make his paintings accessible, nor does he show off his skill as a photorealist. Avoiding both of these approaches suggests McGinn is a painter who, given the choice, doesn't take the easy way.

APRIL 17TH, 12.00, MARTIN McGINN
Martin McGinn's studio is in a huge warehouse. He has been in the art world for many years and could tell me the scoop about everybody, but I can't repeat what he said because I don't remember. He is now a new star. A.E.

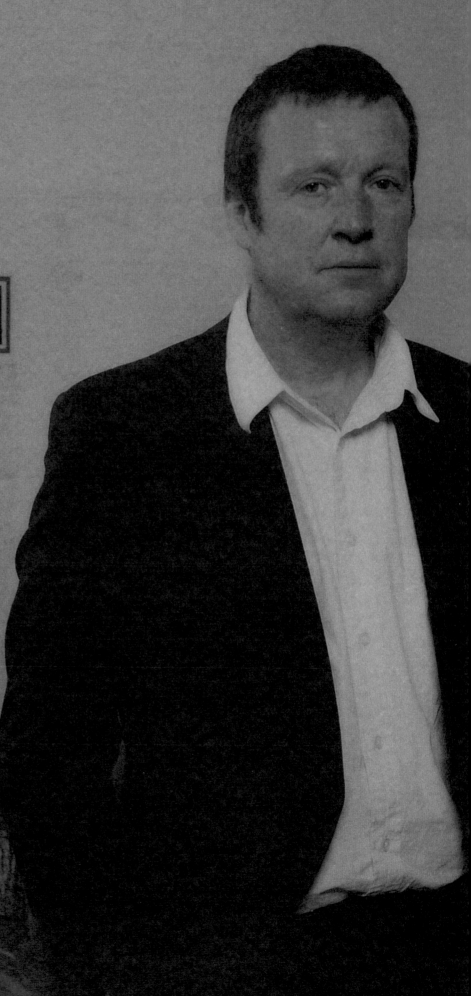

MARTIN McGINN

LAUNDRY, 2001. OIL ON CANVAS, 274,3 X 274,3 CM.

MARTIN McGINN

LEFT: LOST IN SUPERMARKET, 2002. OIL ON CANVAS, 233,6 X 182,8 CM.

LATE NIGHT SHOPPING, 2001. OIL ON CANVAS, 243,8 X 365,8 CM.

HALAL, 2001. OIL ON CANVAS, 213,5 X 367 CM.

MARTIN McGINN

LISA MILROY

Lisa Milroy moved to London from Canada via Paris to study at St Martin's School of Art (1979). She then went on to Goldsmiths College from 1979 to 1982, where she was taught by Michael Craig-Martin. Milroy was one of the most successful artists to emerge in the 1980s. In 1989 she was the first woman to win first prize in the John Moores Painting Prize exhibition. She made paintings that combined a cool, formal approach with a wide range of still life subjects such as clothes, vases, and books. These paintings developed into highly detailed descriptions of repeated objects arranged in grid formations. Her paintings were like visual lists in a neat display; she made lightbulbs and handles seem as covetable as shoes. They had shadow and three-dimensional form but no background or context. Her choice of objects ranged from feminine—shoes, fans, decorative plates, and vases—to masculine—car tires and hardware all depicted in a similar way. Through this uniformity Milroy commented on the mass consumerism of the 1980s—the excess, and the pleasure of having lots of identical things. Milroy painted in a realist style, wet-on-wet, by completing a large canvas in the space of a day she was able to render her subject matter as realistic without turning her practice into an exercise in photorealism.

During the 1990s Milroy was doing a lot of travelling, visiting countries such as Japan, Italy, and Africa. This fed into her work and, if in the previous decade she had followed a still life tradition, in the 1990s she would take landscape and portraiture as her theme. She made paintings of subjects familiar to the places she visited. In a series of works made after her journey to Japan, Milroy's tight, realistic style of painting complements the ritualistic elements she borrowed from Japanese lifestyle. In *Kimono* (1996) she has paid close attention to the layering of meaning inherent in the wearing of this dress. The pose is incredibly formal and the fabric is stiff; the girl looks more like a doll than a real person.

In the late 1990s Milroy made a series of paintings of London cityscapes. The images featured specific London details, a style of house or shop, the tube logo, road signs, double decker busses and BT payphones. They are not romantic or exciting, neither emotional nor photographic; these paintings are banal to the point of being sentimental. In this series Milroy simultaneously expresses the alienation of the city with the comfort of its familiarity.

In 2001, Milroy had a major retrospective at Tate Liverpool. This exhibition presented her work by theme rather than chronologically and also included her most recent paintings, which marked a distinct change in style. Her approach to painting has loosened and her subject matter now comes from her memory rather than observation. Her paintings look like a sketchbook train of thought that has been transformed into the subject of a large canvas.

MAY 21ST, 10.00, LISA MILROY
Lisa Milroy is shy, I had to photograph her twice she was so nervous. But she was a pleasure and had a serenity about her, rather like a queen. She and Fiona Rae exude the same feeling. She is particular and has strong ideas that she sticks to. Her studio looked like a converted school with good light. She had just moved in. She was the only person who introduced me to her agent. A.E.

LISA MILROY

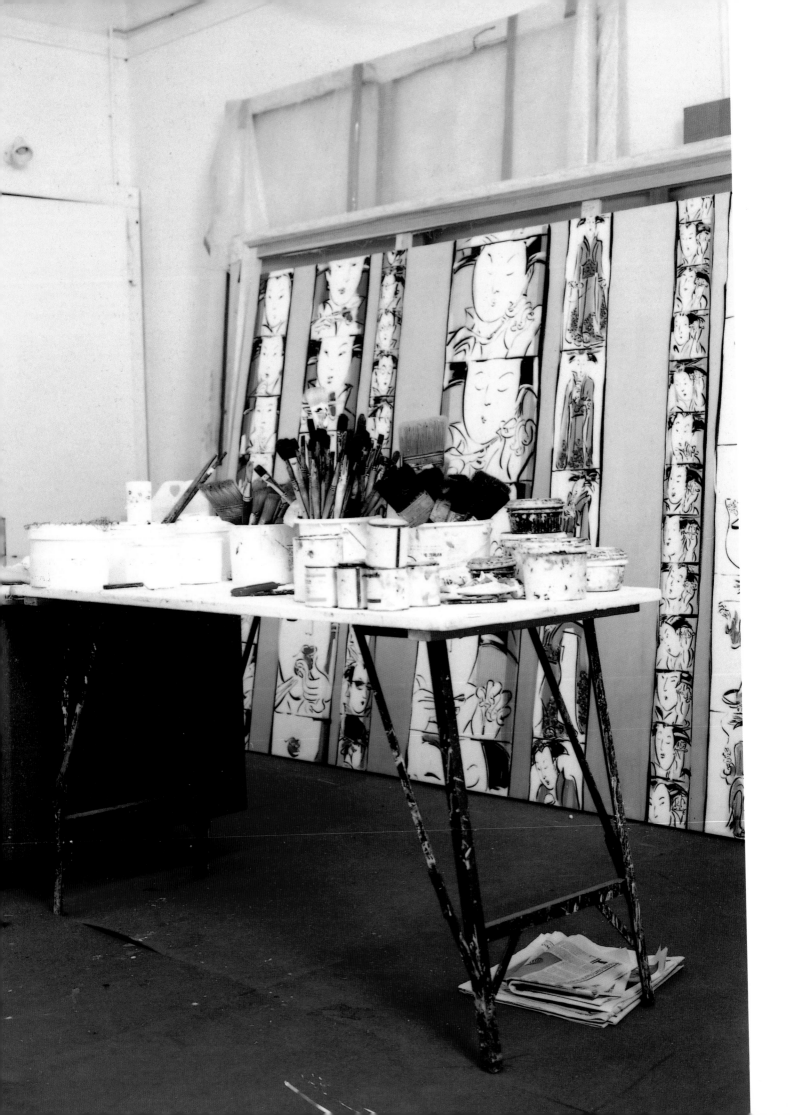

GEISHAS IN MOTION, 2002. OIL ON CANVAS, 178 X 246,5 CM.

LISA MILROY

FRUIT AND VEG, 1999. OIL ON CANVAS, 138,4 X 182,9 CM.

SHOES, 1990. OIL ON CANVAS, 203,2 X 260 CM.

LISA MILROY

SARAH MORRIS

Sarah Morris hasn't quite made up her mind if she is the Bret Easton Ellis or the Jay McInerney of contemporary art. An interest in American serial killers kick-started her glittering career. She painted words that were as banal as they were vacuous. Slickly produced, they screamed out, *JOHNNY, LIAR, SUGAR, MENTAL.* Who Johnny was and why he deserved a painting was never clear, but people started to notice her work. Morris then painted images of women's legs in fishnet tights and high-heeled shoes. Simple and iconic, these graphically striking works looked like the artist was heading for a discussion on fashion and femininity through the au courant style of making figuration look like abstraction. It seemed as if Morris was going to combine Lisa Milroy's early preoccupation with shoes and Sarah Lucas's hardbitten toughness. Painted in household gloss, the works were simple, bold in color, and flatly painted with no unnecessary texture or detail. The leg paintings came in different colourways, and a cottage industry was born. They declared no interest in showing off any skill other than the ability to paint with a stencil. Morris side-stepped Lucas's anger and Milroy's skill to embrace Warhol's yawn. Her work multiplied, and she proved that you can have a good idea again and again and again. There is more of Warhol's legacy in Morris than just his seriality. She has adopted his technique of using a simple graphic image painted in an unemotional, deadpan way. Slick and seductive, they are made to suck you in and spit you out. Then you kind of wonder if she is describing banality or is just a victim of it. But I wouldn't dwell on this too long as, who cares, it's not so important.

Manolo was put away and Mies was brought out as fashion gave way to architectural grids, and skyscraper facades were given the gloss paint and stencil treatment seen from many angles. Morris's work is so popular that it pops up in many shows. She really knows how to make a smart product and fill a space. The alienation of the modern city, with its banal sense of beauty, is perfectly summed up in what she does. People hover in front of her paintings, asking, "Is that abstraction or figuration?" Some people have said she's the new Mondrian, but Mondrian didn't do perspective, so maybe she has the edge.

APRIL 30TH, 3.00, SARAH MORRIS
Sarah Morris wanted to be photographed in her house, which is not what I wanted to do as I wanted to photograph her studio. Anyway she was pregnant, so I forgave her. Sarah was wearing pink, and she was the only artist with a make-up artist. She looked like the girl behind the Chanel counter, and I felt underdressed. Sarah is married to Liam Gillick, who was nominated for the Turner Prize this year. A.E.

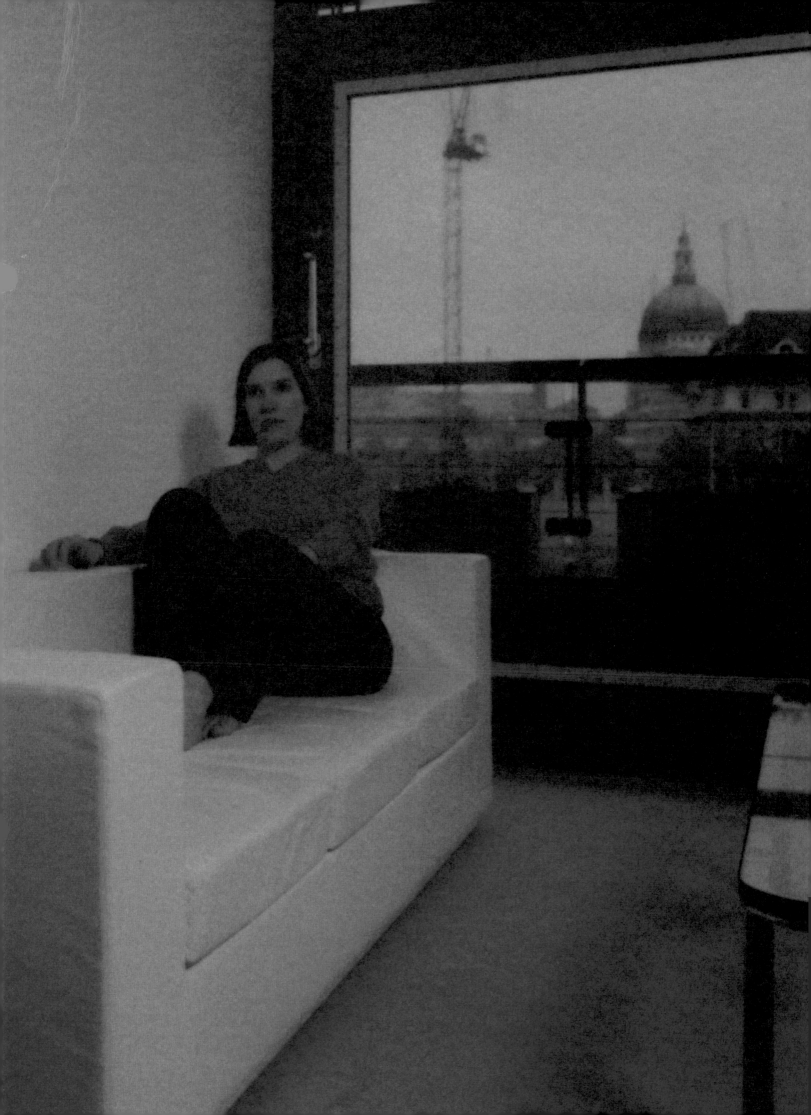

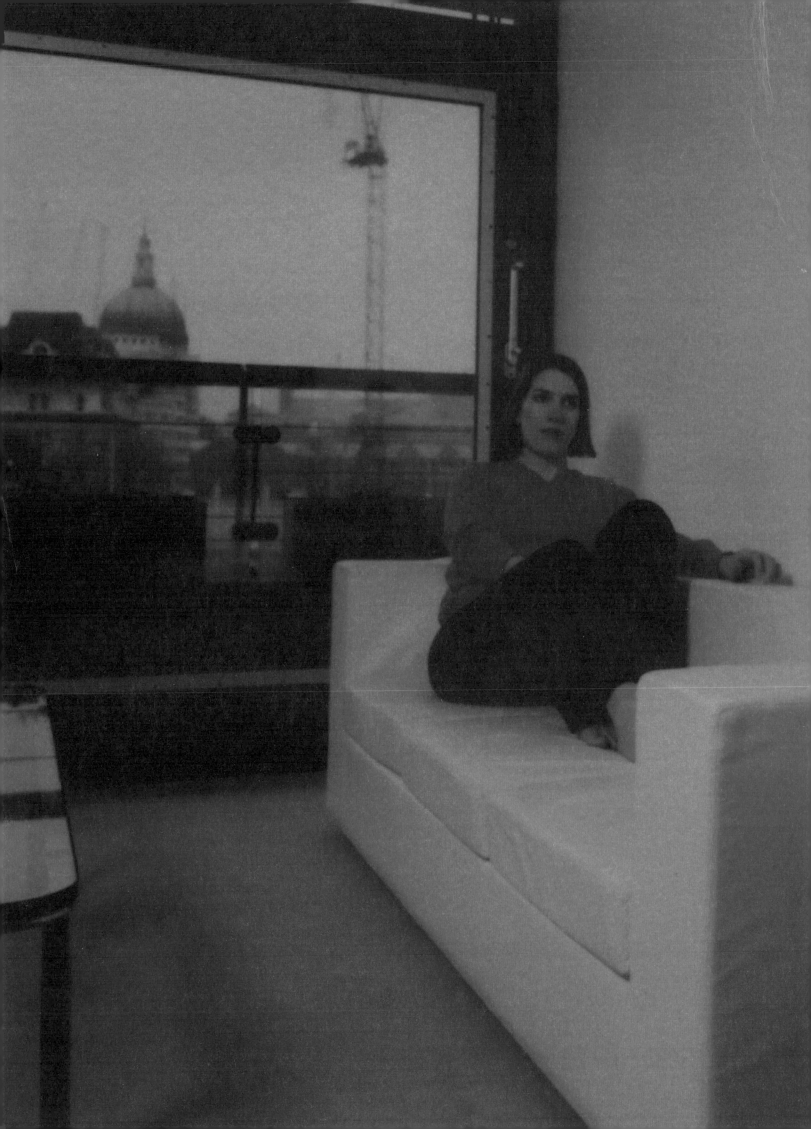

TIM NOBLE & SUE WEBSTER

MISS UNDERSTOOD & MR MEANOR, 1997. RUBBISH, WOOD, PROJECTOR, 140 X 70 X 60 CM.

TIM NOBLE & SUE WEBSTER

ABOVE: ISABELLA BLOW, DETMAR BLOW'S WIFE, WITH TIM NOBLE.
LEFT: DETMAR BLOW, FROM MODERN ART INC., THE GALLERY
WHICH REPRESENTS TIM NOBLE & SUE WEBSTER, WITH THE ARTISTS.

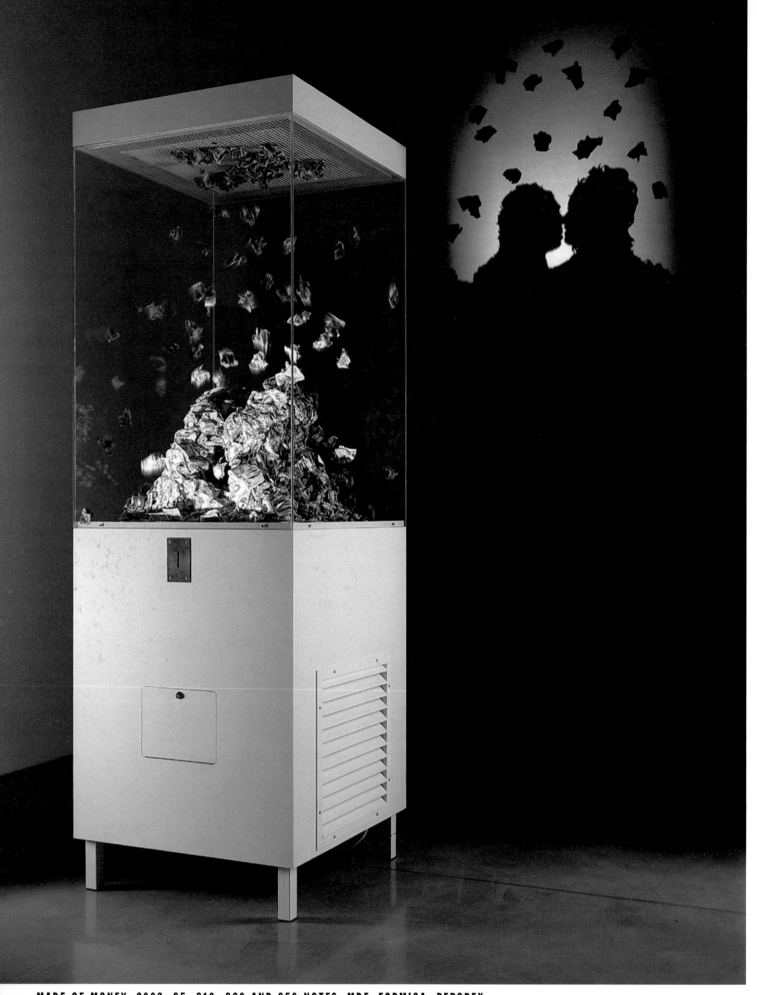

MADE OF MONEY, 2002. £5, £10, £20 AND £50 NOTES, MDF, FORMICA, PERSPEX,
3 ELECTRIC FANS, SLOT MACHINE MECHANISM, PLASTIC TOKENS, LIGHT PROJECTOR, 220,9 X 76,2 X 76,2 CM.

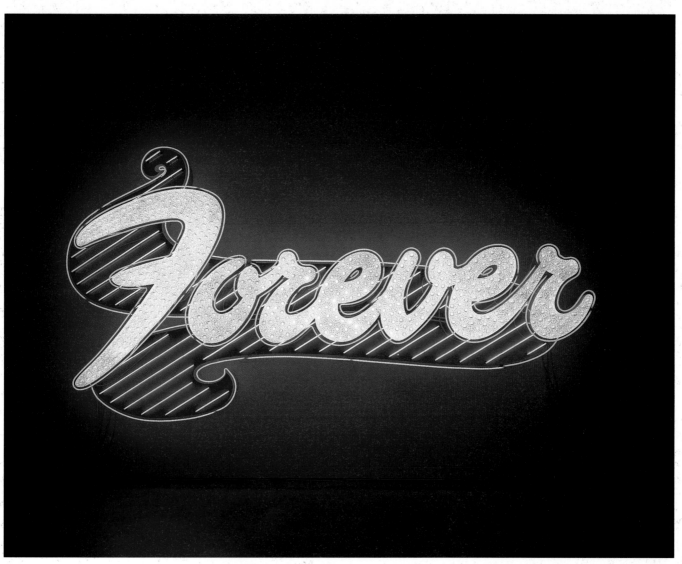

FOREVER, 2001. 58,39 X 30,15 X 5,20 M. 509 LAMPS, HOLDERS, DAISY WASHERS, ICE WHITE TURBO REFLECTOR CAPS, STEEL FRAME, PAINTED ALUMINIUM, ELECTRIC BLUE NEON OUTLINES; 28 HOT PINK NEON STRIPES; 33 NEON TRANSFORMERS; ELECTRONIC LIGHT SEQUENCER (28 CHANNEL SCROLL ON/OFF, 7 LETTER SPELL AND SHIMMER EFFECT).

TIM NOBLE & SUE WEBSTER

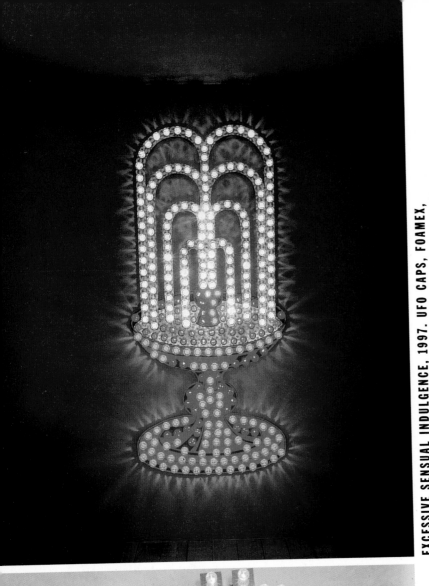

EXCESSIVE SENSUAL INDULGENCE, 1997. UFO CAPS, FOAMEX, LIGHTBULBS, SEQUENCER, 109 X 109 CM.

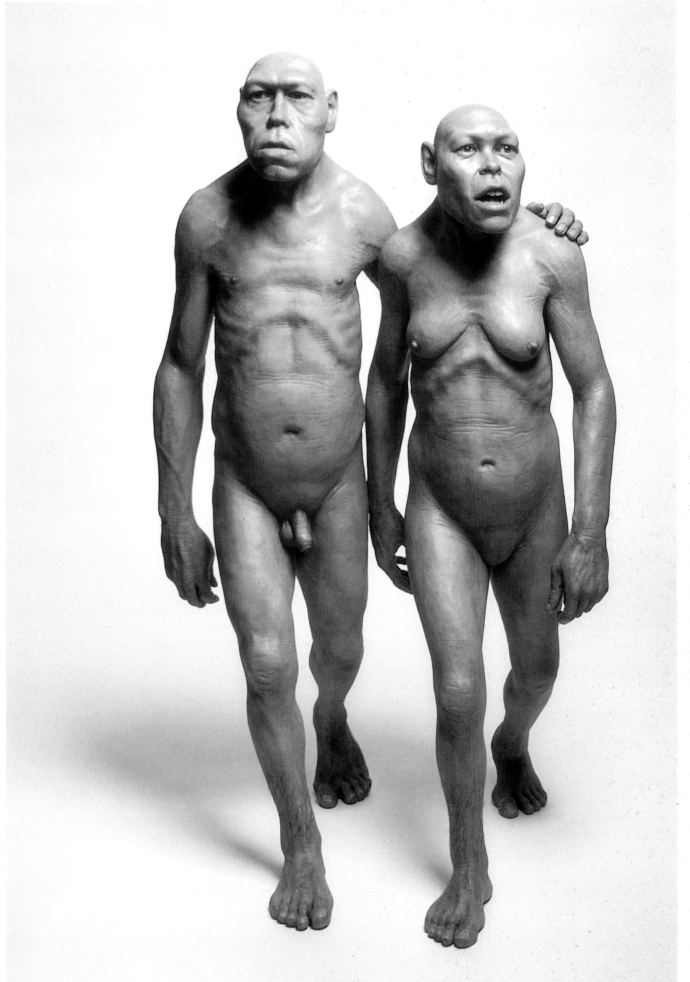

TIM NOBLE & SUE WEBSTER

THE NEW BARBARIANS, 1997-1999. GLASS REINFORCED PLASTIC, TRANSLUCENT
RESIN PLYBOARD, FIBREGLASS. FIGURES: 137,1 X 83,8 X 71,1 CM. COVE: DIMENSIONS VARIABLE.

JULIAN OPIE

When Julian Opie designed the cover for Blur's *The Best of Blur* album, his portraits of the band members were seen everywhere, from buses and billboards to the set of *Top of the Pops* and in the National Portrait Gallery. This project and subsequent advertising campaign introduced Opie's work to a wider audience and affirmed his popularity in and out of the art world.

Opie is one of Britain's leading contemporary artists. He has consistently adapted his style of making art since he left Goldsmiths College in 1982. He creates sculptures, computer images, and two-dimensional and three-dimensional gallery and public installations. His work distills our experiences of everyday landscapes, portraits, objects, and still lifes into simple, but slick and appealing generic visual images. Throughout his career, Opie's manipulation of scale and color has been a consistent element, changing the viewer's sperception of what he or she sees, whether it is in his early small architectural models, concrete spaghetti junctions, enlarged air vents, or his more recent vast vinyl portraits.

Although Opie first became known for his painted sculptures, constructed from traditional materials such as metal and wood, he has made most of his recent work with the aid of a computer. His studio feels clean and modern, with a long desk along one side holding three or four computers. While the look of his work has gone from hands-on to hands-off, and computers play an important role in the process, Opie remains in control of every aspect of making his art without having to be physically involved. Since the mid-1990s Opie has concentrated on large-scale portraits and landscapes for which he uses a computer to manipulate photographs and then fabricates the images in colored sign-makers' vinyl. Using a computer program called Vectra, he makes striking portraits that reduce photographs to the minimum amount of information needed to create a recognisable image. With dots for eyes and lines for mouths, the portraits combine the personal with the impersonal, merging a photographic image with the type of pictogram found on lavatory doors and road signs.

For his exhibition at the Lisson Gallery in London in 2001, Opie designed the accompanying catalogue in the style of a cheap mail-order booklet. It is both honest and provocative to present work in the basic terms of colors, sizes, and price. It refers to how Andy Warhol changed the acceptability of repetition and commercialism in art, but also exists as a free, multiple, and integral part of the exhibition.

MARCH 21ST, 10.00, JULIAN OPIE
I visited Julian Opie's studio twice, and both times he was very quiet but charming, although he never looked up from his computer. Another attractive man, I was beginning to wonder at this stage if you could succeed in this world if you were ugly, and then I met Jim Lambie and realized that probably not. A.E.

JULIAN OPIE

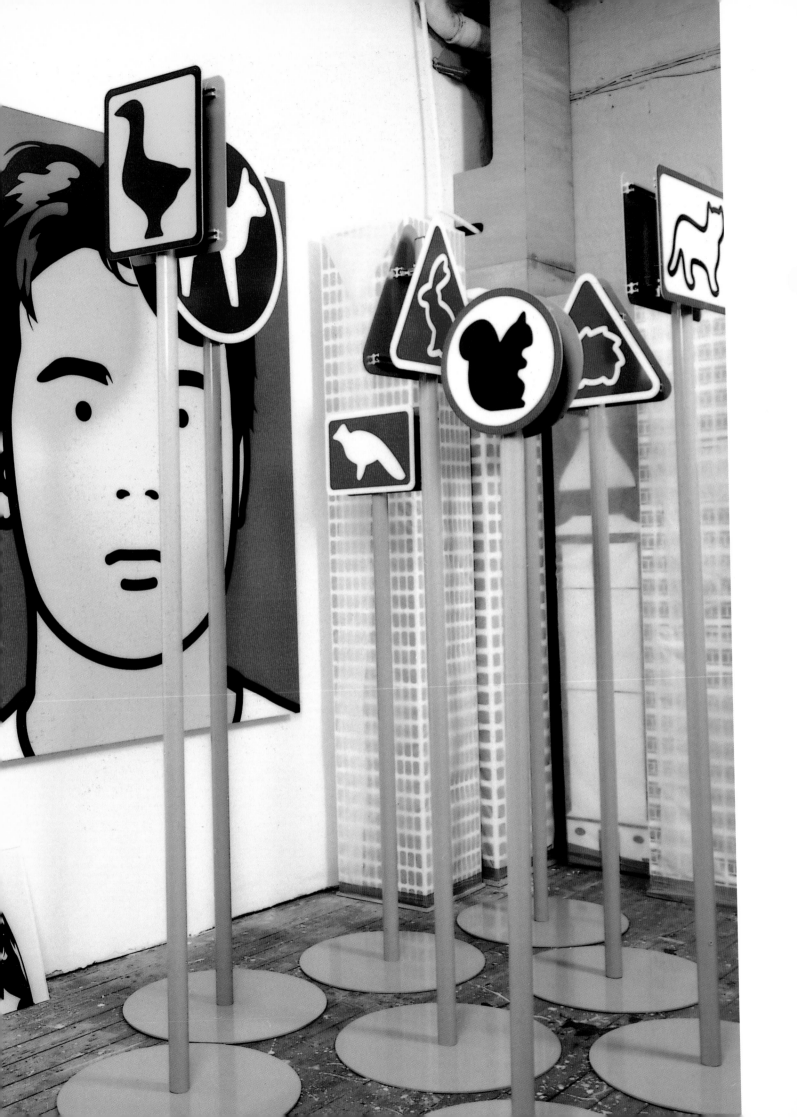

CHRISTINE, RECEPTIONIST, 2, 1999. VINYL, 192 X 174 CM.

JULIAN OPIE

RICHARD PATTERSON

Richard Patterson left Goldsmiths College in 1986 and took part in Damien Hirst's *Freeze* exhibition in 1988, but his work really hit the art world headlines in the mid-1990s. He painted a toy motorbike and a Minotaur—heroic legends of mythology or popular culture that have been watered down into Christmas cracker trophies. Patterson takes such toys and obscures them with paint or Plasticine before photographing them. He then works on top of the photograph to create further marks on the picture plane and then enlarges this into grandscale. For the months it takes him to make his painting Patterson is a slave to his photograph, enlarging it in the old-fashioned way of scaling it up rather than using a projector or a blown-up photocopy. While he paints in oil he creates the appearance and texture of thick acrylic materials: whether it is the plastic toys he is painting, the blobs of Plasticine he has stuck onto them, or the cheap sheen of the photographic print.

Patterson's style of painting follows on from Gerhard Richter and James Rosenquist, and there is also more than a passing similarity to Malcolm Morley. But while these references are a compliment, Patterson has found an area in contemporary art that is his own. He paints the reality and fantasy of a hot-blooded male, fast bikes and women, you've got Victoria Beckham (formerly known as Posh Spice), Daisy Duke, war soldiers, and, in *Culture Station - Zipper* (1995), the hedonistic advertising lifestyle. He makes the reality of a painstaking technique feel exciting and instant; the viewer is impressed with what they see in the final result. In the first visual hit there is no evidence of labour, it is only when you realise that the gesture is flatly painted rather than a quick expressive movement, that it clicks what's going on. But his subjects and skilled handling of paint do nothing but complement each other, as both drip with beauty and romantic idolization. In *Young Minotaur* (1997), Patterson plays different areas of culture against themselves. He presents a cheap toy as a stand-in for what it symbolises and abstract expressionism as photorealism. He simultaneously indulges and mocks the activity of painting. By copying his photos of toys so accurately, he tempts you to believe that paint is cheap and plastic. That like his heroic soldiers, the heroics of painting can just as soon become mass manufactured. The only truth he allows in his work is his skill.

MARCH 23RD, 11.00, RICHARD PATTERSON
Richard Patterson had also just flown in from New York. He no longer has a studio in London, so I just photographed him in a very neutral way. He has the face of a Gap ad. He helped find fellow artists who would be in the book. A.E.

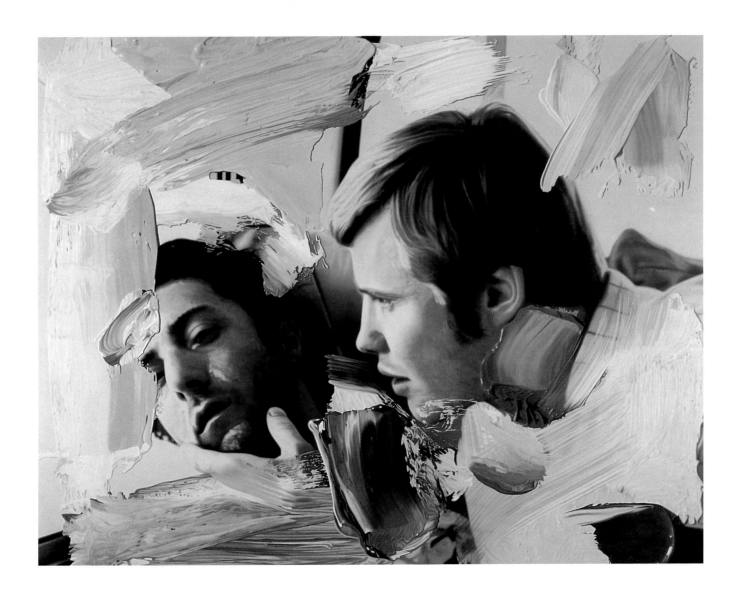

RICHARD PATTERSON

THE KENNINGTON YEARS, 2001. OIL ON CANVAS, 233,7 X 299,8 CM.

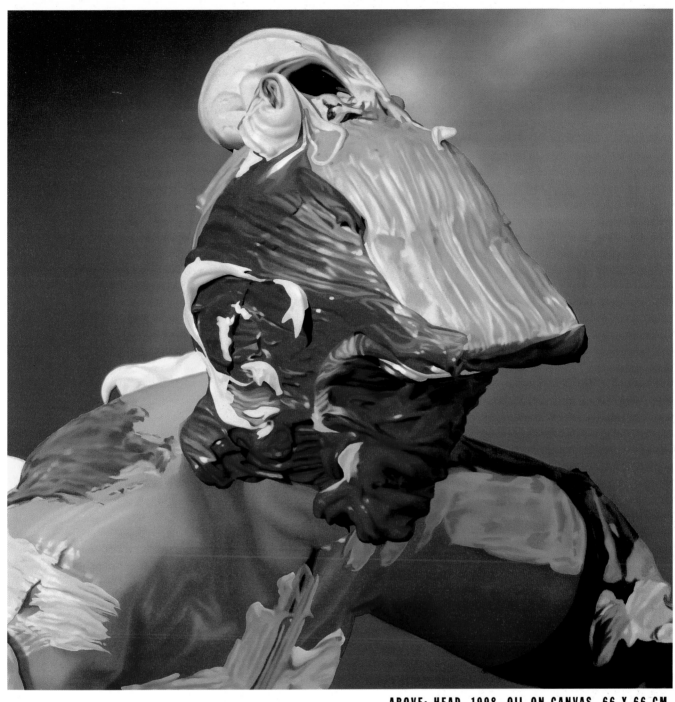

ABOVE: HEAD, 1998. OIL ON CANVAS, 66 X 66 CM.
LEFT: RED STUDIO, 1996. OIL ON CANVAS, 208,3 X 138,4 CM.

RICHARD PATTERSON

GINGER, BABY & THOMSON, 1997. OIL ON CANVAS, 56 X 81,3 CM.

RICHARD PATTERSON

DAISY, 2002. OIL ON CANVAS, 314,9 X 233,6 CM.

DAN PERFECT

Dan Perfect's paintings mismatch the sophisticated chic of hard-edged abstraction with the unkempt imaginative world of storybook illustration. Perfect is a newcomer to the London art scene, but he has already taken part in group shows at Anthony d'Offay Gallery, the ICA, and Andrea Rosen in New York. He paints backgrounds of graduated colored tints reminiscent of 1960s, cool abstraction, and onto these bands of color he places squiggled shapes which look like they could have been taken from an imaginary cartoon landscape or children's book illustration. He animates these formal arrangements of color and shape so they have a narrative feel. The clash between these two visual languages makes Perfect's work pertinent. He unites opposing elements and in doing so, makes his audience rethink the playful urge behind some of the great twentieth-century masters such as Miró, Klee, and Kandinsky. Perfect has tackled head-on the challenges of reviving an interest in abstraction in painting after the recent glut of figurative work. He has found a new way of making stripe paintings imbued with a *Jungle Book* feel for the sinuous and calligraphic. Borrowing from Philip Guston's complexity of motif and simplified forms, Perfect's work adds to the discussion initiated by American artists who have been looking at the language of abstraction and turning it into something new, for example Laura Owens's decorative swirls and perspectival vistas and Inka Essenhigh's energetic arenas of calligraphic mystery. Perfect's paintings unify the complexity of the adult world with the simplicity of a child's. Shapes have personalities and identities. Their positioning indicates whether they are at war or at play. The work tempts the viewer into entering this land of make believe as it examines and deconstructs the imagination.

MARCH 14TH, 10.00, DAN PERFECT
Dan Perfect is an artist who also has a pop star sideline. He is the trendy husband of Fiona Rae, with boyish charm and a very comfortable chair in his studio where I'm sure he has a siesta during the afternoon. His paintings remind me of the cartoons my children watch. He was nominated for the Beck's prize along with Kirsten. A.E.

DAN PERFECT

FOLLOWING THE TRAIL ON THE SEA-FLOOR TO A SUNKEN SHIP, 2002.
OIL AND ACRYLIC ON CANVAS, 213,4 X 304,8 CM.

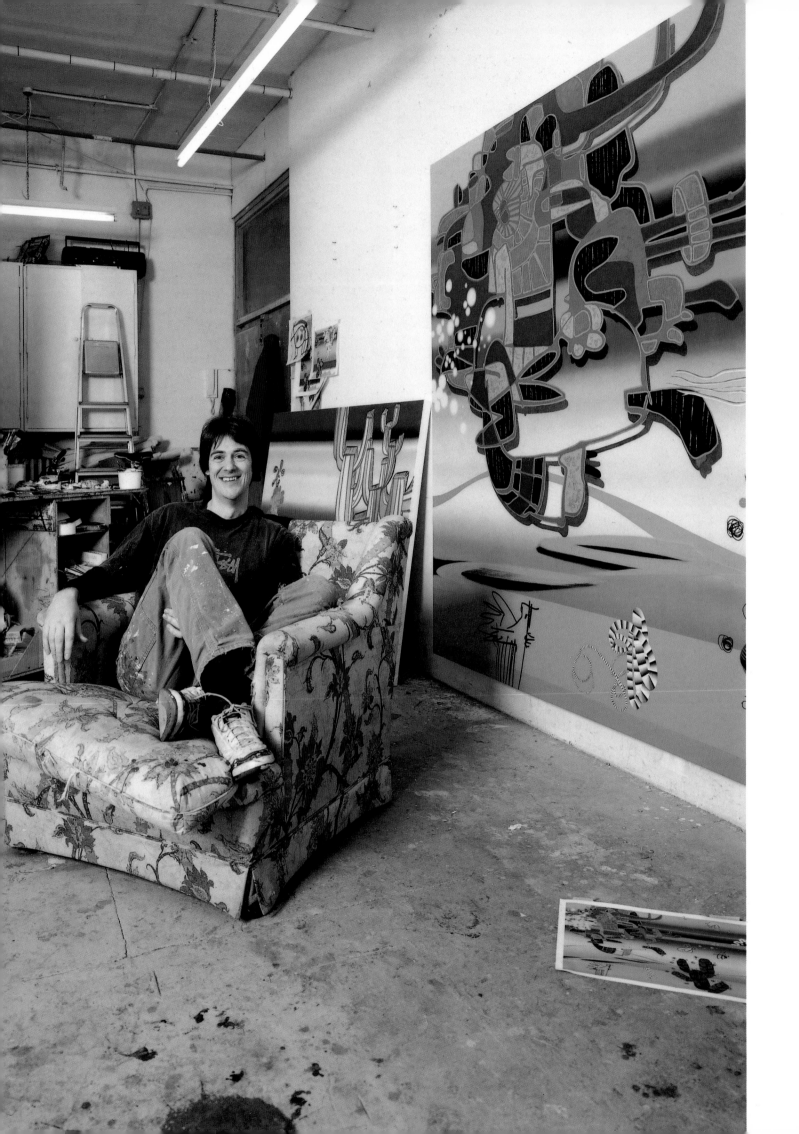

FROM TOP TO BOTTOM: CLIMB UP TO THE BRIGHTLY COLORED WINDOW, 2001, 127 X 152 CM; YOU ARE GREETED BY A WARRIOR WHO IS FLYING IN FROM THE RIGHT, 2002, 175,3 X 213,4 CM; FIND THE CORNER OF THE VALLEY WITH THE SPIKES BEHIND SOME ROCKS, 2001, 163 X 244 CM. ALL: OIL & ACRYLIC ON CANVAS.

FROM TOP TO BOTTOM: SHIMMY OVER THE WHITE DRAGON, BUT DO NOT GET TOO CLOSE TO THE LAVA, 2000; THE ADVENTURE IS OVER AND IT'S TIME TO HEAD FOR HOME, 2001; WITH THE AREA CLEARED OF DANGER, YOU CAN NOW EXPLORE, 2000; FINISH OFF THE BIRD MONSTER TO END THE LEVEL, 2001. ALL: OIL & ACRYLIC ON CANVAS, 164 X 244 CM.

GRAYSON PERRY

The first "little-girl frock" that Grayson Perry bought for his alter-ego, Claire, was a bridesmaid's dress from a charity shop. Now he designs Claire's dresses himself, paying close attention to the fabric, bows, and accessories. Claire is Perry's transvestite identity, featured in his life and in his art; she has a room in his house and appears in his photographs and on his ceramic pots. Claire is one aspect of Perry's nonconformity. Another is his pottery, which he started at evening classes not long after he left Portsmouth Polytechnic in 1982.

Perry chose ceramics because, as a material associated with craft, it is seen as inferior within contemporary art, something that he felt matched his own low self-esteem. Perry styles his pots on classical Japanese and Chinese designs usually kept to a domestic scale and displayed on plinths. He enjoys the hands-on practicality and detail involved, while ceramics' low standing as a craft provides a vehicle for Perry to voice his outspoken views on the art world, sex and sexuality, stereotypes of masculinity, war, pollution, pornography, and his own troubled childhood. His pots are like cute dogs with vicious teeth: What at first looks like a traditional, elegant urn decorated with slip drawing, transfers, writing, and glazes, is, on closer inspection, an attack on anyone who walks into his firing line.

In works such as *Boring Cool People* (1999) he shows his dislike for IKEA shopping, loft living and fashion victims, while *We Are What We Buy* (2000) takes aim at contemporary artists. But Perry's anger is not just directed at others, his stories are often autobiographical. He grew up in a dysfunctional family where he got into trouble as a teenager for wearing his sister's clothes. His dad left when he was five, and Perry gives the impression that his stepfather, "the milkman," was a poor replacement, intolerant of displays of femininity in boys. Perry reflects on his childhood in works such as *Growing Up as a Boy* (2000), *Nostalgia for the Bad Times* (1999), and *Mad Kids, Bedroom* (1997). He contrasts the bleak landscape of his hometown, Chelmsford, with pictures of American Indians and Victorian girls, using humor and wit in parallel with anger and dark emotions.

When his pots were first shown at the James Birch Gallery in 1984, they were a sell-out success, but it wasn't until the contemporary art/craft renewal in the 1990s that he hit the headlines. Perry showed with Anthony d'Offay and in *Protest and Survive* at the Whitechapel Art Gallery. His 2000 exhibition at Laurent Delaye Gallery led to *The British Art Show*, the *New Labour* exhibition at the Saatchi Gallery, and a retrospective at The Stedelijk Museum in Amsterdam. By earning success as a contemporary artist through using craft and elements of decoration, Perry has outwitted the art world—not only has he subverted the craft associations of pottery, but he has done so at the expense of contemporary art itself.

APRIL 2ND, 11.00, GRAYSON PERRY
The first time I met him he was Grayson, the second time I met him he was Claire. He'd just had a dress beautifully made and looked like Alice in Wonderland perched on a bed in his spare room that also matched the dress. His studio was crammed full of precious jugs, and you couldn't move. I have to say he is very masculine, even in a dress. I'd love to go on a weekend with him to a tranny convention. He was very cosy to be with. His house is completely different and is in a beautiful square in Central London. A.E.

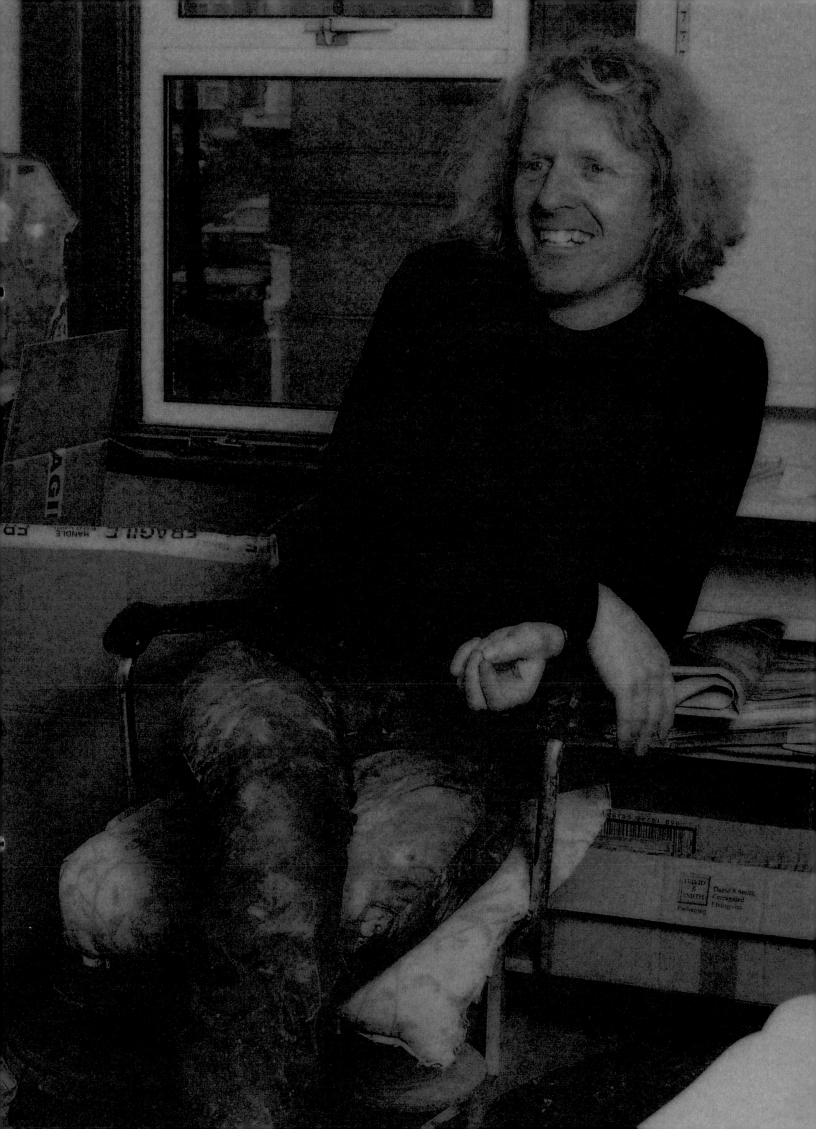

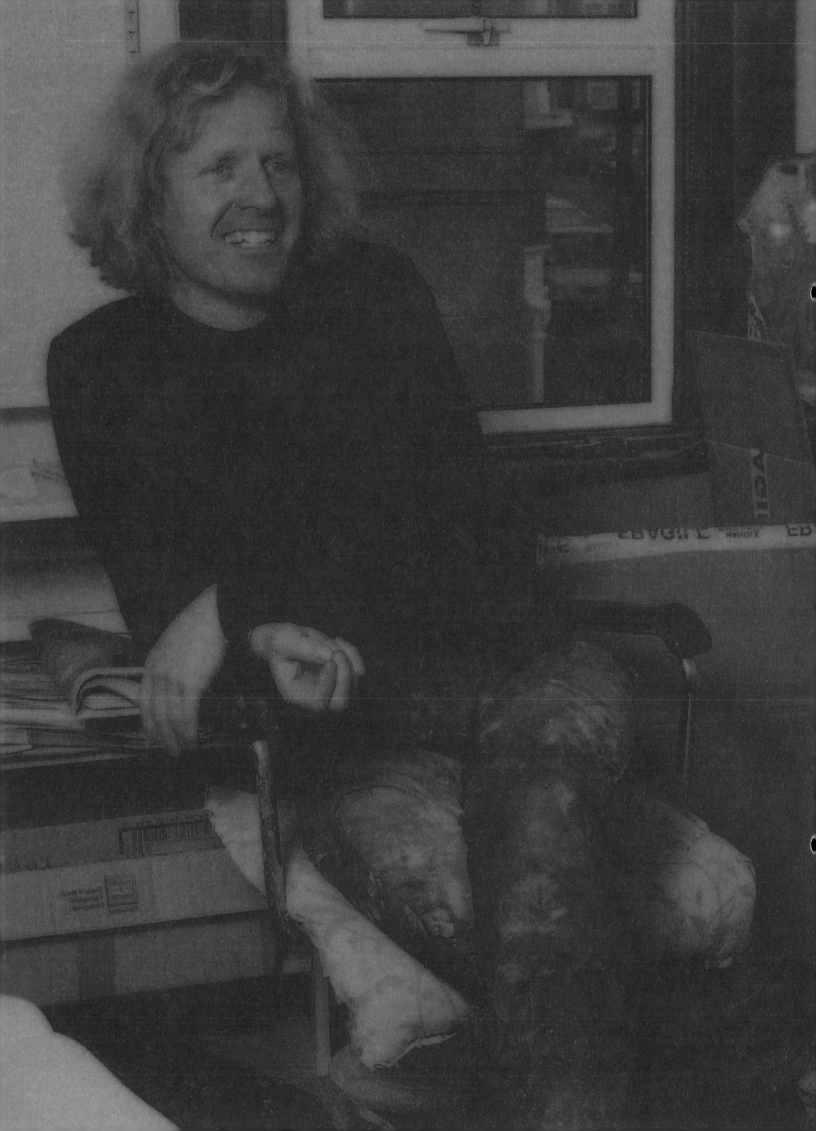

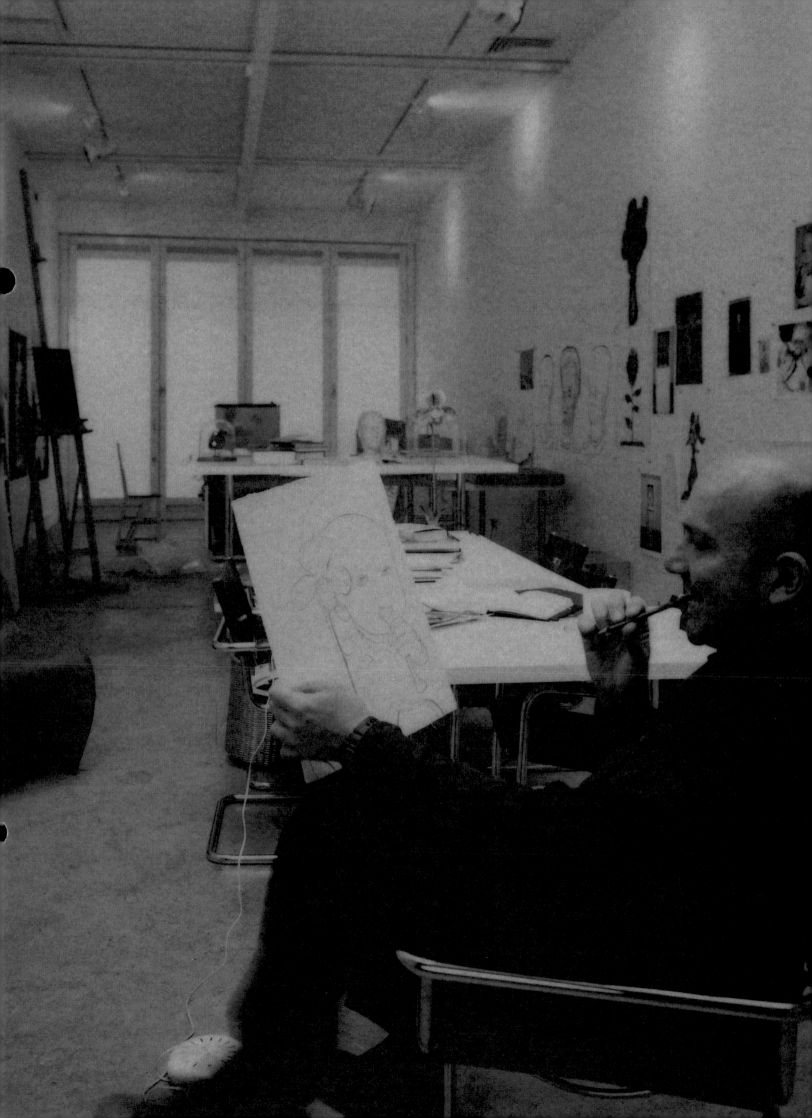

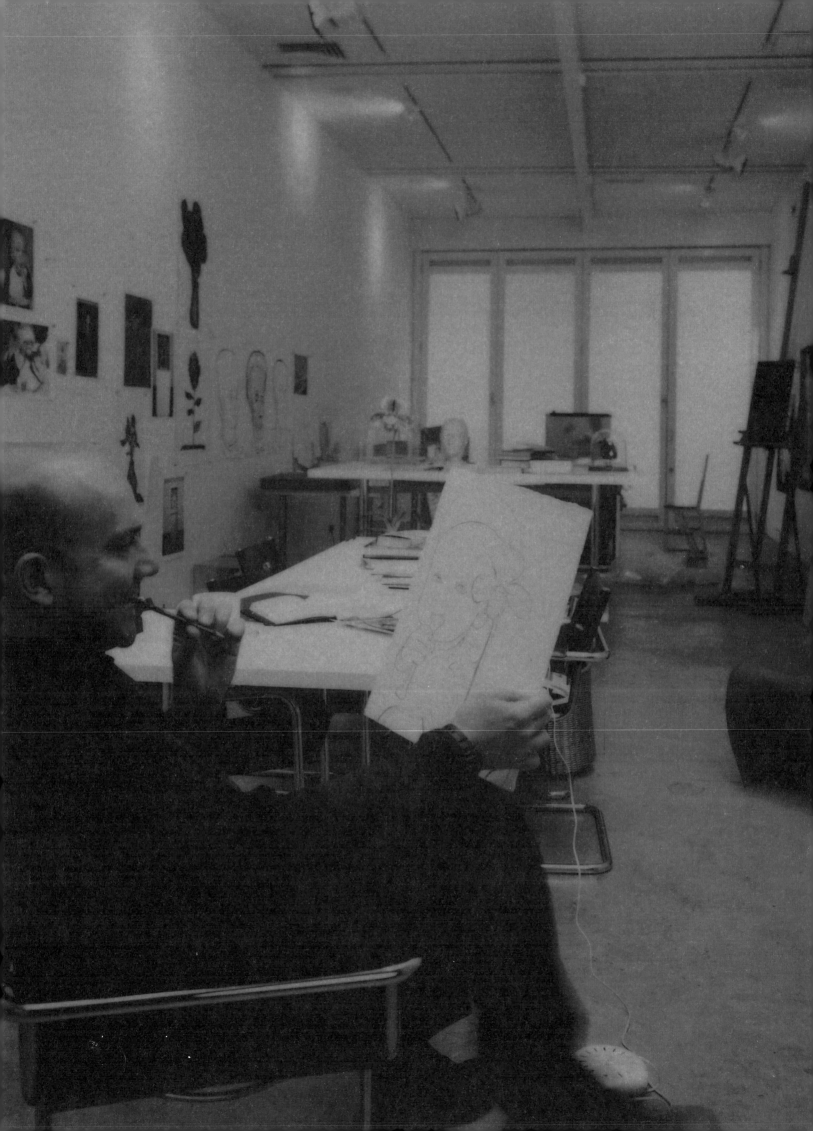

MARC QUINN

ORCHID IN THE PARK (DETAILS), STUDY FOR ORCHID, 2002. STAINLESS STEEL, HEIGHT 12 M.

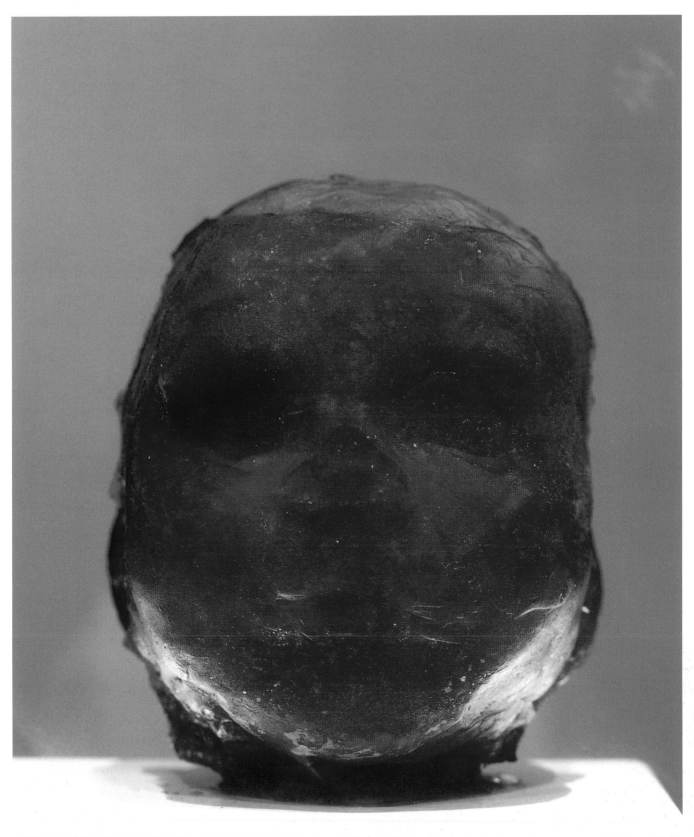

MARC QUINN

ABOVE: LUCAS, 2001. HUMAN PLACENTA AND UMBILICAL CORD, STAINLESS
STEEL, PERSPEX, REFRIGERATION EQUIPMENT, 204,5 X 64 X 64 CM.
LEFT: BABY LUCAS WITH ORCHID IN FRONT AND FLOWERS ALL AROUND
(DETAILS), DRAWING FOR ARTIFICIAL NATURE, 2002.
STUDY FOR FROZEN SCULPTURE IN ARTIFICIAL MILK AND FLOWERS.

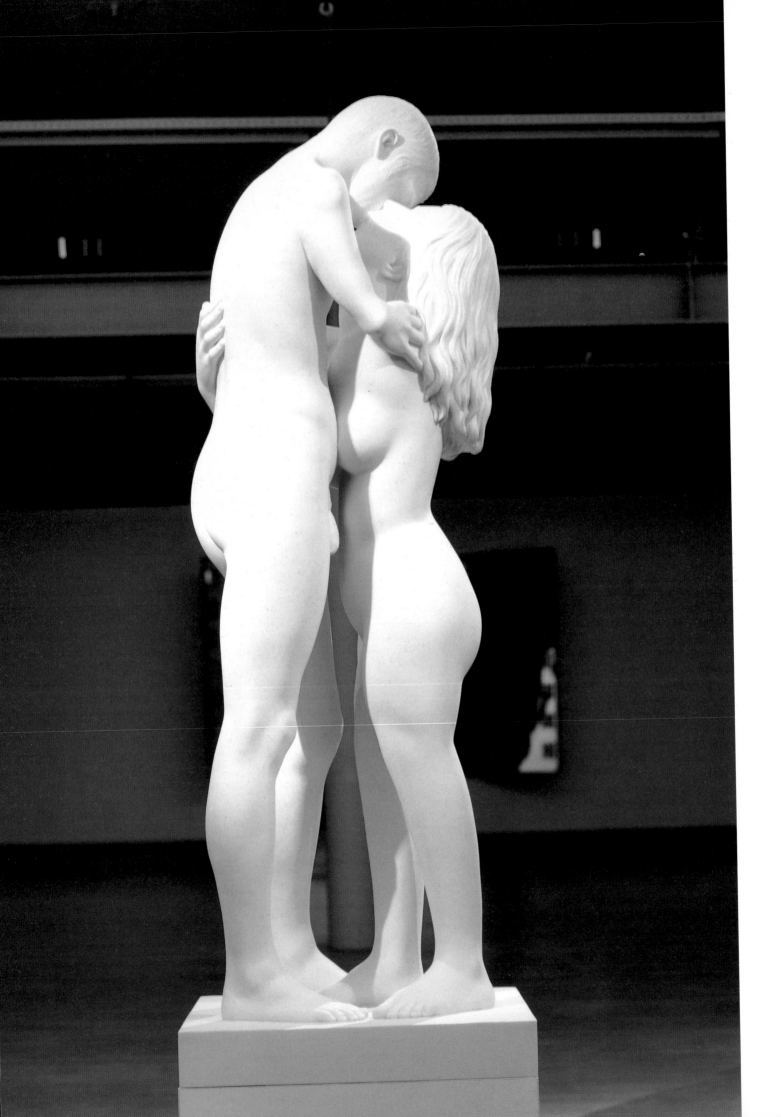

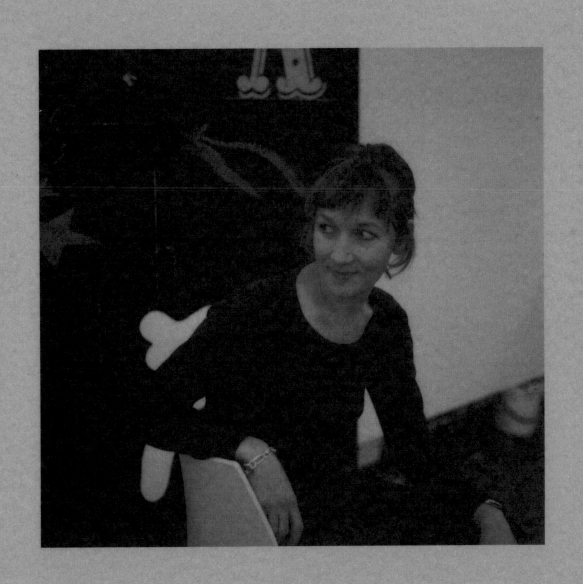

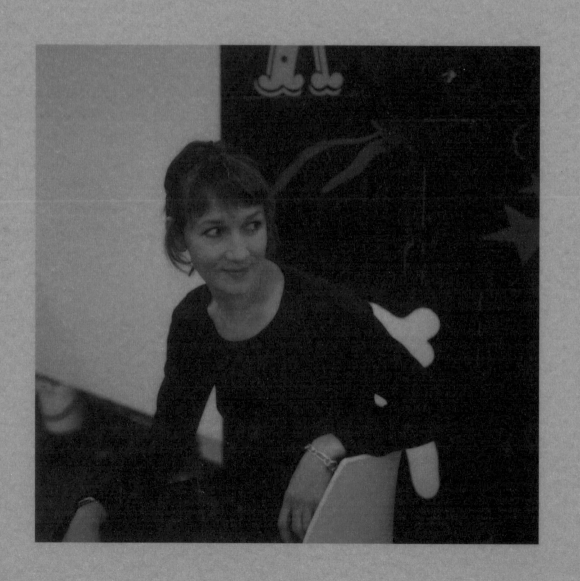

FIONA RAE

RODEO, 2001. OIL, ACRYLIC AND GLITTER ON CANVAS, 246 X 203,5 CM.

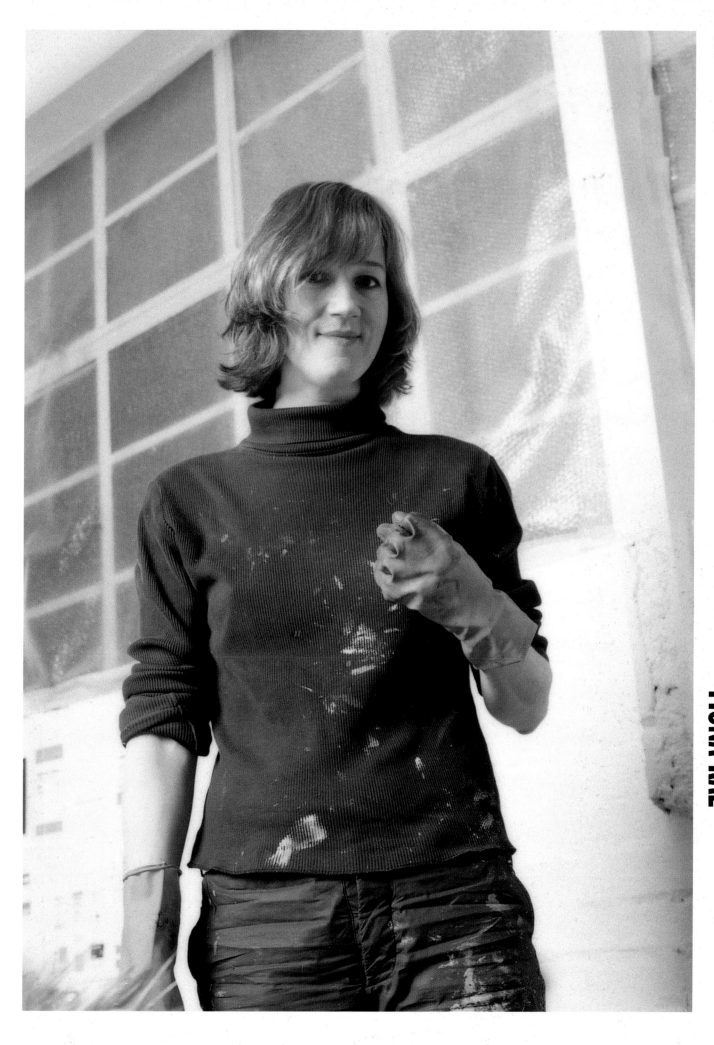

LOVESEXY, 2001. OIL, ACRYLIC AND GLITTER ON CANVAS, 246 X 203,5 CM.

STARMONKEY, 2002. OIL AND ACRYLIC ON CANVAS, 71,1 X 61 CM.

FIONA RAE

ASTRONAUT, 1998. OIL AND ACRYLIC ON CANVAS, 243,8 X 213,4 CM.

FIONA RAE

GREEN SHADE, 1997. OIL AND ACRYLIC ON CANVAS, 243,8 X 213,3 CM.

MICHAEL RAEDECKER

Like a scene from a 1970s road movie, Michael Raedecker's paintings are full of open spaces and underlying tension. He paints isolated houses, portraits, and empty rooms in murky colours that seem familiar more from the memory of watching a film or a description in a book than from the actual experience of a place. He overlays flat areas of neutral, earth colours with poured paint, and then stitches directly onto the canvas to define shapes, and uses scrunched-up wools to add texture. Raedecker's use of sewing comes from an earlier career in the fashion industry in his hometown of Amsterdam. He moved to London to study art at Goldsmiths College, graduating in 1997. He left college to instant success. He took part in a line-up of important London group shows, including *Die Young Stay Pretty* at the ICA, *Loose Threads* at the Serpentine Gallery, and *Examining Pictures* at the Whitechapel Art Gallery. In 1999 he won the John Moores Painting Prize and was short-listed for the Turner Prize in 2000.

Raedecker's paintings follow the traditional Dutch genres of landscapes, interiors, and portraits—but his off-key compositions owe more to an influence from modern cinema. He uses emptiness to subvert ordinariness, which plays on the idea of a quiet scene before the action. In *Up* (1999), he uses an aerial viewpoint, and in *Hollow Hill* and *Kismet* (both 1999), a distorted reflection to create an unnerving sense of perspective. With embroidery he creates thick shadows made even more prominent because they are physical as well as tonal. In *Reverb* (1998) the stitched blind at the window looks taut, ready to snap under the strain. Because the paintings' compositions are quite empty, small details become strong focal points, such as the vista through a window or a painting hanging on a bedroom wall. Raedecker has often returned to the same subjects in his work: an empty hotel room deliberately showing a domestic space that contains no personal effects, allowing the viewer to add his or her narrative. Similarly ambiguous are his anonymous portraits of wrinkled old men. The skill with which Raedecker uses wools and yarns as stand-ins for painted lines or gestures has given him a distinctive style. He emerged on the London art scene at a time when craft skills had been given a makeover; now his work has outlived its fashionable beginnings and his innovative approach has made him one of the most original artists of his generation.

APRIL 4TH, 1.00, MICHAEL RAEDECKER
Michael Raedecker wanted to take his own photograph. He has a lot of interests, from music to knitting. I have never seen so many different coloured balls of wool in one place. Hidden away was a picture of a Page Three girl; he obviously has good afternoons. A.E.

REVERB (DETAIL), 1998. ACRYLIC AND THREAD ON LINEN, 61 X 81 CM.

MICHAEL RAEDECKER

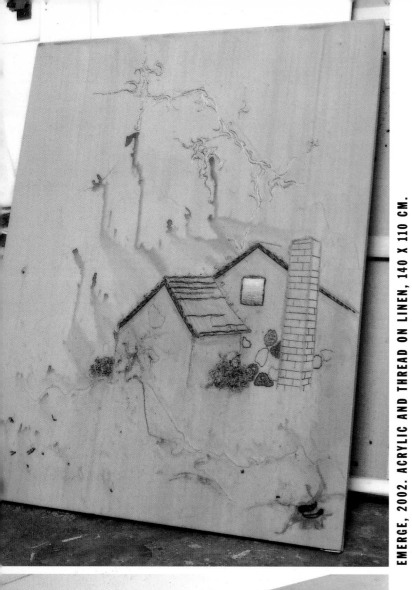

EMERGE, 2002. ACRYLIC AND THREAD ON LINEN, 140 X 110 CM.

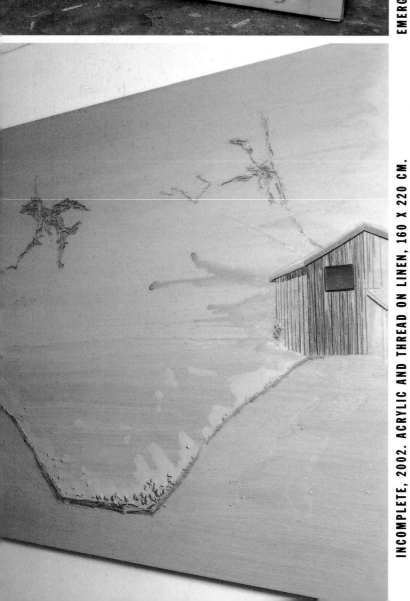

INCOMPLETE, 2002. ACRYLIC AND THREAD ON LINEN, 160 X 220 CM.

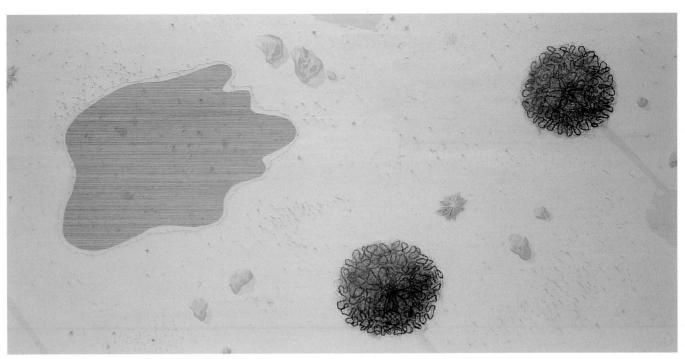

UP, 1999. ACRYLIC AND THREAD ON LINEN, 170 X 341 CM.

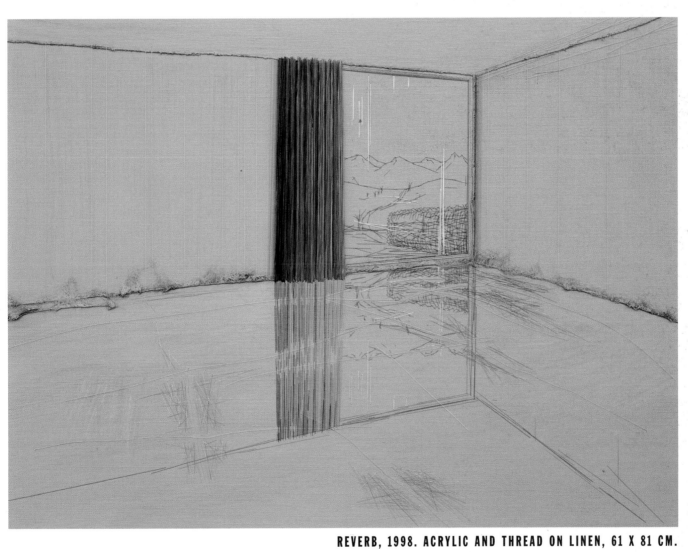

REVERB, 1998. ACRYLIC AND THREAD ON LINEN, 61 X 81 CM.

MICHAEL RAEDECKER

PHANTOM, 1999. ACRYLIC AND THREAD ON CANVAS, 122 X 147 CM.

MICHAEL RAEDECKER

NEIL RUMMING

There is a cupboard in Neil Rumming's kitchen where he keeps the meteorite, solar-system information cards he's collected from Shreddies cereal boxes. He talks about art, but he is equally interested in trivia and the rubbish of life. In a conversation he can go from discussing academic art theory to telling you the scientific name for some obscure part of the human brain. This eclectic knowledge is what you see in his work.

Like investigations into art, he recycles powerful and potent images and painting styles that have become redundant. Rumming's *Bikini Brain* (2001) is like the painting equivalent of the TV series "I love the 70s." The outline is taken from a scientific drawing of the inside of a human head, chosen from a book called *Head 2 Heads,* but Rumming has swapped the real blood and brain for his own imagery. *Bikini Brain* is the first painting from his *Dissection* series and offers him a way to reminisce about styles of drawing, painting, and retro subjects, but from a 2001 perspective. He uses a comic-book style of illustration to blend fact with fantasy of the disastrous Bikini Atoll H-bomb test in 1954. He includes rainbows, lightning bolts, and sunsets against rolling waves, creating every type of romantic landscape in one. But at the base of the "head," is a nuclear cloud painted in impasto style.

At first glance Rumming's paintings can appear as blown-up, stylized drawings for tattoos, with their strong outlines and bright colors, but up-close the prettiness describes exposed flesh or the surface of a rock face. To make his paintings, Rumming first puts together a collage: he draws an outline of a recognizable logo or motif—the Ferrari horse in *Stallion* (2001) or the Playboy bunny in *Bunny* (2001)— and fills it with images that he relates to that subject. He then works the collage up into a painting, mixing imagery from all corners of the visual world, from abstraction to pop to kitsch to photorealist to comic book, but he controls it by limiting each painting to one subject. *Pop Tomb* (2002) directly references three established painting styles: American Pop artist Roy Lichtenstein's mechanical brushstroke, which was a critique of Abstract Expressionism; Jason Martin's one-sweep process brushstroke; and Franz Klein's monochromatic painting. Within this mixing of styles is an illustration of a skeleton, representing the death of Lichtenstein and also symbolizing the end of Pop Art. *Pop Tomb* resurrects Lichtenstein's argument of the mechanical vs. the handmade but shows Rumming's interest in both genres by including the skeleton set within Martin's gestural painting, which became relevant post-Pop Art. Rumming uses art history like an encyclopedia that came free with being an artist.

MARCH 6TH, 2.00, NEIL RUMMING
Neil Rumming shares a huge studio with ten other people. He is an extrovert and could be a film star. He is very confident and you would think he has been in the art world for a very long time, but in fact he's new to it and has just been nominated for the Beck's prize. A.E.

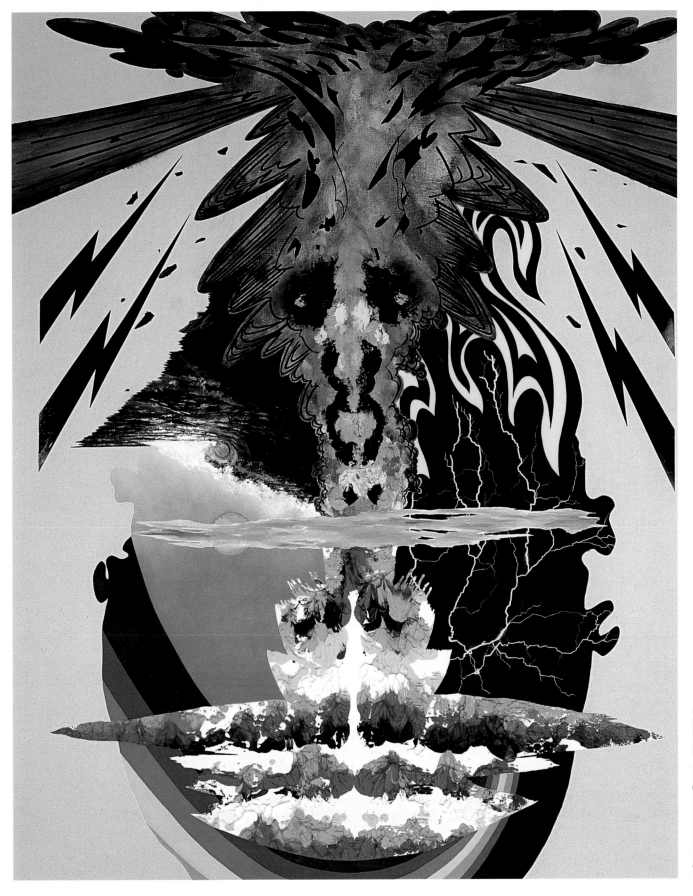

NEIL RUMMING

BIKINI BRAIN, 2001. OIL AND ACRYLIC ON CANVAS, 200 X 150 CM.

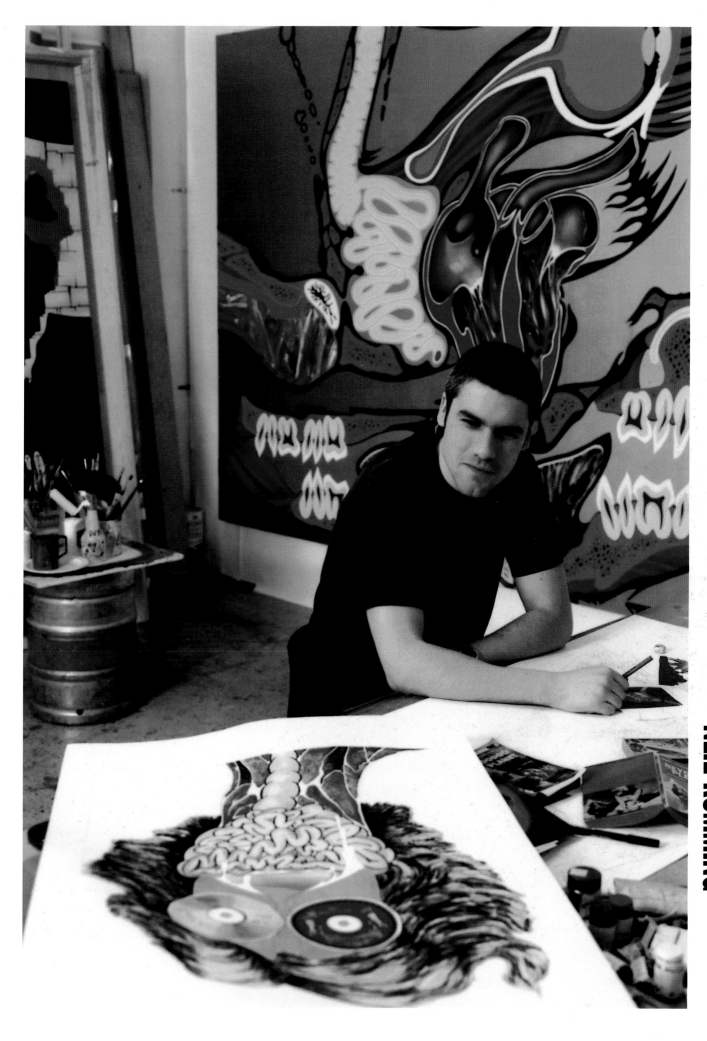

NEIL RUMMING

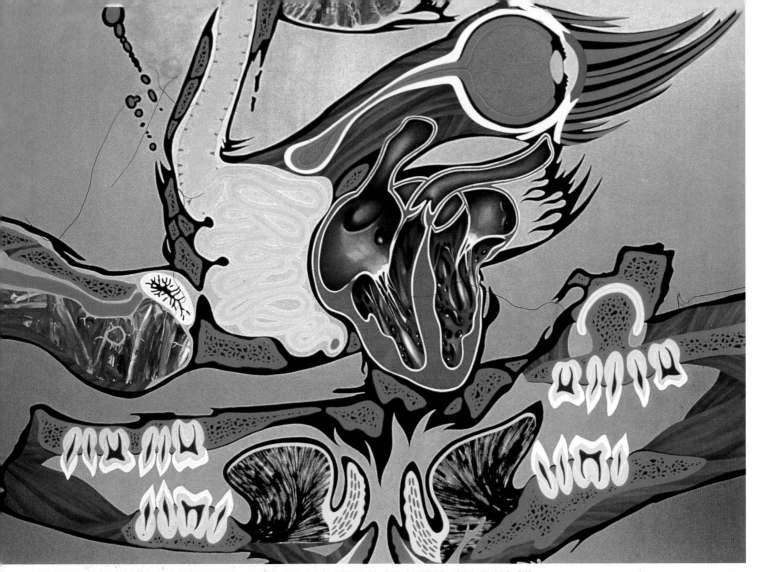

FRANKENSTEIN, NOT LICHTENSTEIN, 2002. OIL AND ACRYLIC ON CANVAS, 300 X 214 CM.

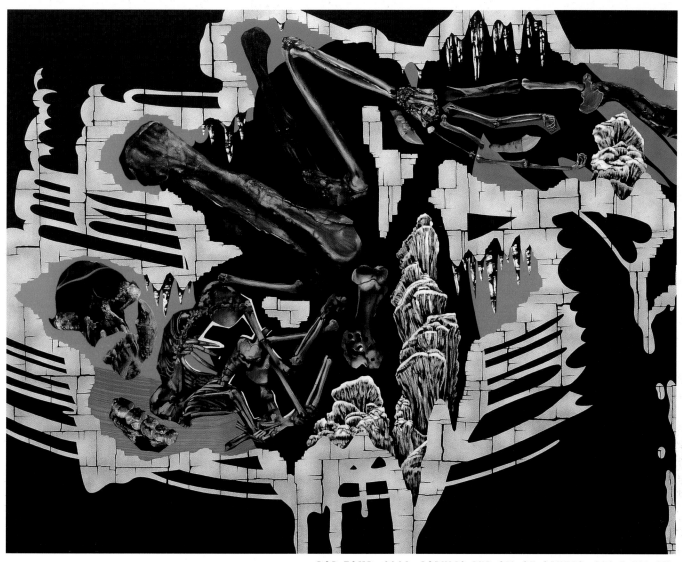

POP TOMB, 2002. ACRYLIC AND OIL ON CANVAS, 300 X 214 CM.

NEIL RUMMING

JENNY SAVILLE

In the early 1990s Jenny Saville turned the fear that many women share of confronting their naked bodies into a full-scale nightmare. Her-larger-than-life paintings of female bodies transformed society's weight obsession into a physical reality, and in so doing, exposed the exaggerated view that people have of their weight. In 1994, two years after Saville graduated from Glasgow School of Art, her paintings were included in the Young British Artists III exhibition at the Saatchi Gallery in London. She was subsequently labelled as the artist who painted fat women. The label stuck, but she was also noted as a strong female force in contemporary painting for successfully updating such a traditional genre as painting the nude.

Comparisons are frequently made between Saville's paintings and those of Lucien Freud, the difference being Saville prefers to paint from photographs, and she doesn't place her figures in any particular setting. Saville's models (including herself) are usually painted from the least flattering vantage. In one of her best-known paintings, *Propped* (1992), a woman is pictured from the ground up, sitting on a stool, grabbing handfuls of flesh from her legs with a look of anxiety on her face. In *Plan* (1993), lines are drawn across excess areas of fat, as if in preparation for the plastic surgeon's knife. As her paintings developed, Saville kept the same subject and scale, but moved away from the political, feminist slant and began to focus on her fascination with how the materiality of paint could be manipulated to represent human flesh. In *Fulcrum* (1999), she piled three bodies, including her own, on top of one another to create a stack of women. She, a friend, and her friend's mother become objects, like meat, put into incredibly awkward positions. Looking at the center of the composition, it is impossible to make out the various limbs as the detailed brushwork and subtle tonal shifts in color merge. Likewise, in *Shift* (1996-97), Saville pushed bodies together creating vertical strips of flesh and skin—subtle color gradations and thickly applied paint create the substance of flesh as well as the appearance of skin. Different-sized naked females are arranged on the canvas like human sardines in a can—too vast to be real, they become areas of light shadow, pink tones, and blue veins. Saville's obsession with the body has led her to investigate plastic surgery and graphic medical photography; her explorations have even led her to make an ambiguous painting that resembles a body that is part pig, part woman.

JUNE 26TH, 1.00, JENNY SAVILLE
Jenny Saville likes plastic surgery as much as I do. Her studio was like a butcher shop, full of different coloured blood, and very realistic. She had a curious amount of medical books on murder, surgery, and teeth. As she spoke she gave me a lecture on the different layers of skin and then quickly changed the conversation to her favourite place, a palace in Italy. Jenny is sophisticated, with wonderful bosoms and a great face full of life. I really liked her. Her studio is in a multicoloured district of London where they make clothes, which I didn't know existed. A.E.

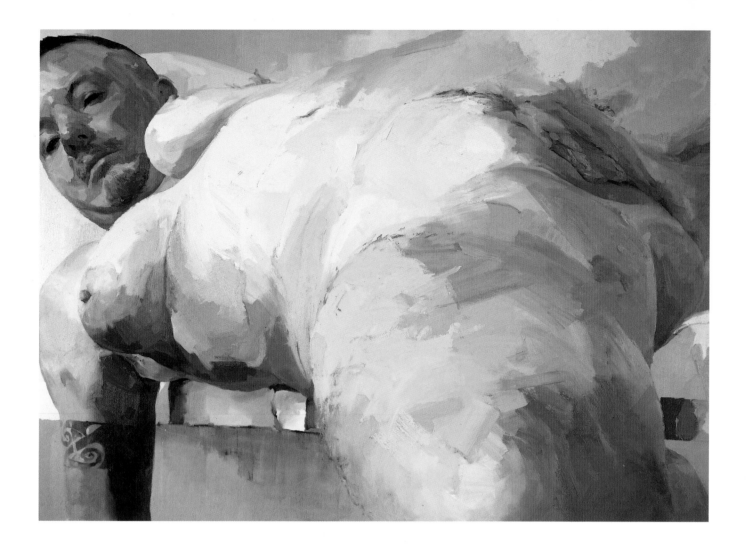

JENNY SAVILLE

MATRIX, 1999. OIL ON CANVAS, 213,4 X 304,8 CM.

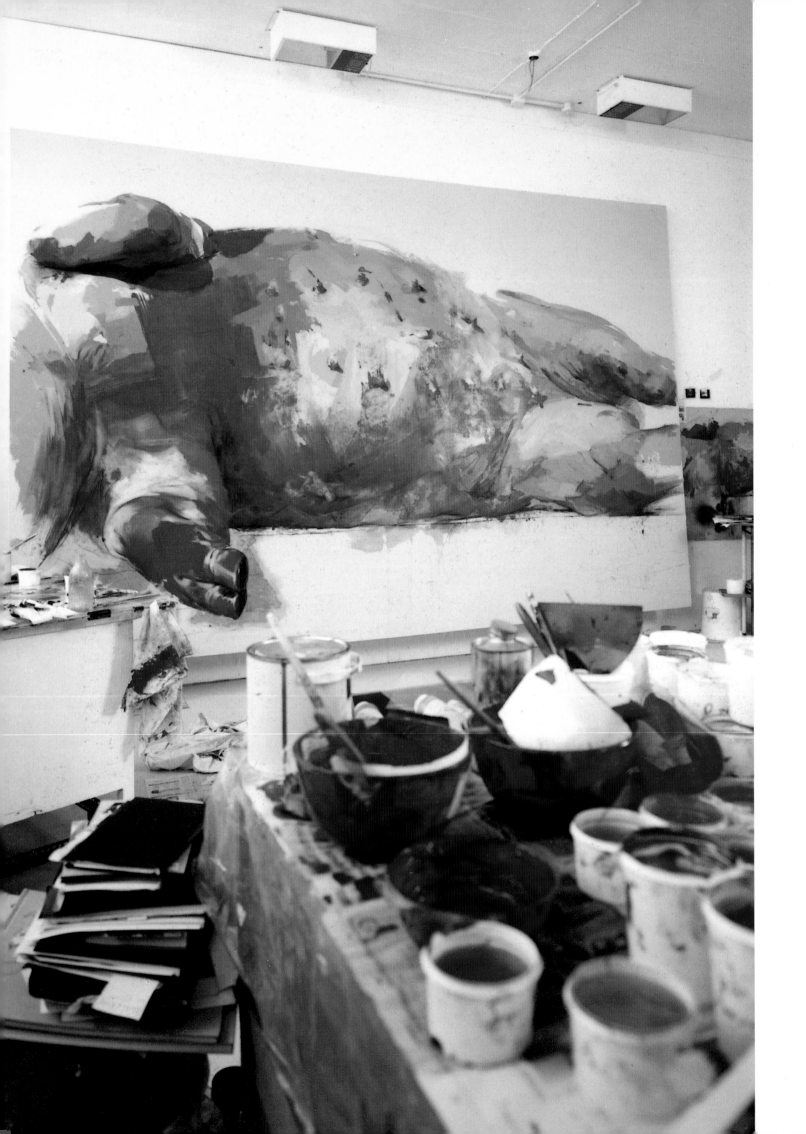

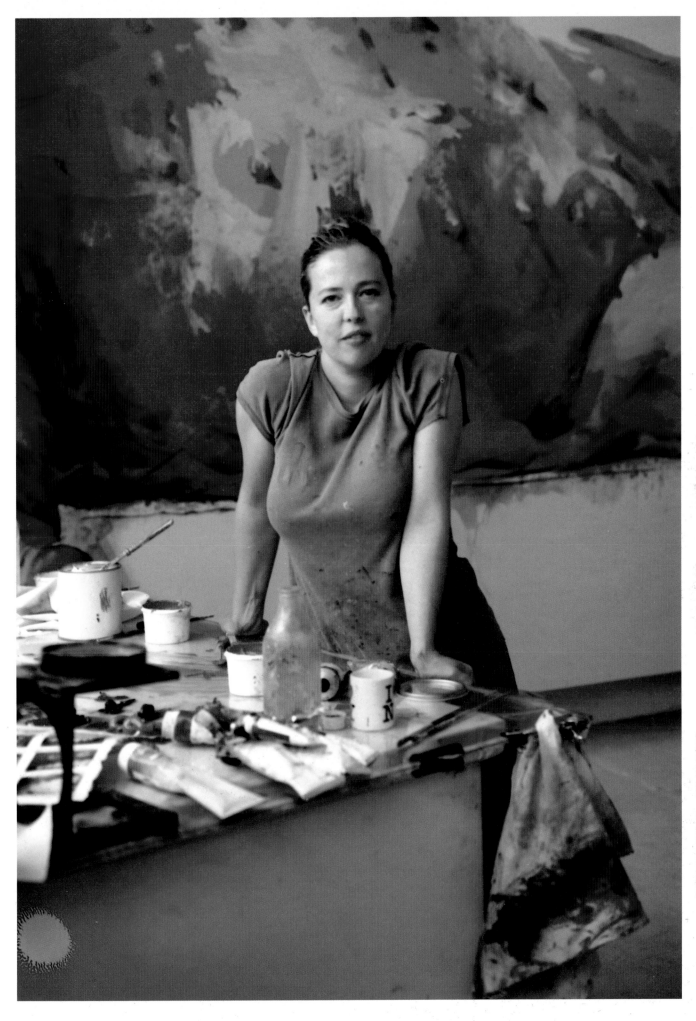

JENNY SAVILLE

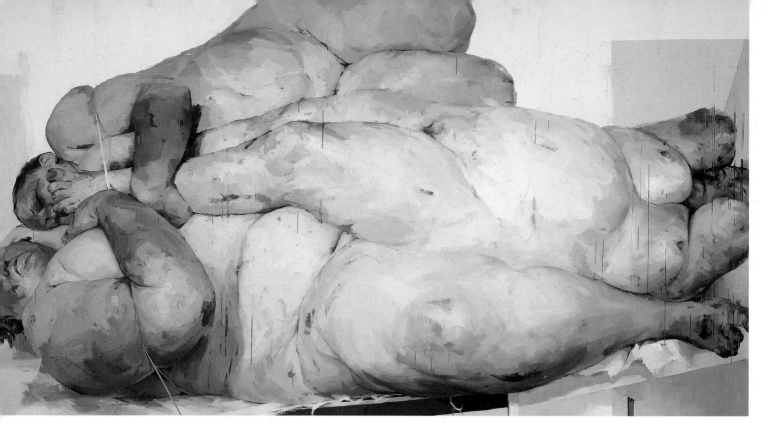

FULCRUM, 1999. OIL ON CANVAS, 261,1 X 487,7 CM.

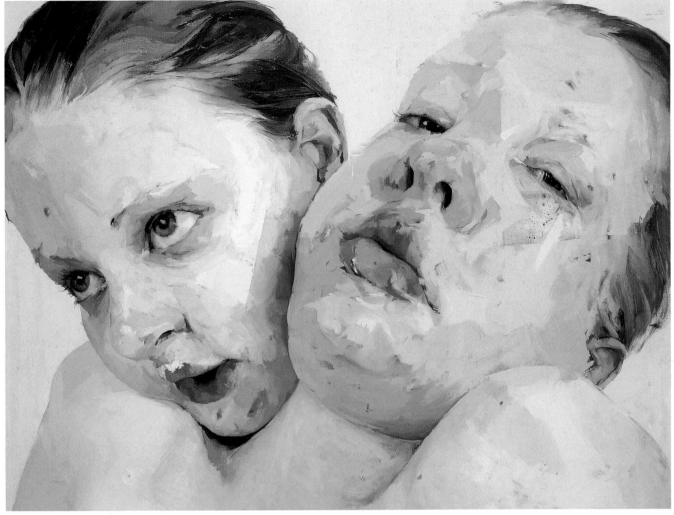

HYPHEN, 1999. OIL ON CANVAS, 274,3 X 365,8 CM.

JENNY SAVILLE

D. J. SIMPSON

D. J. Simpson's work is not easy to categorize. At first glance it appears to be painting, but Simpson doesn't use paint. It has elements of Paul Klee-style drawing, but depending on its position in a room and how it occupies space, it could be sculpture or installation. Simpson has been using an electric router to make his work since 1997, cutting into chipboard or plywood covered with coloured Formica or aluminum. His "paintings" are comprised of doodles, lines, sketchy drawing, and geometric shapes. They resemble Abstract Expressionist Mark Tobey's Eastern calligraphy, which seems an odd thing to revive in contemporary art, but Simpson is able to take away the associations of mysticism yet retain the elegant use of line. There is something of Cy Twombly's chalk and blackboard works in the way Simpson's works are both drawings and paintings. Also apparent are elements of Clyfford Still's paintings from the 1960s. Still made textured surfaced monochromes by covering up what he had painted underneath; Simpson does the same, but instead of adding paint to a surface, he carves out layers of board or wood with his router. The variety of mark making is fast paced, yet detailed, considering the scale of the works—when examined closely, the panels reveal the intimacy with which they have been dug out. As they lean against the wall in a seemingly casual arrangement, the monochrome panels and their monumental scale recall Minimalism and the physicality of Richard Serra's sculptures.

When Simpson left Goldsmiths College in 1998, his work was considered a breath of fresh air. His large, incised monochromes were simply made on a surface of aluminum, or decorative colour or laminate, but they had a fucked-up, school kid does graffiti edge to them. People quickly responded to Simpson's intelligent revival of a number of painting styles within a sculptural format. In *Abstract Art* at Delfina Gallery in 2000, the two-dimensional/three-dimensional nature of his work related well to both the painters and sculptors in the show. In *Heart and Soul* (1999), he carved small, overlapping ovals directly into the wood-panelled walls. For his solo show at Entwistle Gallery in 2000, three large panels were tilted against the wall at a diagonal. These works dominated and dictated the space with their threatening physical presence in a way that wasn't polite or compromising. Simpson did what many artists try to do, but few succeed at. He took over the space and made it his own with work that dwarfed the viewer and overwhelmed the icy austerity of the West End gallery. Likewise, in *New Labour* at the Saatchi Gallery in 2001, Simpson's work actually leaned against the beams of the building and created a partition in the huge central space of the gallery. It takes a large piece to make the Saatchi Gallery look small, but Simpson's work isn't simply big for big's sake. He is able to handle scale, to balance the heroic tradition of abstraction with the craft connotations of wood carving, and still avoid being slapped with a label.

APRIL 10TH, 3.00, D. J. SIMPSON
D. J. Simpson had borrowed a studio as his work is so large he couldn't fit it into his normal one. He was busy with a saw, a drill and a polisher when I came in. You couldn't see his face as he was wearing goggles and had a huge mop of curly hair. A.E.

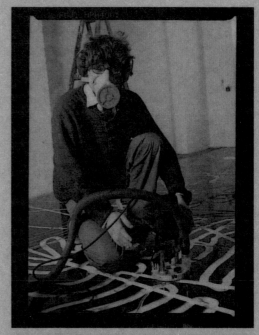
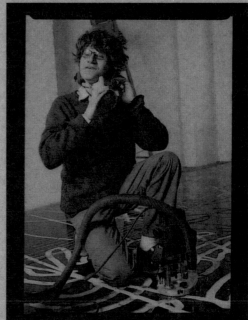
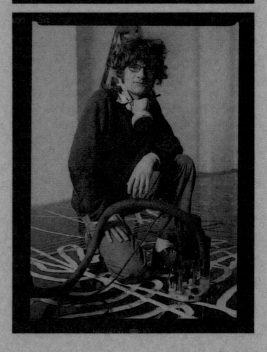

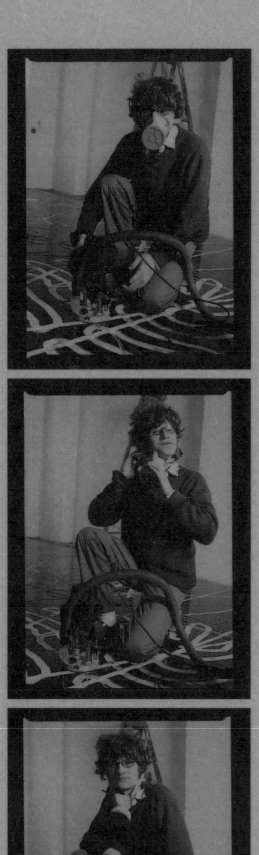
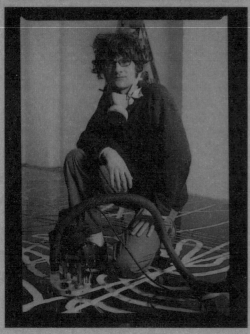

D. J. SIMPSON

SECONDARY MODERN (DETAIL), 2001. FORMICA ON BIRCH PLYWOOD, 365,8 X 731,5 CM.

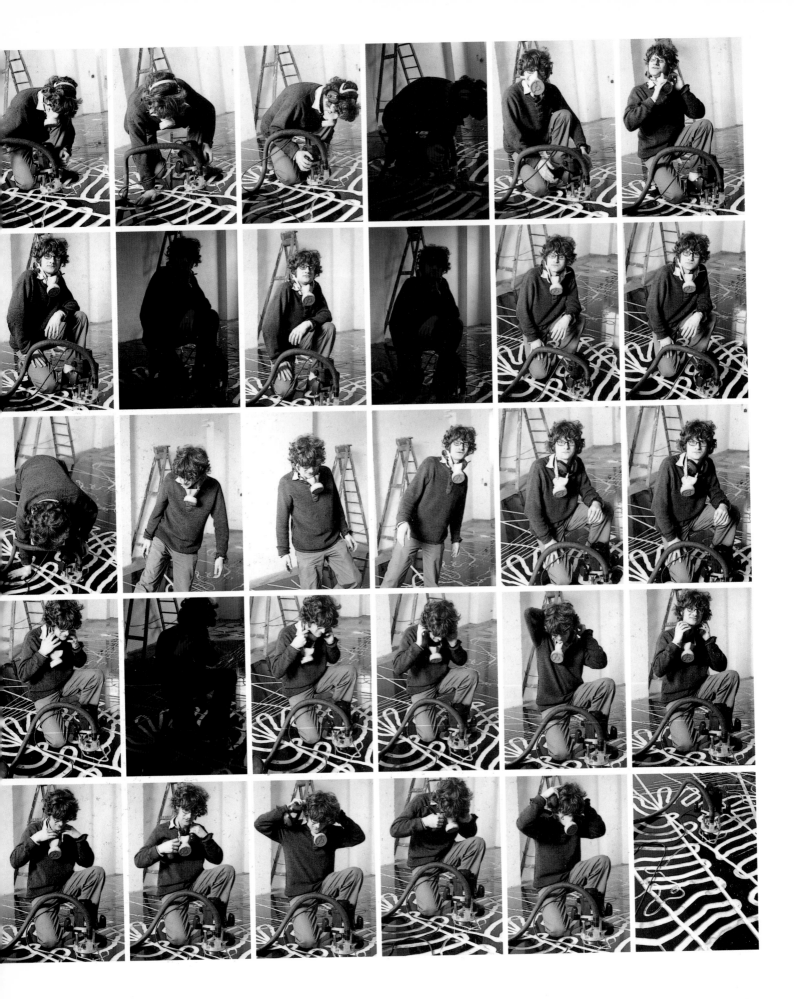

SCHNOERKEL PAINTING, 2000. ALUMINIUM LAMINATE ON MDF, 274 X 731 CM.

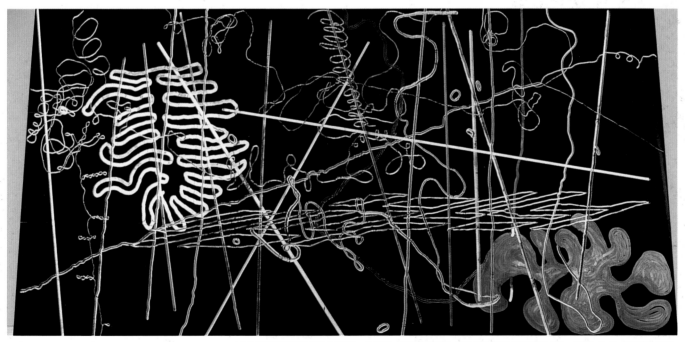

SECONDARY MODERN, 2001. FORMICA ON BIRCH PLYWOOD, 365,8 X 731,5 CM.

D. J. SIMPSON

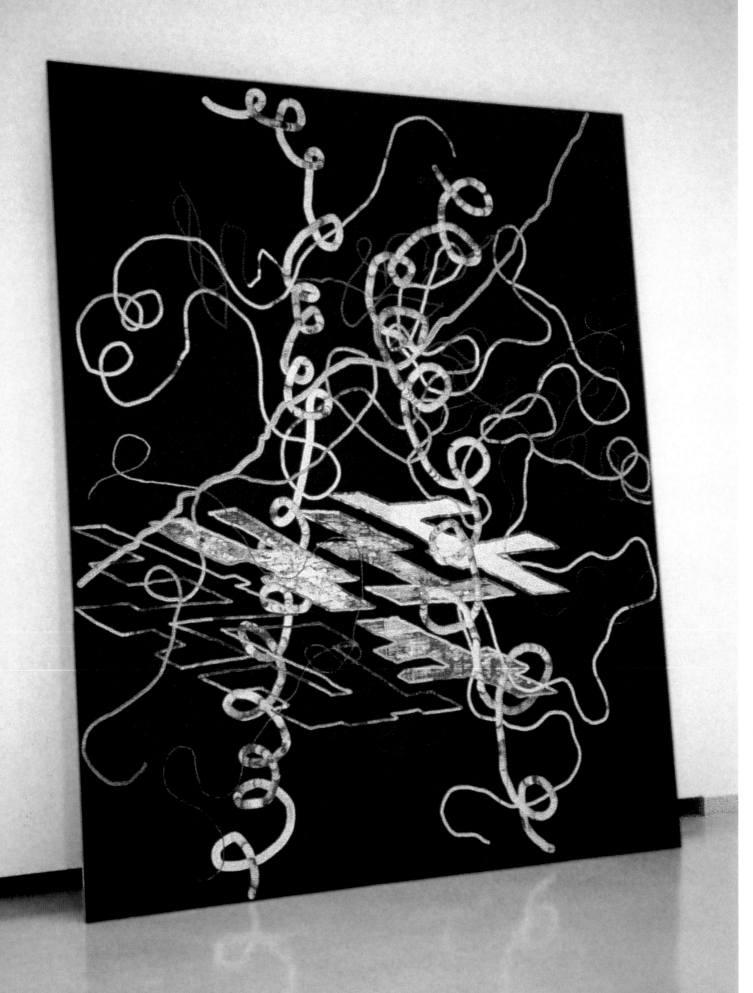

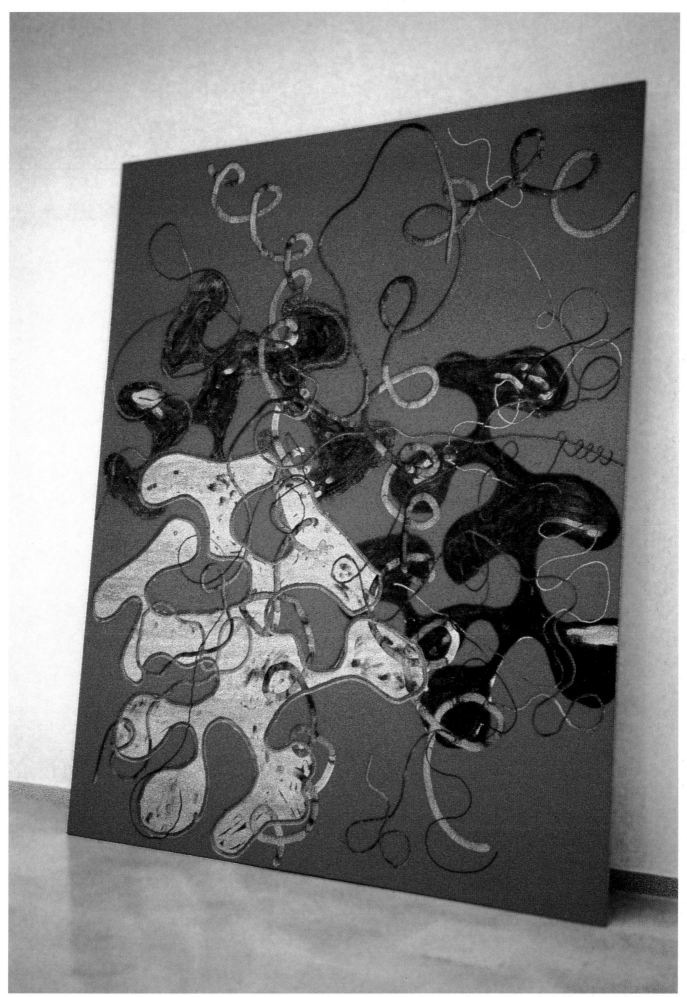

D. J. SIMPSON

ABOVE: EVERYWHERE AND ALL OVER, 2001. FORMICA ON BIRCH PLYWOOD, 360 X 300 CM.
LEFT: EGO TRIPPIN, 2001. FORMICA ON BIRCH PLYWOOD, 300 X 360 CM.

SAM TAYLOR-WOOD

The first time I ever laid eyes on Sam Taylor-Wood, she had her jeans down around her ankles and was wearing a white T-shirt with "FUCK SUCK SPANK WANK" written brazenly across her chest. Her hair was tied back carelessly and she had that "fuck-you" expression on her face. This was her 1993 self-portrait making me think she was going to be a scary character. "Who is that?," I thought. Not long after, I met her in person and thought, "What a fresh-faced ingenue!" Her demure manner held a lot of gentleness yet self-confidence. "That girl makes art? Hmm, interesting."
I followed her career with my now ex-husband Charles Saatchi, and we collected her work with a passion. It was so provocative, so strong, so original, so raunchy, and yet so elegantly humane. Often people would ask me to explain her work to them, and I had to answer that I couldn't. I'd tell them just to look and find the universal emotions behind her images. The power of her art comes from deep intellect, her keen eye for the visually exciting comes from a strong questioning and emotionally enlivened mind.

She's also a babe. She is always dressed with such impressive individual style (a muse for designers Alexander McQueen and Stella McCartney) and can outshine super-models with her innate femininity and fashion sense. As I got to know her at art events and social dinners, I began to feel a kinship with her. She married her dealer, Jay Jopling, the dashing and successful owner of White Cube, and soon after had a daughter, Angelica, the year before I had given birth to my daughter Phoebe.
In 1997 she was honored with the Most Promising Artist award at the Venice Biennale. The following year she was nominated for the prestigious Turner Prize.
I've always loved Taylor-Wood's intuitive interpretation of art history and her ability to clearly reinterpret painful emotions. When I first saw her work *Atlantic* at the Tate in 1999, I was moved to tears. It's a video of an argument between a man and a woman in a restaurant. You witness the woman's distraught face but only the man's aggressive gesturing hands. The piece is not silent, but viewers are not allowed full access to the conversation. You experience the hub of the restaurant, and snippets of the couple's exchange fade in and out. However, you do not need to hear everything to feel the domestic violence and the isolation of the two people.
I would not call Sam a feminist, but she is a female artist and manages to tell the truth with a combination of brutality and finesse. She gives us real stories of life: fear, suffering, pain, anxiety, heartbreak, loneliness, and all the other truly human sides of our life on earth. In her latest work she confidently explores herself in a range of incredibly moving and personal pieces. It is because of her unconditional strength, among other reasons, that I am proud and honored to know that girl called Sam.

K.H.S.

MAY 7TH, 4.00, SAM TAYLOR-WOOD
Sam Taylor-Wood is the star you would imagine she is from the picture in *Hello*, and I realized this as I sat in Jay Jopling's office last week watching her new video of a hare and a peach. The hare completely disintegrated long before the peach and this is an image that will stay with me for a long time.

A.E.

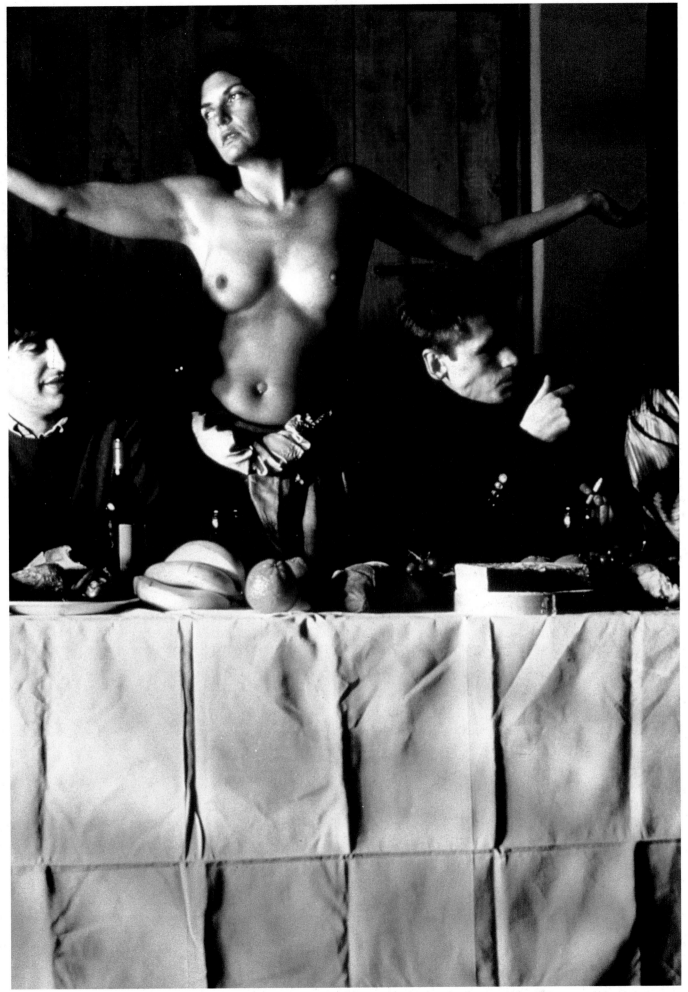

SAM TAYLOR-WOOD

WRECKED (DETAIL), 1996. C-TYPE COLOUR PRINT, 152,4 X 396,2 CM.

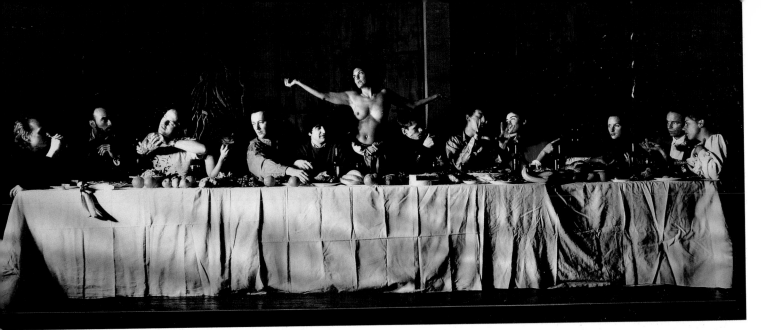

WRECKED, 1996. C-TYPE COLOUR PRINT, 152,4 X 396,2 CM.

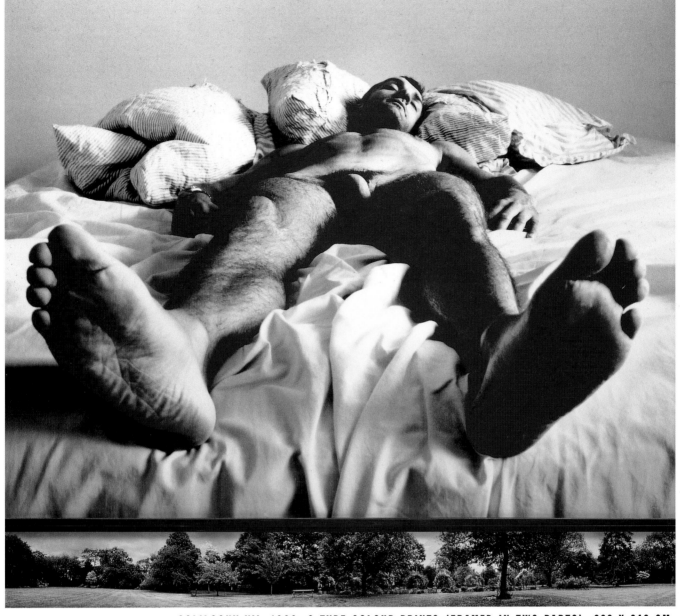

SOLILOQUY VII, 1999. C-TYPE COLOUR PRINTS (FRAMED IN TWO PARTS), 222 X 242 CM.

SAM TAYLOR-WOOD

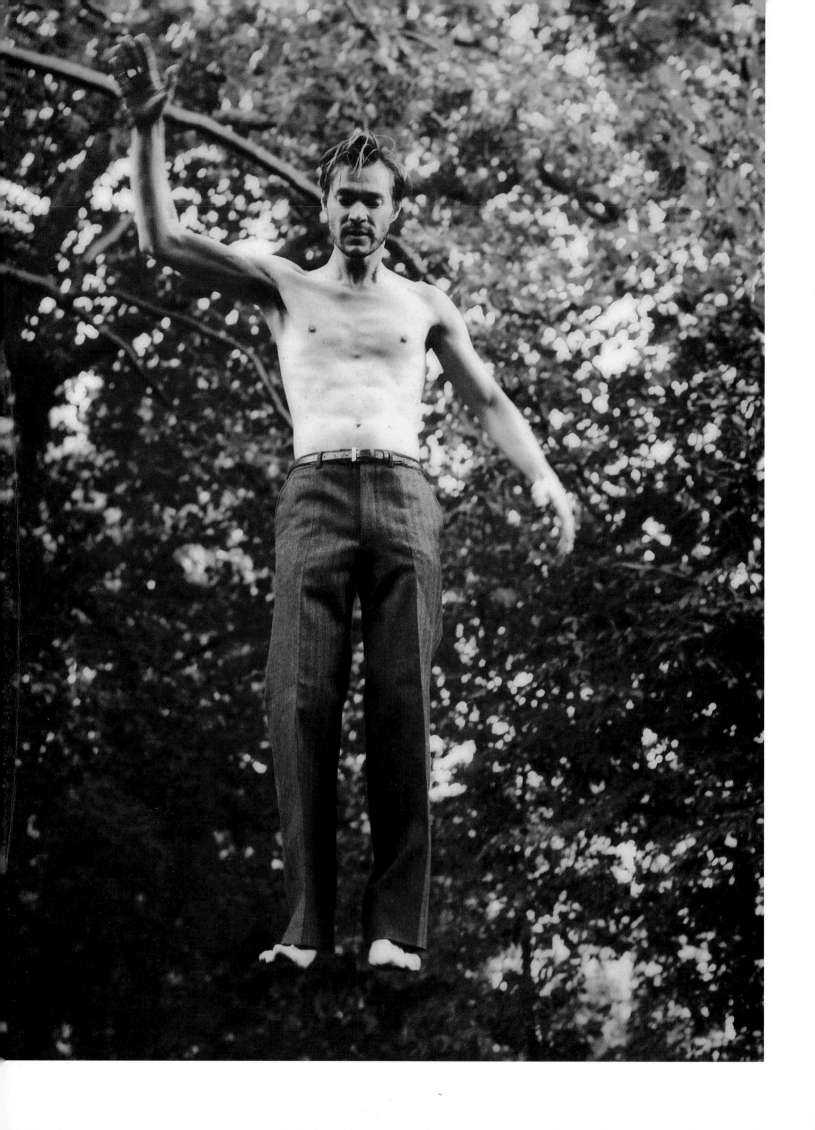

ABOVE: SELF PORTRAIT AS A TREE, 2000. C-TYPE PRINT, 75,6 X 91 CM.
LEFT: THE LEAP, 2001. C-TYPE BACK MOUNTED ON PLEXI, 253 X 187 CM (INC. FRAME).

SAM TAYLOR-WOOD

GAVIN TURK

In his Royal College of Art MA show, Gavin Turk's space was empty except for a fake English Heritage plaque that read, "Borough of Kensington Gavin Turk Sculptor Worked Here 1989-1991." It made him an art-school failure but an art-world success. This was to be the first of many artworks in which Turk authorized his own fame. The conservative attitude of the college misinterpreted Turk's conceptual gesture as a declaration of a slacker work ethic and saw the "sculpture" as an act of ungrateful subversion by an egomaniac who publicly declared that he had nothing else to show from his two years of study there. Turk's thinking cap became a dunce's hat according to the college marking system. In his bold statement he declared himself a Conceptual artist and stuck two fingers up at a school that valued object making and a craft tradition. The absence of objects was filled with the myth of the artist.

Turk made himself known by disguising himself as a variety of famous people. Finding forms for his daydreams of fame, he asked the audience to share his delusions of grandeur. In the early 1990s he made a series of signature works. *Piero Manzoni* (1992) questioned what it meant to make something authentic, picking up on the buzz of Roland Barthes's idea of the death of the author and the fashion for appropriation. Turk continued this line of thought in other works by writing his signature with the material or styles used by other artists.

Turk's search for himself and his identity went beyond signing his name. *Pop* (1993) took his *Stars in Their Eyes* teenage posturing out of the bedroom and gave it sculptural form. He cast himself as every rebel's dream in a waxwork figure dressed as the dead Sex Pistols's punk rocker Sid Vicious in the stance of Warhol's gunslinging Elvis Presley, presented in a vitrine. *Pop* was like a Cindy Sherman photograph as a sculpture with a touch of youth culture and celebrity thrown in. It was shown in *Sensation,* and Turk turned up to the opening dressed as a tramp, a performance he later drew upon to make a waxwork model, a series of photographs, and other related sculptural objects.

Turk's *Pimp* (1997) is an oversized, polished, black skip that was manufactured to order, combining the look of a ready-made with that of a minimal sculpture. Likewise, his bronze bin bags are exact replicas of the real thing; placed in the gallery, they occupy the space like a grandiose formal sculpture. Turk again manages to attach poetic meaning to nothingness. He avoids autobiography but builds his reputation by associating himself with the lives of cult figures and legendary artists, and in doing so he has created his own myth, that of Gavin Turk.

MAY 1ST, 11.00, GAVIN TURK
Up a slim staircase with many floors I arrived at the studio of Gavin Turk, who was obsessed with his baby. He is the first man I've seen who loves babies. He couldn't stop playing with him. Very charismatic and charming. His studio is not in the East End, but near Charing Cross. He was busy making bronze look like a box while his child was thumping everything with a hammer. A.E.

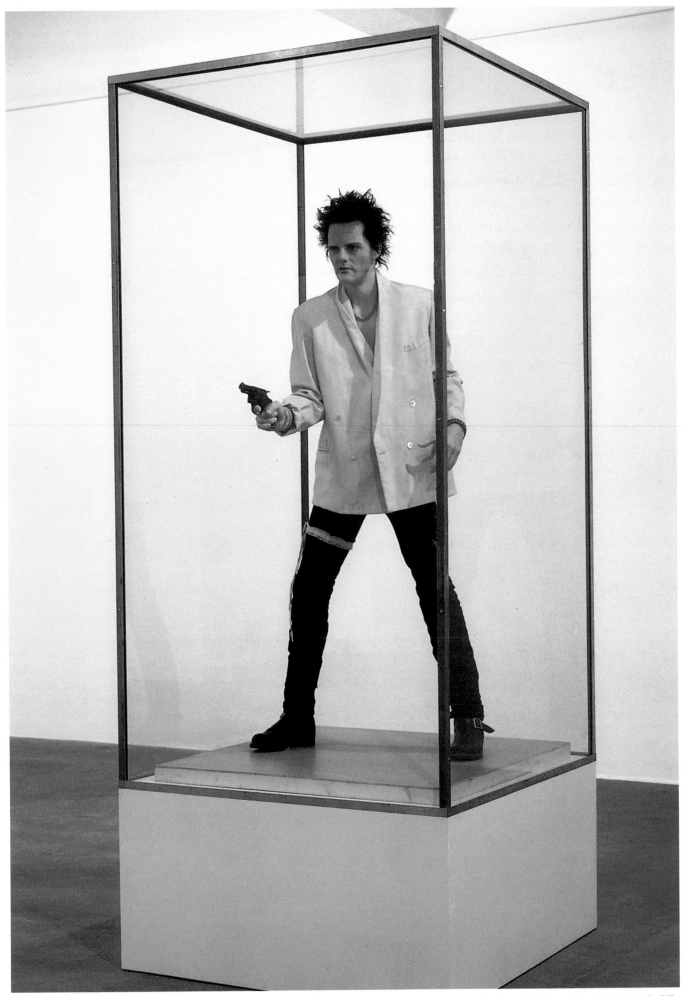

POP, 1993. WAXWORK IN WOOD, GLASS AND BRASS VITRINE, 279 X 115 X 115 CM.

GAVIN TURK

BOROUGH OF KENSINGTON

GAVIN TURK
Sculptor
worked here
1989~1991

ABOVE: THE DEATH OF MARAT, 1998. MIXED MEDIA AND VITRINE. VITRINE: 200 X 250 X 170 CM.
LEFT: CAVE, 1995. SILKSCREEN ON PLASTIC, 48,5 CM. DIAMETER.

GAVIN TURK

PIMP, 1996. PAINTED STEEL, 183,5 X 373 X 184 CM.

GAVIN TURK

BAG 10, 2001. PAINTED BRONZE, 43 X 53 X 46 CM.

REBECCA WARREN

Rebecca Warren's *The Mechanic* (2000) is named after the film starring Burt Reynolds and inspired by a Helmut Newton photograph of a woman straddling and suffocating a man. In Warren's three-dimensional version, a woman's naked bum sticks up in the air above a man's erection and stumpy legs. Because they are spinning around, these two fragile, miniature figures look as if they have appeared from nowhere and might dis-appear any minute. This delicately colored, rotating sculpture plays on the kitsch association of trinket-box figurines.

Warren started working in clay after a study trip to Greece. Prior to that, she had worked in a variety of media, such as installation, video, photography, and neon. She wanted to produce objects that required a hands-on involvement. The unfinished look of her sculpture is a celebration of the malleable qualities of clay.

Warren's sculptures often resemble maquettes: they are unfired and appear as though she stopped at the most pleasurable point of her making. She resists forming them into a conventional figurative sculpture. The entanglement of the figures within the clay relates to Warren's understanding of the history of art and how she reconciles a range of eclectic influences, from the works of Rodin and Umberto Boccioni to Fontana and Robert Crumb. Warren puts incompatible moments of art history together. She connects artists working in different media from different historical periods. By copying aspects of their work, she has found a way to explore her fascination and obsession with them. She enjoys taking two-dimensional images of artists and giving them three-dimensional form, and often merges several sources together, but unites them through her own method of making.

The first of her clay sculptures, *Helmut Crumb* (1998), was shown at the Approach Gallery as part of the group show *It's a Curse It's a Burden* curated by the artist Glen Brown. *Helmut Crumb* is a two-part sculpture—two pairs of legs, one standing beneath the other—and as the title suggests, it was inspired by a Robert Crumb newspaper cartoon of a woman and a Helmut Newton photograph. The work illustrates the ways in which women's bodies have been reduced to sexual parts by the male gaze of artists. Warren, through her lumpy forms, delivers a version that is more granny's tights than sex kitten.

APRIL 30TH, 11.00, REBECCA WARREN
Rebecca Warren has an interesting face, I could have photographed it all day. Her studio appeared full of ghosts. It is small, compact and all her sculptures lie underneath huge plastic sheets to stop them from drying out.
A.E.

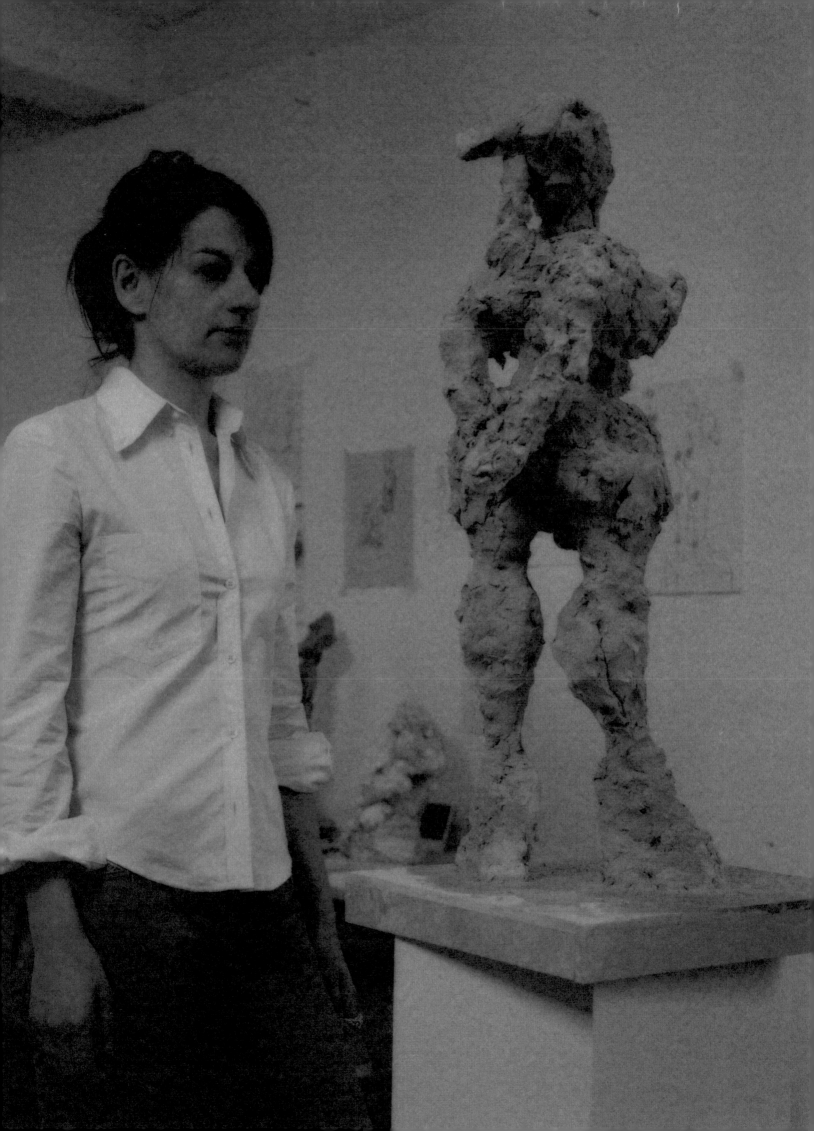

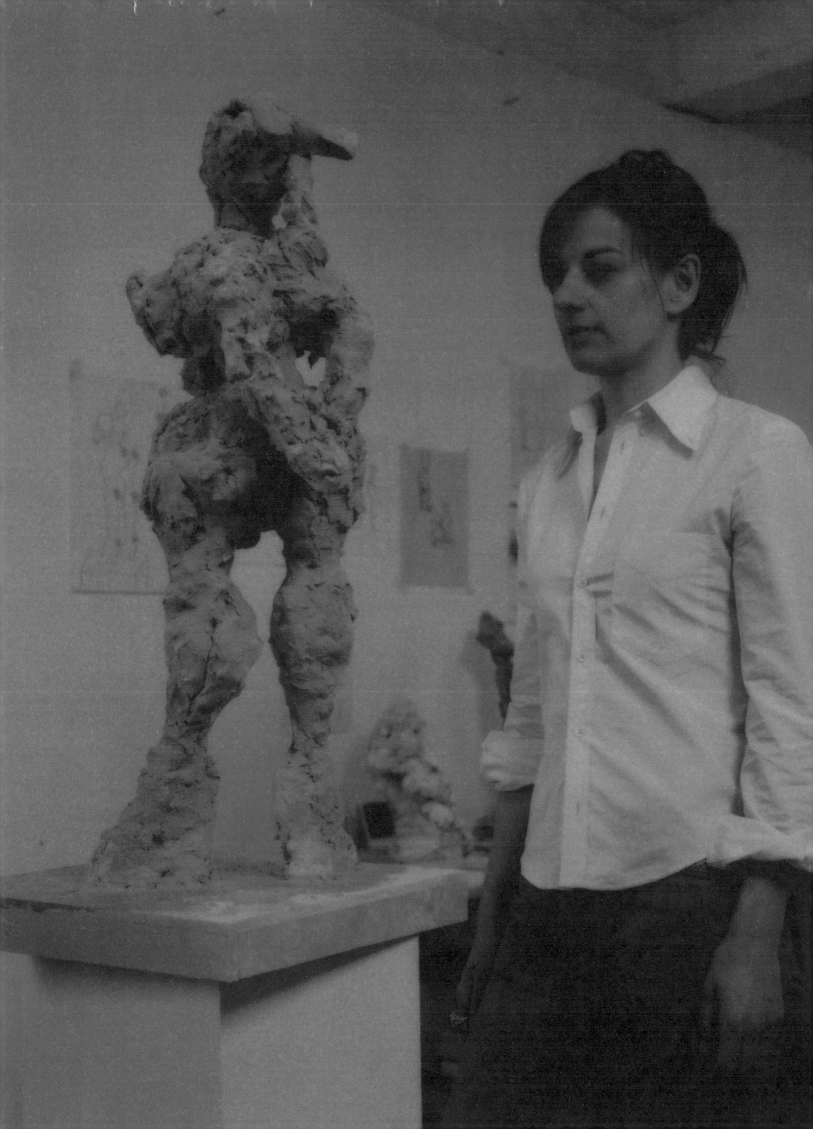

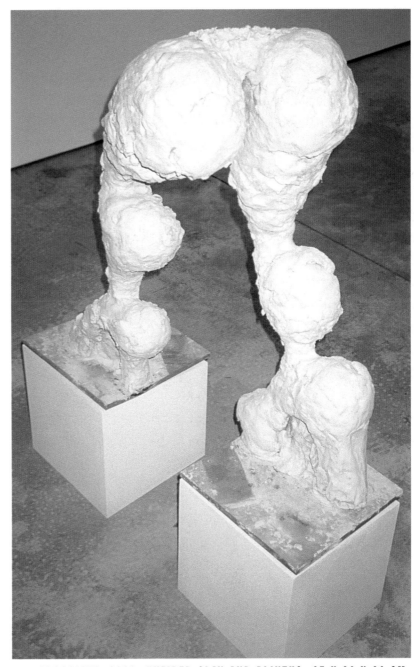

CROCCIONI, 2000. UNFIRED CLAY AND PLINTHS, 85 X 34 X 84 CM.

REBECCA WARREN

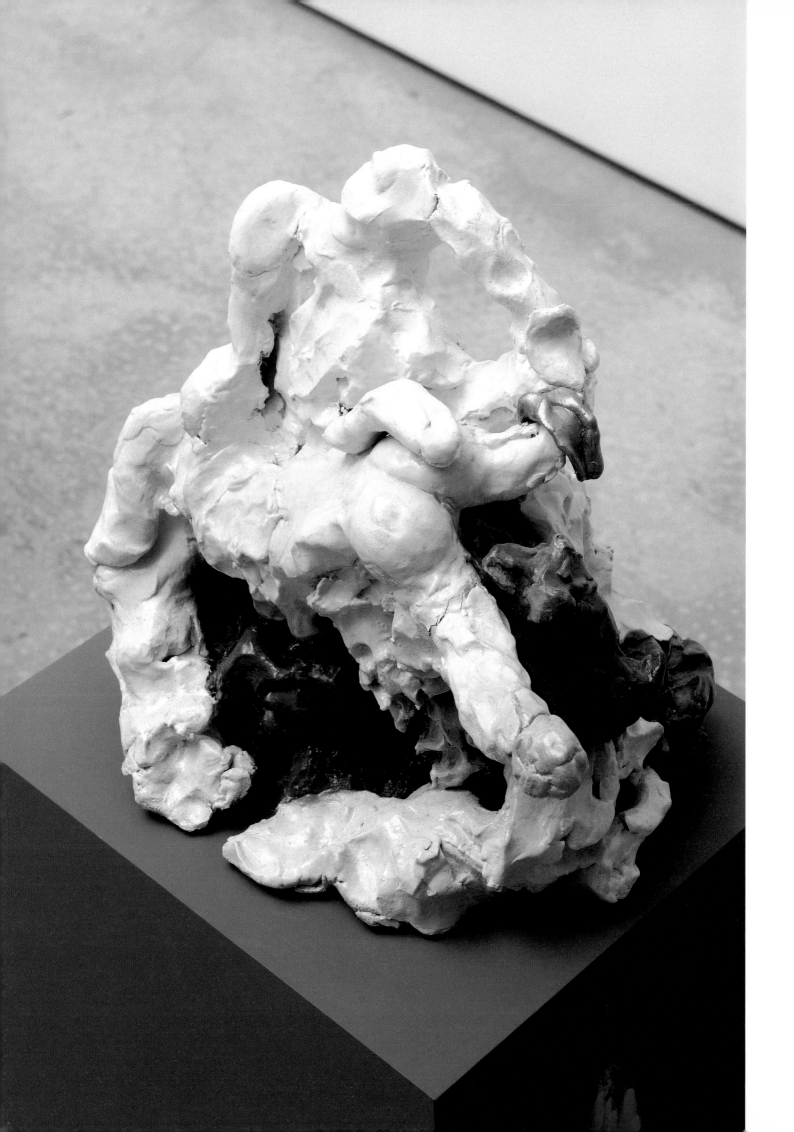

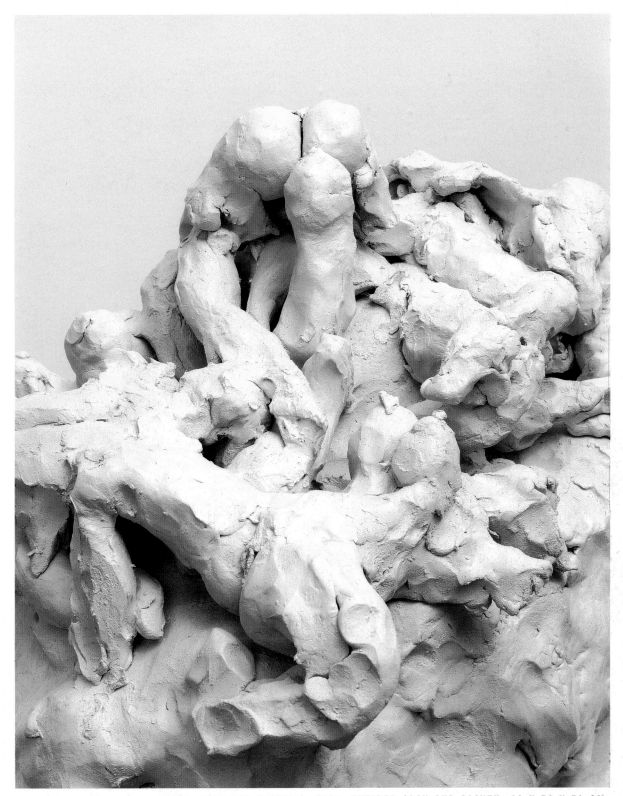

ABOVE: EMPEROR (DETAIL), 2001. UNFIRED CLAY AND PLINTH, 40 X 56 X 50 CM.
LEFT: MOULIN ROUGE, 2000. PAINTED, UNFIRED CLAY AND PLINTH, 30 X 40 X 34 CM.

REBECCA WARREN

GILLIAN WEARING

Gillian Wearing's film and photography came to public attention following a renewed interest in the gritty realism of 1970s TV documentaries, but just before the explosion of reality TV in the 1990s and its contagious obsession with other people's lives. By taking the documentary as a model, Wearing is able to present the fragility of her artistic concerns through a hard-hitting and familiar format. Her films can be embarrassingly funny, and as such, the viewer is asked to question the reality of what he or she is seeing and separate it from the experience of watching a TV documentary. Unlike the TV voiceover style, Wearing usually keeps her distance by allowing her subjects to analyze themselves, thus letting the story tell itself.

In 1992 Wearing began a series of photographs titled *Signs that say what you want them to say and not signs that say what someone else wants you to say*, in which she asked strangers on the street to write down on large sheets of paper anything they wanted and then to hold them up while being photographed. Wearing took a step back from straight portraiture, but kept its directness. As an artist she became local and pedestrian, involved in the world rather than just commenting on it. She put herself in a real situation instead of placing her subject in a contrived one. These photographs are like portraits with subtitles, and in *Confess all on video. Don't worry, you will be in disguise. Intrigued? Call Gillian* she took the idea a step further by offering strangers the opportunity to speak freely on video.

In her films *Homage to the woman with the bandaged face who I saw yesterday down Walworth Road* (1995) and *Dancing in Peckham* (1994), Wearing turned the camera on herself, even though both subjects were inspired by somebody else. Her interest in the marginalised and the vulnerable led her to blur the distinction between documentary and the re-creation of actual observation, choosing not to exploit the person she had been drawn to; she instead borrowed what it was of the original event that had caught her attention. Her behavior in both films—dancing in a shopping center to no music, and walking down a busy road with her face covered in white bandages—makes her the focal point, while, at the same time, the films record other people's reactions to her.

Wearing's work highlights the type of people who would usually be ignored or conversations that would be inappropriate in day-to-day life. She tunes into society's loners and outcasts and presents them as people worth listening to, without imposing judgmental commentary that forms stereotypes and reinforces prejudices.

TOMORROW... GILLIAN WEARING
Gillian Wearing says "tomorrow"... but tomorrow never comes. I never managed to photograph her. A.E.

CONFESS ALL ON VIDEO..., 1994. VIDEO TAPE, 30 MINUTES.
ON FILM: DANCING IN PECKHAM, 1994. VIDEOTAPE, 25 MINUTES.

FROM TOP TO BOTTOM: SIGNS THAT SAY, 1992-1993.
C-TYPE PRINTS, 40 X 30 CM.

CONFESS ALL ON VIDEO..., 1994. VIDEO TAPE, 30 MINUTES.

GILLIAN WEARING

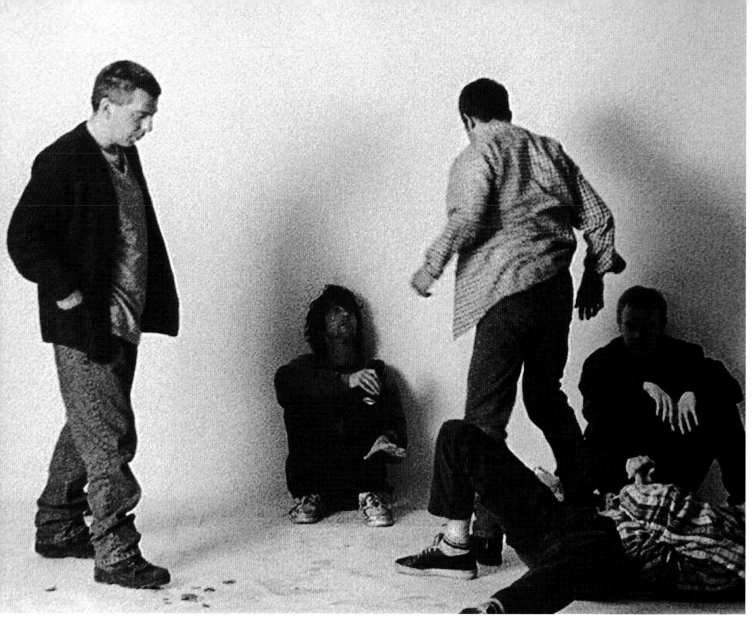

DRUNK, 1999. DVD 3 SCREEN VIDEO PROJECTION, 23 MINUTES.

DRUNK, 1999. DVD 3 SCREEN VIDEO PROJECTION, 23 MINUTES.

GILLIAN WEARING

RACHEL WHITEREAD

The first negative cast that Rachel Whiteread made was "by pressing a spoon into sand and then poured lead into the space it left behind." She has applied the same principle to all of her sculpture since, casting the inside spaces of furniture, domestic objects and buildings with a variety of materials including plaster, resin, rubber, and concrete.

Whiteread first studied painting at Brighton Polytechinic from 1982 to 1985 and sculpture at the Slade School of Art from 1985 to 1987. She became known for casting the inside space of everyday items of furniture that we often take for granted. In her early work, Whiteread cast small items of personal furniture such as a dressing table from her home, the space underneath her bed, and the inside of her childhood wardrobe. These sculptures described intimate relationships with objects and furniture without being overtly sentimental. In 1990, Whiteread made *Ghost*, an entire room cast in single blocks of concrete which was then reassembled and shown in London's Chisenhale Gallery. Whiteread enclosed the empty, invisible areas inside of a domestic space and gave them a physical presence.

Formally, Whiteread's sculpture follows a 1960s minimalist aesthetic, as everything is stripped back to a pure monochromatic form without much detail or ornamentation. However, she sullies the minimal form with the existence of life and memories of previous lives. In 1993, when Whiteread was nominated for the Turner Prize, she was working on her largest cast to date. *House* was an interior cast taken from a Victorian terraced house in Bow in East London. The three-story building was cast in concrete from the basement up, new foundations were laid to support it. The original house was literally knocked away and peeled off from the outside, revealing a vast concrete monument. Although only commissioned by Artangel as a temporary public sculpture, the ambition of the work was appreciated by those that saw it and was heralded as Whiteread's greatest work. On the night she was awarded the Turner Prize, she learnt that *House* would be pulled down. Since then she has made further public artworks including *Monument* (2001) for the empty plinth in Trafalgar Square, the *Holocaust Memorial* (1995) on Judenplatz in Vienna, a project which took five years to realise, and *Water Tower* (1998) in New York, commissioned by the Public Art Fund.

JUNE 19TH, 14.00, RACHEL WHITEREAD
Rachel Whiteread is a cosy, freckly woman who looks like a math teacher and wears Jesus sandles. Her studio has one of the most interesting views overlooking a canal and she has a huge collection of doll houses. I felt very much that we were interrupting her work.　　A.E.

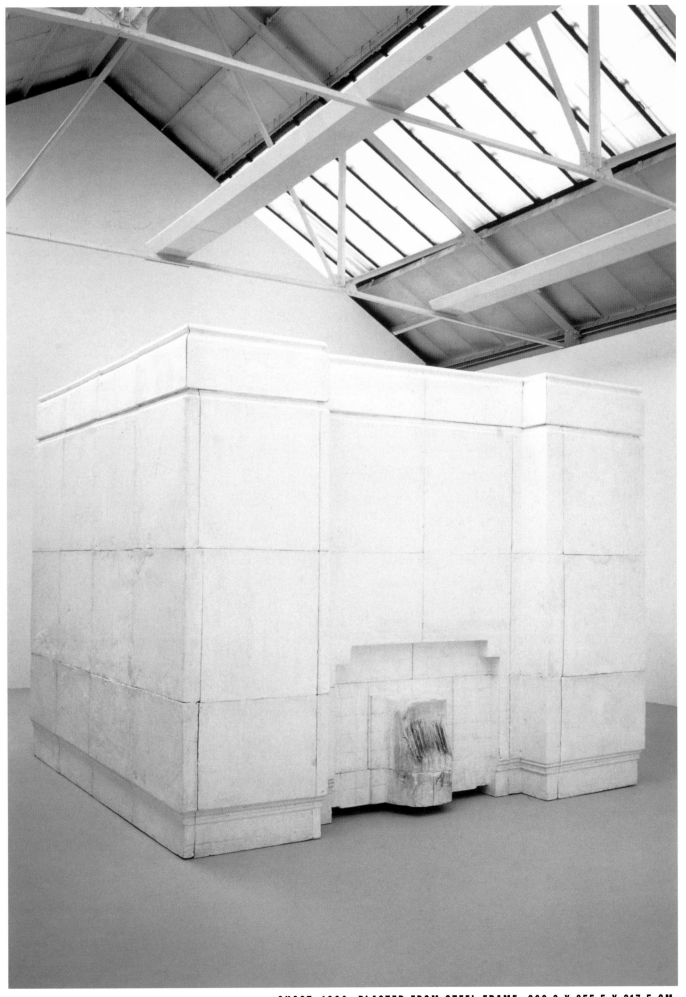

GHOST, 1990. PLASTER FROM STEEL FRAME, 269,3 X 355,5 X 317,5 CM.

RACHEL WHITEREAD

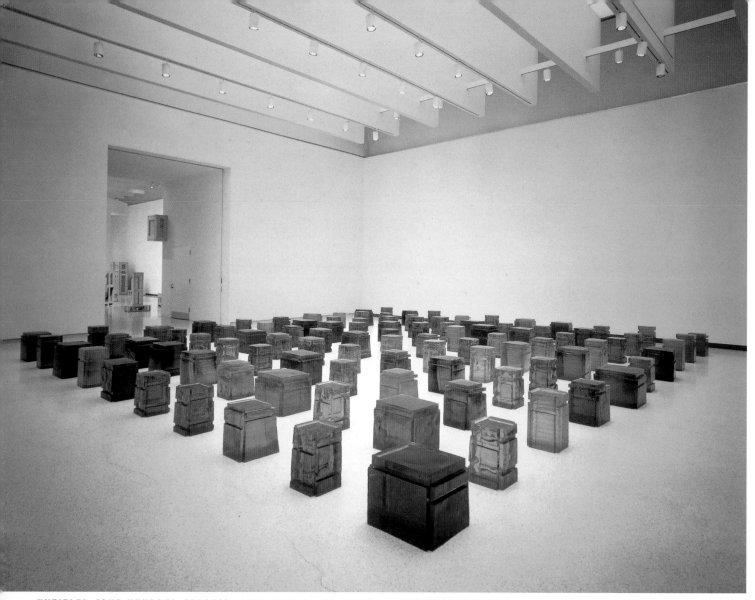

UNTITLED (ONE HUNDRED SPACES), 1995. RESIN, 100 UNITS, DIMENSIONS VARIABLE.
INSTALLED AT CARNEGIE INSTITUTE, PHILADELPHIA, USA.

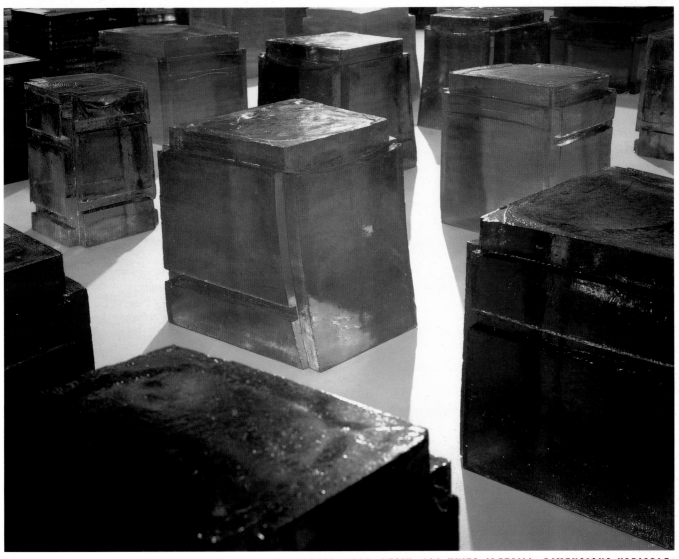

UNTITLED (ONE HUNDRED SPACES), 1995. RESIN, 100 UNITS (DETAIL), DIMENSIONS VARIABLE.

RACHEL WHITEREAD

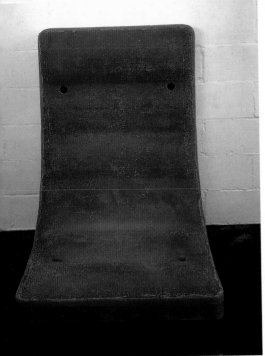

UNTITLED (AMBER BED), 1991.
RUBBER, 129,5 X 91,4 X 101,6 CM.

UNTITLED (ORANGE BATH), 1996.
RUBBER, POLYSTYRENE, 80 X 207 X 110 CM.
INSTALLED AT HAUNCH OF VENISON.

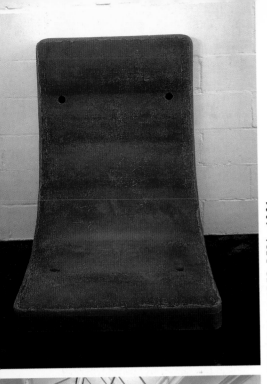

UNTITLED (SQUARE SINK), 1990.
PLASTER, 106,6 X 101,6 X 86,3 CM.

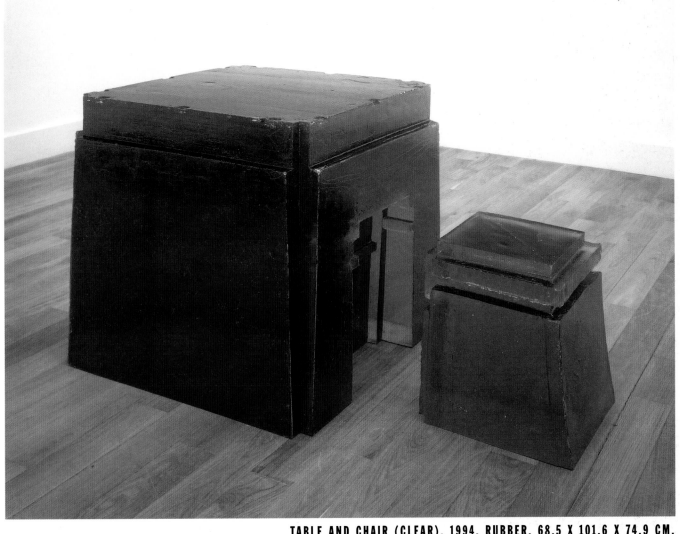

TABLE AND CHAIR (CLEAR), 1994. RUBBER, 68,5 X 101,6 X 74,9 CM.

RACHEL WHITEREAD

GALLERIES IN LONDON

DEALERS & GALLERIES

Anne Faggionato

20 Dering Street
London W1S 1AJ
Tel. 44 (0)20 7493 6732
Fax 44 (0)20 7493 9693
www.anne-faggionato.com

The Approach

1st Floor, 47 Approach Road
London E2 9LY
Tel. 44 (0)20 8983 3878
Fax 44 (0)20 8983 3919
www.theapproachgallery.co.uk

Entwistle

6 Cork Street
London W1S 3EE
Tel. 44 (0)20 7734 6440
Fax 44 (0)20 7734 7966
www.entwistlegallery.com

Gagosian Gallery

8 Heddon Street
London W1B 4BU
Tel. 44 (0)20 7292 8222
Fax 44 (0)20 7292 8220
www.gagosian.com

Haunch of Venison

6 Haunch of Venison Yard
London W1K 5ES
Tel. 44 (0)20 7495 5050
Fax 44 (0)20 7495 4050
www.haunchofvenison.com

Hayward Gallery

Belvedere Road
London SE1 8XZ
Tel. 44 (0)20 7960 5226
Fax 44 (0)20 7401 2664
www.hayward.org.uk

Houldsworth

33-34 Cork Street
London W1S 3NQ
Tel. 44 (0)20 7434 2333
Fax 44 (0)20 7434 3636
www.houldsworth.co.uk

Laurent Delaye Gallery

11 Savile Row
London W1S 3PG
Tel. 44 (0)20 7287 1546
Fax 44 (0)20 7287 1562
www.laurentdelaye.com

Lisson Gallery

52-54 Bell Street
London NW1 5DA
Tel. 44 (0)20 7724 2739
Fax 44 (0)20 7724 7124
www.lisson.co.uk

Malborough Fine Art

6 Albemarle Street
London W1S 4BY
Tel. 44 (0) 20 7629 5161
Fax 44 (0) 20 7629 6338
www.marlboroughfineart.com

Maureen Paley Interim Art

21 Herald Street
London E2 6JT
Tel. 44 (0)20 7729 4112
Fax 44 (0)20 7729 4113
interim.art@virgin.net

Modern Art

73 Redchurch Street
London E2 7DJ
Tel. 44 (0)20 7739 2081
Fax 44 (0)20 7729 2017
www.modernartinc.com

Saatchi Gallery

County Hall
London SE 1
Tel. 44 (0)20 7823 2332
Fax 44 (0)20 7823 2334

Sadie Coles HQ

35 Heddon Street
London W1B 4BP
Tel. 44 (0)20 7434 2227
Fax 44 (0)20 7434 2228
www.sadiecoles.com

Sprueth Magers Lee

12 Berkley Street
London W1J 8DT
Tel. 44 (0)20 7491 0100
Fax 44 ()020 7491 0200
info@spruethmagerslee.com

Timothy Taylor Gallery

1 Bruton Place
London W1J 6LS
Tel. 44 (0)20 7409 3344
Fax 44 (0)20 7409 1316
www.ttgallery.com

Victoria Miro Gallery

16 Wharf Road
London N1 7RW
Tel. 44 (0)20 7336 8109
Fax 44 (0)20 7251 5596
www.victoria-miro.com

Vilma Gold

66 Rivington Street
London EC2A 3AY
Tel. 44 (0)20 7613 1609
Fax 44 (0)20 7256 1242
www.vilmagold.com

Waddington Galleries

11 Cork Street
London W1S 3LT
Tel. 44 (0)20 7851 2200
Fax 44 (0)20 7734 4146
www.waddington-galleries.co

White Cube

48 Hoxton Square
London N1 6PB
Tel. 44 (0)20 7930 5373
Fax 44 (0)20 7749 7480
www.whitecube.com

DEALERS

Anthony D'Offay Gallery Ltd

9 & 23-24 Dering Street
London W1
Tel. 44 (0)20 7499 4100
Fax 44 (0)20 7493 4443
www.doffay.com

Paul Stolper

118 Mortimer Road
London NW10 5SN
Tel. 44 (0)20 8968 4446
Fax 44 (0)20 7734 9008
www.paulstolper.com

Karsten Schubert Ltd.

47 Lexington Street
London W1R 3LG
Tel. 44 (0)20 7734 9002
Fax 44 (0)20 7734 9008
www.karstenschubert.com

Hester Van Roijen

21 Carlyle Mansions
London SW3 5LS
Tel. 44 (0)20 7376 4921
Fax 44 (0)20 7352 2379
hester@binternet.com

PHOTOCREDITS

All the photographs made for this book: © Amanda Eliasch.
Other photographs for the works: © the artists
p. 15, 18-19, 23-27 © DACS/Courtesy Waddington Galleries, London; p. 31 © Marc Domage, Paris, 2002; p. 33 © Modern Art, London; p. 34 © Marc Domage, Paris, 2002; p. 35 © Modern Art, London; p. 37, 39-41, 43-47, 49 © Gagosian Gallery, London; p. 51, 54-56 © Waddington Galleries, London; p. 59, 62-65 © Gagosian Gallery, London; p. 67 © Courtesy Jay Jopling/White Cube, London; p. 69, 71 © Stephen White/Courtesy Jay Jopling/White Cube, London; p. 73, 77 © Saatchi Gallery, London; p. 80-83, 85 © Courtesy Jay Jopling/White Cube, London; p. 87-89 © Laurent Delaye Gallery, London; p. 93-95, 97, 99 © Stephen White/Courtesy Jay Jopling/White Cube, London; p. 101 © Salvatore Ala Gallery, New York; p. 102 © Stephen White/Courtesy Jay Jopling/White Cube, London; p. 103 © Colin Cuthbert/Gateshead Council; p. 108 © Taro Nasu Gallery, Tokyo; p. 114-115, 117 © Vilma Gold, London; p. 119 © Anthony d'Offay Gallery, London; p. 120-121, 123 © Gagosian Gallery, London; p. 125-127 © Anne Faggionato, London; p. 130 © Stephen White/Courtesy Jay Jopling/White Cube, London; p. 133 © Karsten Schubert Ltd., London; p. 134-135, 137, 139-141 © Stephen White/Courtesy Jay Jopling/White Cube, London; p. 143-149 © Victoria Miro Gallery, London; p. 151, 153 © Maureen Paley/Interim Art, London; p. 155, 157 © John Riddy/Lisson Gallery, London; p. 162-165 © Sadie Coles HQ, London; p. 167 © Rare Art Property, New York; p. 175, 177 © Gagosian Gallery, London; p. 179, 182-183 © Houldsworth, London; p. 187 © Hester Van Roijen, London; p. 188, 190-191 © Waddington Galleries, London; p. 193-197 © Stephen White/Courtesy Jay Jopling/White Cube, London; p. 199, 202-205 © Modern Art, London; p. 209 © Galerie Bob van Orsouw, Zürich; p. 211 © James Cohan Gallery, New York; p. 212-214 © Anthony d'Offay Gallery, London; p. 215 © James Cohan Gallery, New York; p. 217, 219 © Prudence Cumings Associates Ltd., London; p. 222-223 © Laurent Delaye Gallery, London; p. 227-228 © Roger Sinek/Courtesy Jay Jopling/White Cube, London; p. 229-231 © Courtesy Jay Jopling/White Cube, London; p. 233, 236-239 © Timothy Taylor Gallery, London; p. 241, 243, 245 © The Approach, London; p. 253, 256-257 © Gagosian Gallery, London; p. 259, 261-263 © Entwistle Gallery, London; p. 265-269, 271-273, 275 © Courtesy Jay Jopling/White Cube, London; p. 277-279, 281-285 © Maureen Paley/Interim Art, London; p. 287-291 © Haunch of V...

...EDGEMENTS

COORDINATION of the book: Amanda Eliasch. Assistant: Amanda Daynes.
PHOTOGRAPHIC ASSISTANTS: Natasha Bidgood, Amanda Daynes, Alex Webster.
ACKNOWLEDGEMENTS to: Philippa Adams, Steven Asquith, Martine Assouline, Rachel Barbaresi, Katy Barker, Laura Bartlett, Chiara Bersi Serlini, Harry Blain, Isabella and Detmar Blow, Mary Boyle, Bob Carlos Clarke, James Cohan, Frank Cohen, Sadie Coles, Sophie Cooke, Pauline Daly, Julie David, Laurent Delaye, Molly Dent-Brocklehurst, Mathilde Dupuy d'Angeac, Lance and Bobby Entwistle, Anne Faggionato, Faye Fleming, Larry Gagosian, Vilma Gold, Sophie Greig, Pippy Houldsworth, Caren Jones, Melissa Knatchbull, Mrs. and Mr. Simon Lee, Nicholas Logsdail, Honey Luard, Virginia McDonald, Metro Imaging, Ellen Nidy, Mariska Nietzman, Maureen Paley, Charlie Phillips, Karim Rabik, Nelly Riedel, Phil Scala, Mr. Jean Louis Sebagh, Stuart Shave, Graham Southern, Julia Sprinkel, Paul Stolper, Tapestry. John Devitt, Kelly Taylor, Timothy Taylor, Joanna Thornberry, Hester Van Roijen, Mr. Leslie Waddington, Rachel Williams.
Acknowledgements to galleries: Anne Faggionato; Anthony D'Offay Gallery, London; Briggs Robinson Gallery, New York; Entwistle, London; Gagosian Gallery, London; Haunch of Venison; Hester Van Roijen; Houldsworth Fine Art, London; James Cohan Gallery, New York; Laurent Delaye Gallery; Lisson Gallery; Maureen Paley Interim Art; Modern Art; Paul Stopler; Saatchi Gallery, London; Sadie Coles HQ; Spruth Marges Lee; The Approach, London; Timothy Taylor Gallery, London; Victoria Miro Gallery; Vilma Gold; Waddington Gallery, London; White Cube, London.
Special thanks to all participating artists, and also to Michel Comte, Johan Eliasch, Kay Hartenstein-Saatchi, Martin Maloney, Charles...

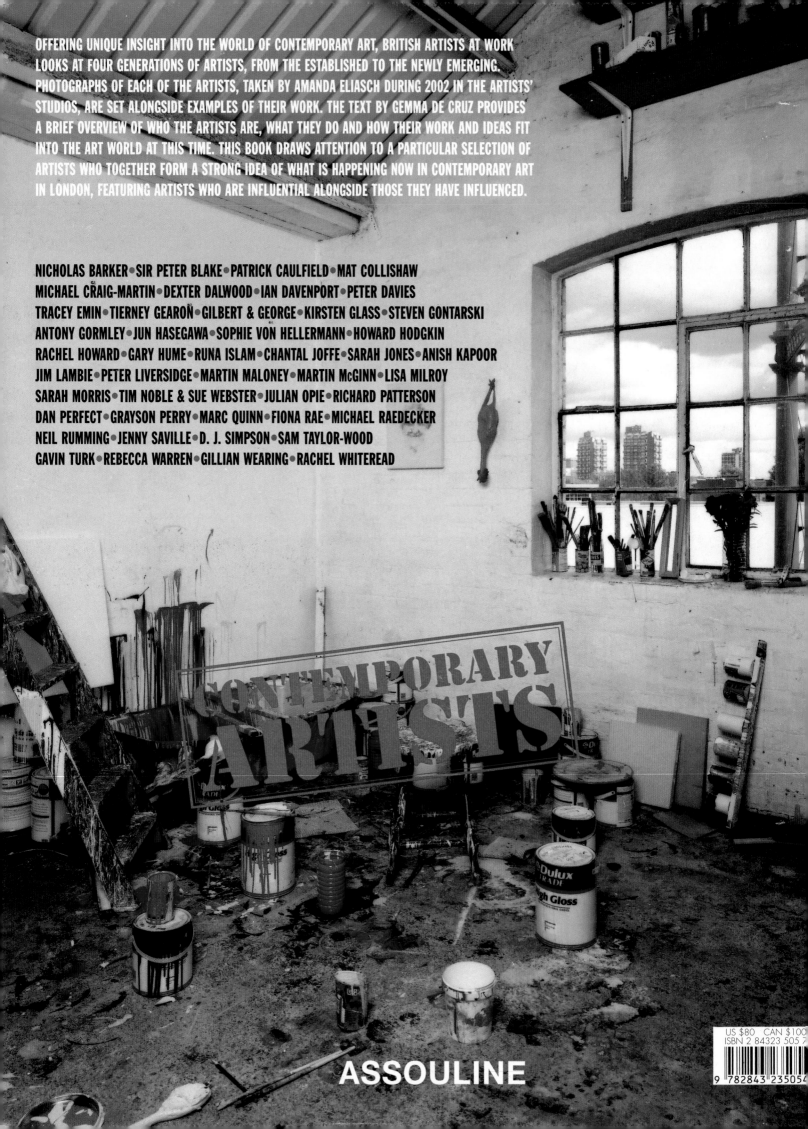

OFFERING UNIQUE INSIGHT INTO THE WORLD OF CONTEMPORARY ART, BRITISH ARTISTS AT WORK LOOKS AT FOUR GENERATIONS OF ARTISTS, FROM THE ESTABLISHED TO THE NEWLY EMERGING. PHOTOGRAPHS OF EACH OF THE ARTISTS, TAKEN BY AMANDA ELIASCH DURING 2002 IN THE ARTISTS' STUDIOS, ARE SET ALONGSIDE EXAMPLES OF THEIR WORK. THE TEXT BY GEMMA DE CRUZ PROVIDES A BRIEF OVERVIEW OF WHO THE ARTISTS ARE, WHAT THEY DO AND HOW THEIR WORK AND IDEAS FIT INTO THE ART WORLD AT THIS TIME. THIS BOOK DRAWS ATTENTION TO A PARTICULAR SELECTION OF ARTISTS WHO TOGETHER FORM A STRONG IDEA OF WHAT IS HAPPENING NOW IN CONTEMPORARY ART IN LONDON, FEATURING ARTISTS WHO ARE INFLUENTIAL ALONGSIDE THOSE THEY HAVE INFLUENCED.

NICHOLAS BARKER•SIR PETER BLAKE•PATRICK CAULFIELD•MAT COLLISHAW
MICHAEL CRAIG-MARTIN•DEXTER DALWOOD•IAN DAVENPORT•PETER DAVIES
TRACEY EMIN•TIERNEY GEARON•GILBERT & GEORGE•KIRSTEN GLASS•STEVEN GONTARSKI
ANTONY GORMLEY•JUN HASEGAWA•SOPHIE VON HELLERMANN•HOWARD HODGKIN
RACHEL HOWARD•GARY HUME•RUNA ISLAM•CHANTAL JOFFE•SARAH JONES•ANISH KAPOOR
JIM LAMBIE•PETER LIVERSIDGE•MARTIN MALONEY•MARTIN McGINN•LISA MILROY
SARAH MORRIS•TIM NOBLE & SUE WEBSTER•JULIAN OPIE•RICHARD PATTERSON
DAN PERFECT•GRAYSON PERRY•MARC QUINN•FIONA RAE•MICHAEL RAEDECKER
NEIL RUMMING•JENNY SAVILLE•D. J. SIMPSON•SAM TAYLOR-WOOD
GAVIN TURK•REBECCA WARREN•GILLIAN WEARING•RACHEL WHITEREAD

ASSOULINE

US $80 CAN $100
ISBN 2 84323 505 7

9 782843 235054